THE BIG BOOK OF DRAWING ANIME

THE COMPLETE STEP-BY-STEP GUIDE

CHRISTOPHER HART

 Get Creative 6

DEDICATION

Special thanks to Art Joinnides and Carrie Kilmer for giving me the opportunity to produce a comprehensive book for aspiring anime artists.

Get Creative 6

An imprint of Mixed Media Resources, LLC
19 W. 21st Street, Suite 601
New York, NY 10010

Editor
PAM KINGSLEY

Creative Director
IRENE LEDWITH

Book Design
DIANE LAMPHRON

Art Directors
DIANE LAMPHRON
JENNIFER MARKSON

Contributing Artists
AKANE
ANZU
CHRISTOPHER HART
KOUKUBOTA
KURI NYANN
PH MARCONDES
TABBY CHAN

Chief Executive Officer
CAROLINE KILMER

President
ART JOINNIDES

Chairman
JAY STEIN

Library of Congress Cataloging-in-Publication Data is available upon request.

Note: This book is intended for use by adults. If children are permitted to use this book, be sure to provide them with child-safe supplies.

ISBN 978-1-68462-083-8

Manufactured in China

1 3 5 7 9 10 8 6 4 2

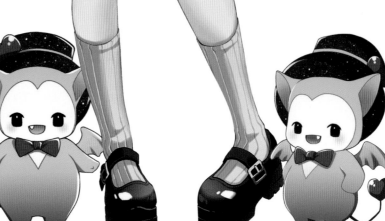

Contents

Introduction

This book is a complete course for the aspiring anime artist.
Within its covers, you'll discover helpful art principles and techniques that will lift your skills and enable you to draw a wide range of popular character types.

These are the foundational skills of anime. They're easy to understand and to put into practice. With them, you can take your art to new levels. They're essential for drawing heads, expressions, and poses, learning the secrets of character design, and telling a story *visually*.

The purpose of this book is to ignite your creativity and couple it with effective art instruction so you can draw the style that you love: anime. The visual examples and instruction in this book work as well for artists who prefer pencil and paper as they do for those who prefer a digital tablet. This is a massive book, and it can give you massive skills.

Let's dive in.

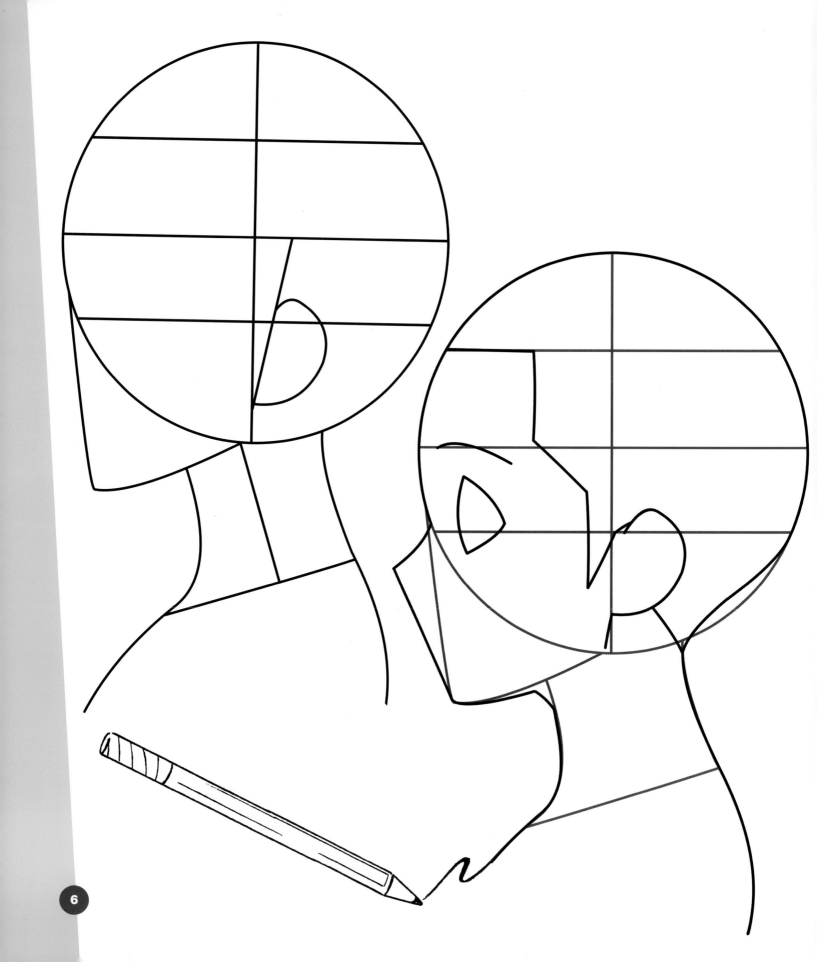

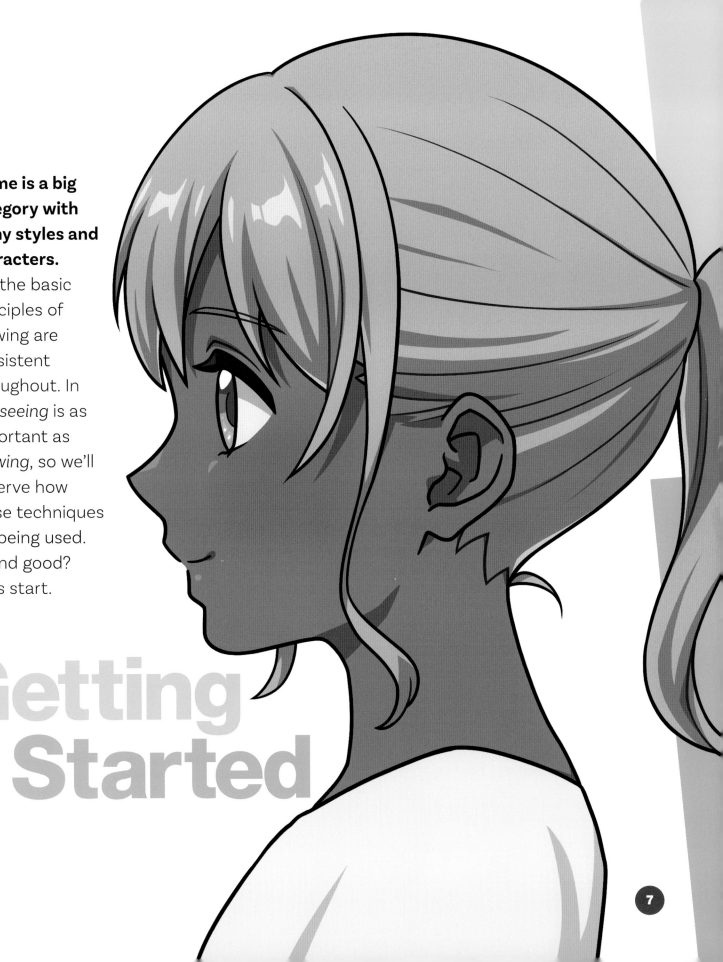

Anime is a big category with many styles and characters. But the basic principles of drawing are consistent throughout. In art, *seeing* is as important as *drawing,* so we'll observe how these techniques are being used. Sound good? Let's start.

Getting Started

How to Use a Simple Character Template

"How can I make my character look the same at different angles?" is an age-old question for artists. The answer is about proportions—basic, easy-to-grasp proportions.

Artists use proportions to compare one part of the body against another. For example, they'll check to see that the tip of the nose in a front view is the same height as the tip of the nose in a ¾ view (see the middle red line below). When it comes to drawing faces, the front view is used as the basis of comparison; it's the clearest angle and has the most information about your character.

FRONT VIEW

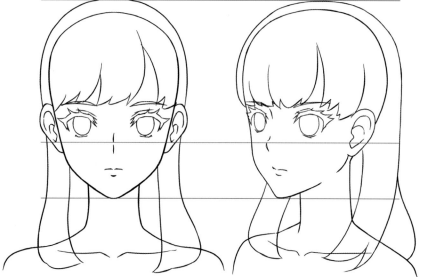

Guidelines (shown in red) are easy to use. Make sure they align for both angles, and your head will look right.

¾ VIEW

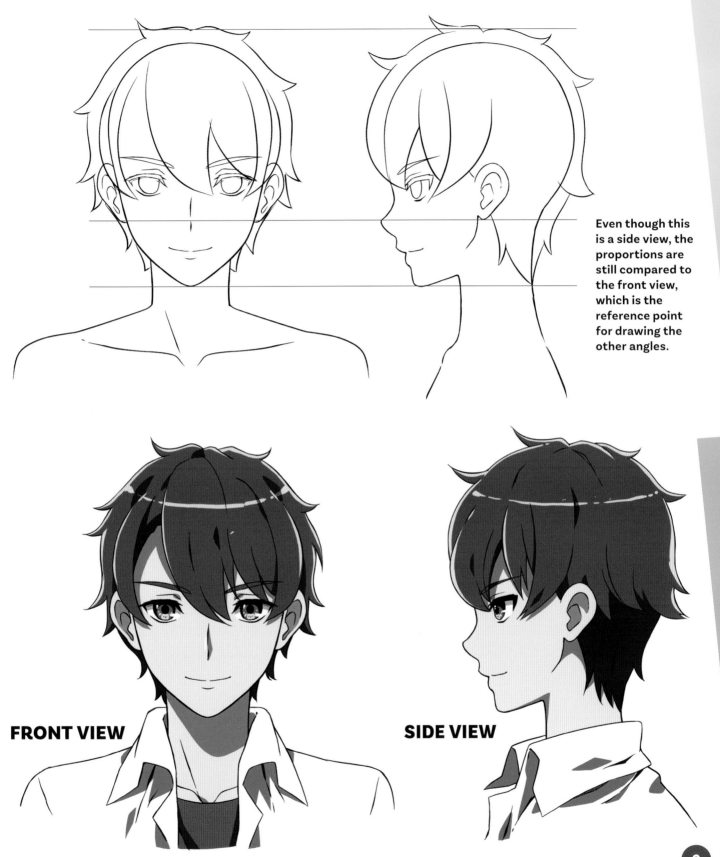

Even though this is a side view, the proportions are still compared to the front view, which is the reference point for drawing the other angles.

FRONT VIEW

SIDE VIEW

How to Improve Faster

Here's an important tip: You will improve faster if you spend more time on the early steps. These hold the key to the look of the final drawing.

FRONT VIEW

Start with a few guidelines to get the position of the features. Then you can draw the rest of the face with spontaneity and the confidence it will turn out right.

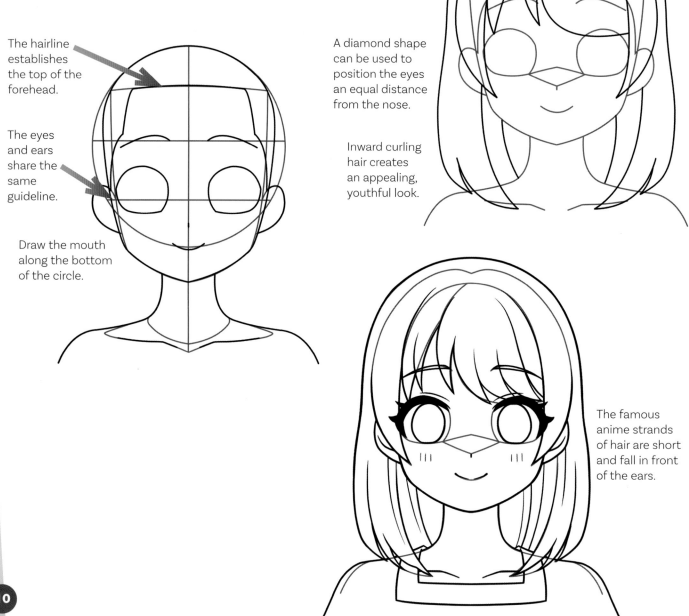

The hairline establishes the top of the forehead.

The eyes and ears share the same guideline.

Draw the mouth along the bottom of the circle.

A diamond shape can be used to position the eyes an equal distance from the nose.

Inward curling hair creates an appealing, youthful look.

The famous anime strands of hair are short and fall in front of the ears.

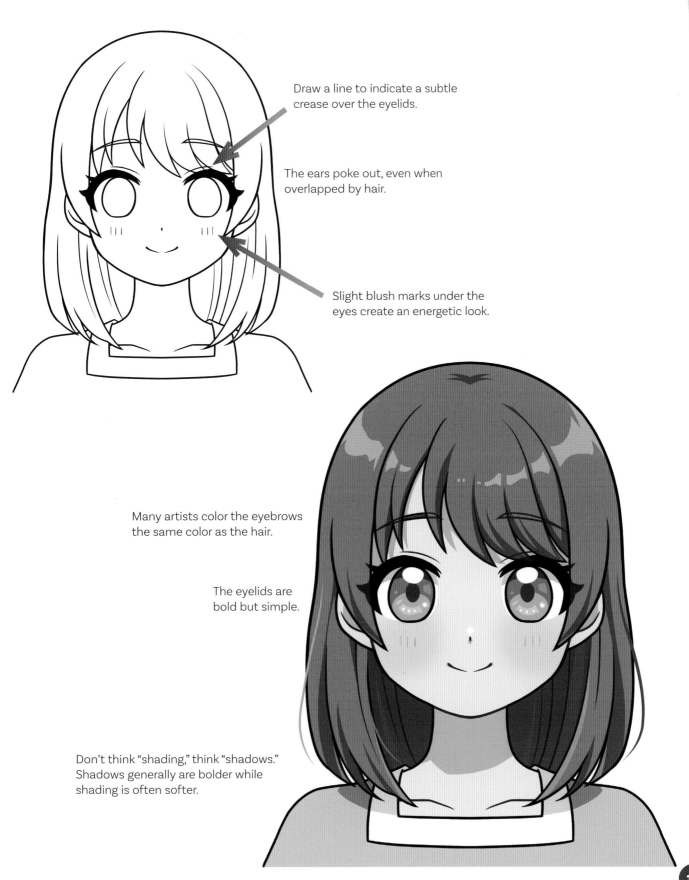

Draw a line to indicate a subtle crease over the eyelids.

The ears poke out, even when overlapped by hair.

Slight blush marks under the eyes create an energetic look.

Many artists color the eyebrows the same color as the hair.

The eyelids are bold but simple.

Don't think "shading," think "shadows." Shadows generally are bolder while shading is often softer.

Now, add the color.

11

SIDE VIEW

The side view is an important angle to learn. Its unique quality can be seen in the steep angle that runs from the tip of the nose to the tip of the chin. This has become a signature look for anime characters.

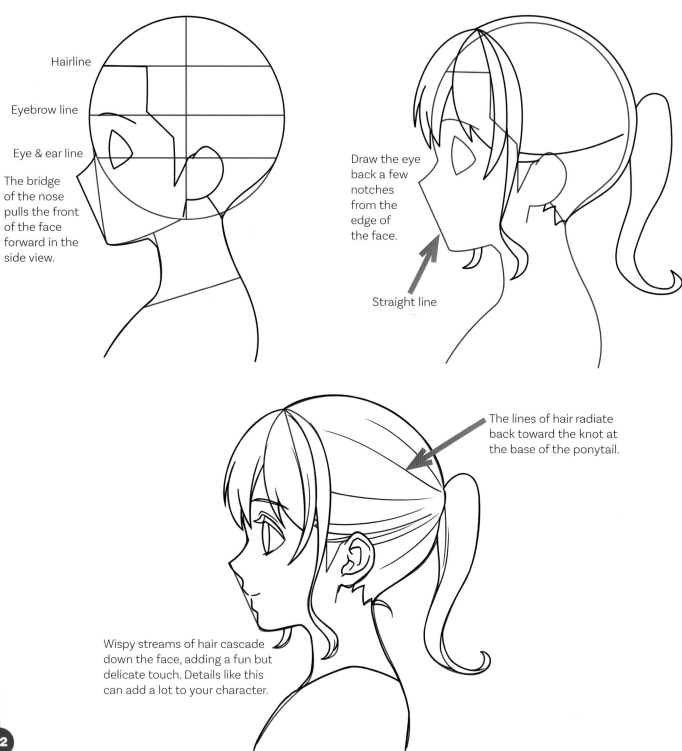

Hairline

Eyebrow line

Eye & ear line

The bridge of the nose pulls the front of the face forward in the side view.

Draw the eye back a few notches from the edge of the face.

Straight line

The lines of hair radiate back toward the knot at the base of the ponytail.

Wispy streams of hair cascade down the face, adding a fun but delicate touch. Details like this can add a lot to your character.

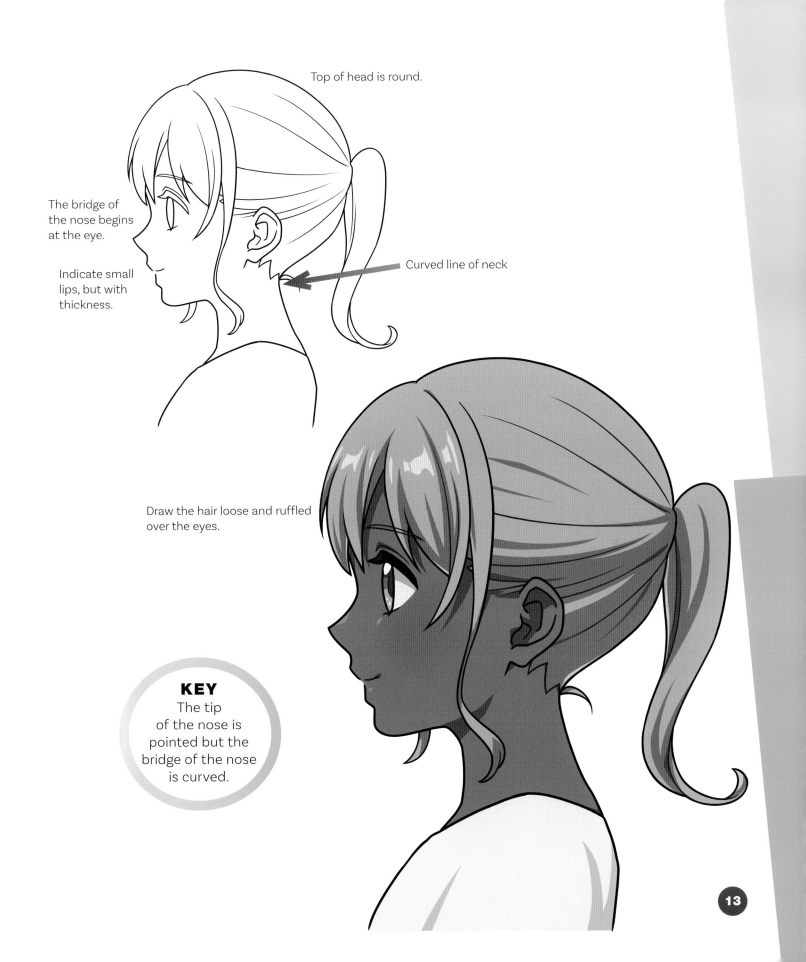

Top of head is round.

The bridge of the nose begins at the eye.

Indicate small lips, but with thickness.

Curved line of neck

Draw the hair loose and ruffled over the eyes.

KEY
The tip of the nose is pointed but the bridge of the nose is curved.

13

HEAD TILT—UP

In this angle, looking up at the head, the bottom of the face looks larger and the top of the head looks smaller.

Draw guidelines on a curve across the face. This emphasizes the upward angle of the head.

The top of the head, above the eyebrows, appears smaller.

Use the hair to emphasize the roundness of the overall shape of the head.

Lower the placement of the ears.

Flatten out the bottom eyelids.

Draw the mouth higher than you would in a regular front view.

Add a slender area of shadow just below the chin.

The jaw looks wider when viewed from this angle.

The hair in front of the ears curves in; the hair behind the ears curves out.

Add a small shadow below the nose and bottom lip, and on the hair that falls below and behind her head.

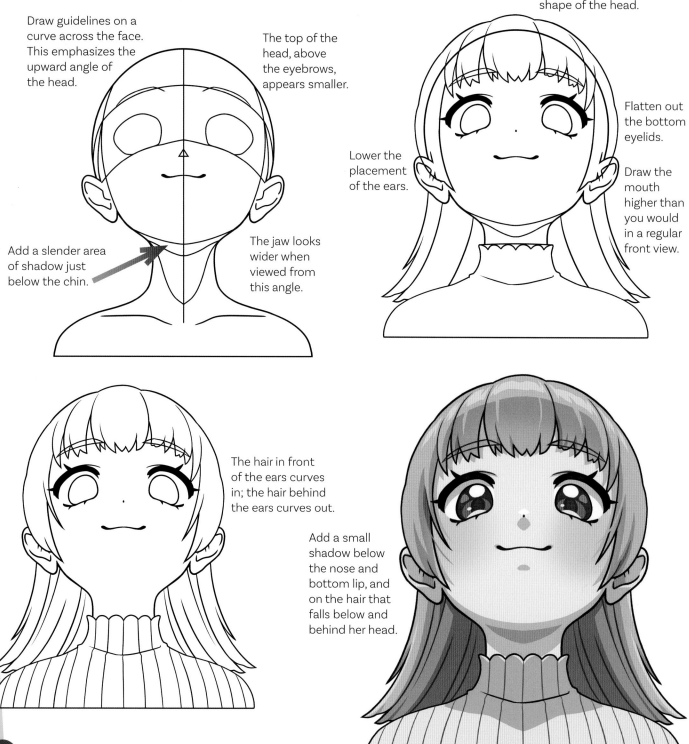

HEAD TILT—DOWN

The farther down the face the features (the nose and mouth) are placed, the smaller they appear.

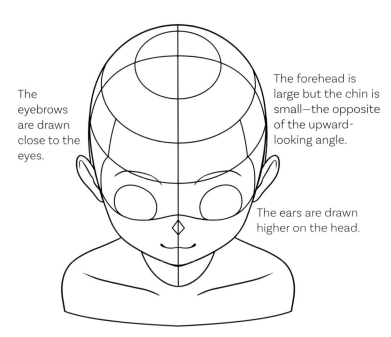

The eyebrows are drawn close to the eyes.

The forehead is large but the chin is small—the opposite of the upward-looking angle.

At this angle, we can see the top of the head and where the strands of hair converge.

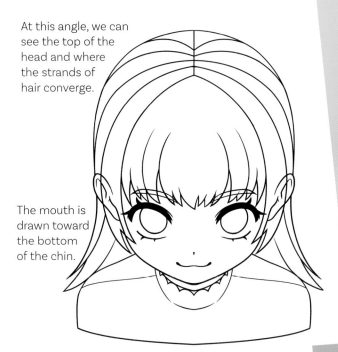

The ears are drawn higher on the head.

The mouth is drawn toward the bottom of the chin.

Add a shine to the top of the head; there's too much hair to leave it undefined.

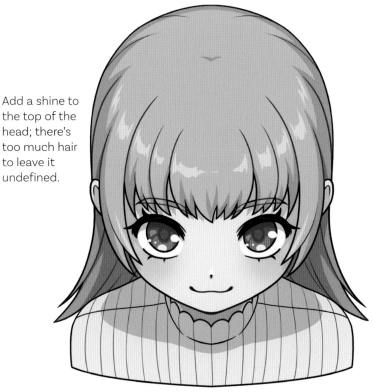

The neck is overlapped by the chin and can't be seen at this angle.

If you haven't drawn angles like these before and it feels a little awkward, trust the proportions.

Mastering Anime Eyes & Hairstyles

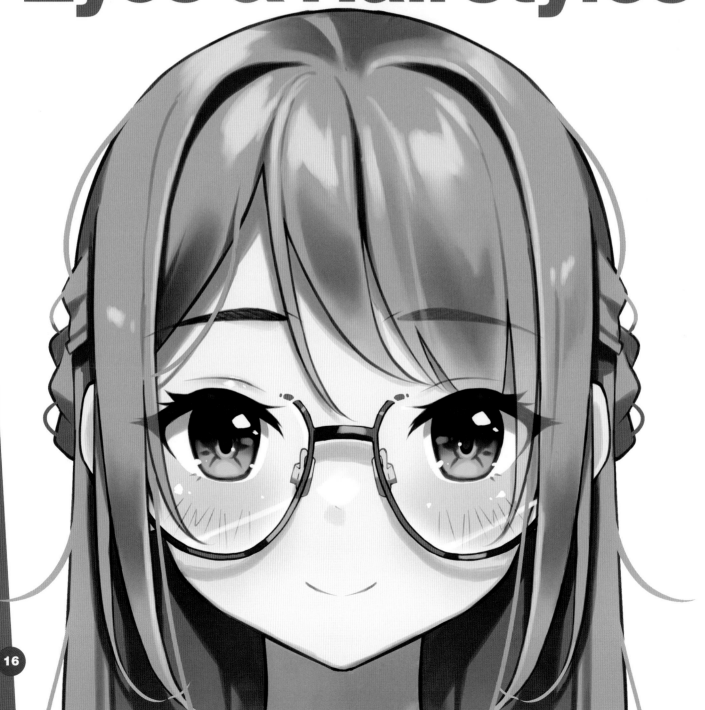

Some books teach you how to draw the anime eye. But which eye is that? There are different eyes for different characters, for different looks. The same is true of hairstyles. Let's see how it's done with a few popular styles.

Eyes

Let's start with the basic eye. Once you've got the foundation, you can use it to create different variations.

PROPORTIONS

The easiest way to draw this important feature is to take note of the proportions. The eyes are drawn just below the halfway point of the head, as measured from top to bottom.

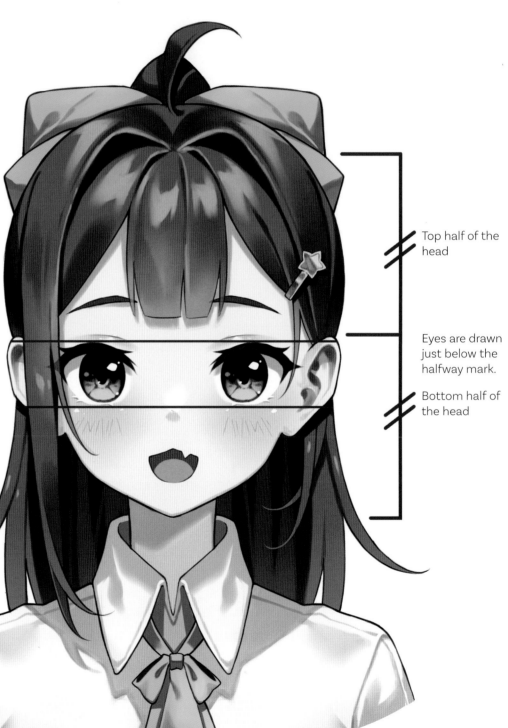

In anime, the iris takes up more room than the white of the eye, which is the opposite of how it appears in realistically drawn people.

Two horizontal guidelines align the eyes on the top and bottom.

Top half of the head

Eyes are drawn just below the halfway mark.

Bottom half of the head

STYLISH EYES

Eyes are adaptable. They can be adjusted to go with current styles and fashions, personalities, and ages.

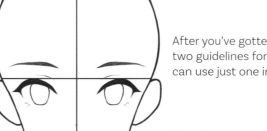

PROPORTION CHECK
The nose should be centered between the eyes.

After you've gotten used to using two guidelines for the eyes, you can use just one instead.

This character appears a bit older than the previous one because the eyeballs are slightly smaller. Bigger eyes make a character look younger.

Hair flops over the head, into wavy curls. Relaxed hair doesn't retain its shape but instead creates a random look, which is fun and dynamic.

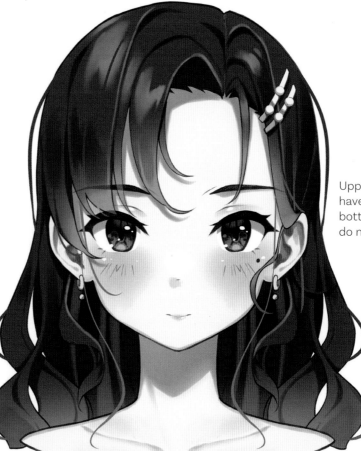

Upper eyelids have thickness; bottom eyelids do not.

By reducing the size of the mouth, the eyes become the focus of the face.

OVERSIZED EYES

Oversized eyes are very popular because they imply cute, cheerful, and energetic character types. They also provide more area for colors and effects.

KEY
Anime eyes are defined by their thick, arching eyelids.

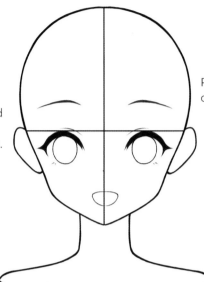

Add an upturned eyelash at the ends of the eyes.

Raise the eyebrows for cheerful expressions.

Eyes are drawn just below the halfway mark on the head.

You can draw the eyes perfectly round or as uneven circles. It's not the shape, it's what you do with it.

The hair falls over the forehead in such a way that it misses the eyes.

A few blush marks on the cheeks are a popular touch.

Many artists like to draw one big "shine" in each eye, while others prefer to draw a series of small shines.

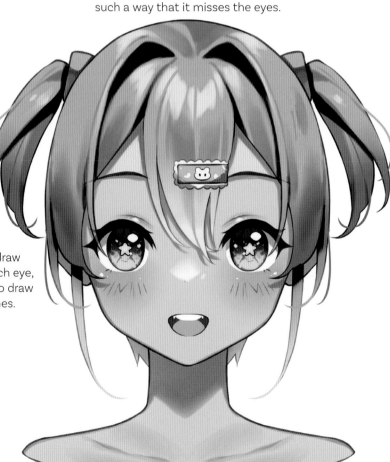

CARING EYES

Subdued eyes are well suited for a caring character type. They are often drawn lightly, even delicately. A few wispy, unturned lashes enhance the look.

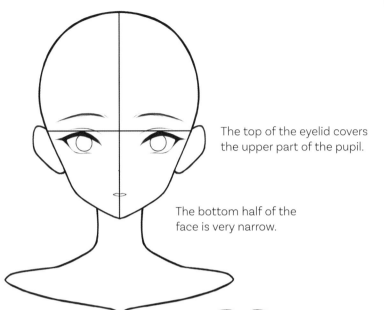

The top of the eyelid covers the upper part of the pupil.

The bottom half of the face is very narrow.

The eyes and the hair are the same color, creating a stronger look.

For a cute look, allow the ears to peek out from under the hair.

The irises are a darker shade of purple to reflect emotional depth.

The smaller the eyeshines, the subtler the expression.

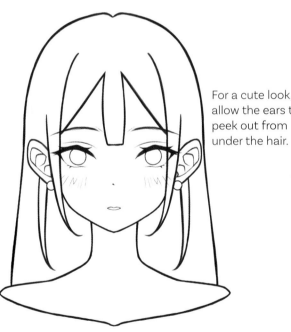

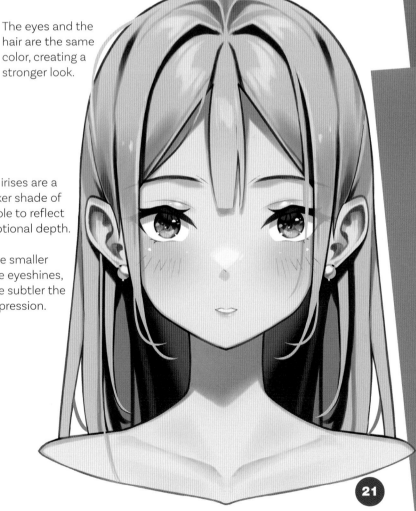

WICKED EYES

Wicked characters enjoy their work, hence the smile that accompanies the expression.

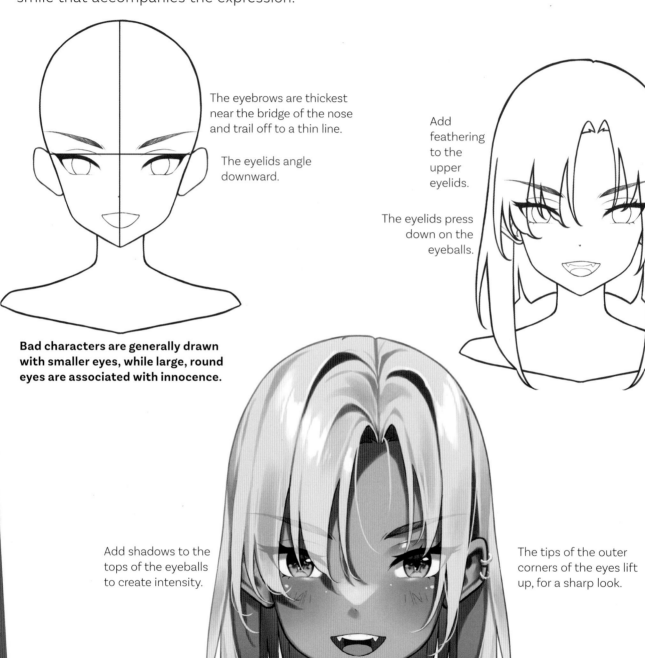

The eyebrows are thickest near the bridge of the nose and trail off to a thin line.

The eyelids angle downward.

Add feathering to the upper eyelids.

The eyelids press down on the eyeballs.

Bad characters are generally drawn with smaller eyes, while large, round eyes are associated with innocence.

Add shadows to the tops of the eyeballs to create intensity.

The tips of the outer corners of the eyes lift up, for a sharp look.

DRAWING EYEGLASSES

The trick to drawing eyeglasses is to make it a two-step process: first draw the position of the eyes, then the glasses. More of the glasses should appear below the eyes than above.

KEY
Don't let the eyes touch the outline of the glasses.

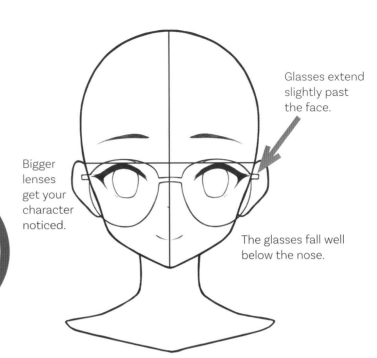

Glasses extend slightly past the face.

Bigger lenses get your character noticed.

The glasses fall well below the nose.

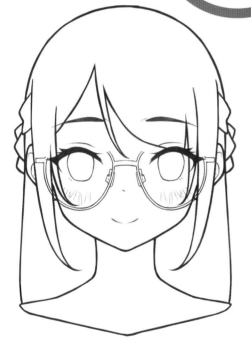

See how natural it looks when you draw full-size glasses that extend down almost to the level of the mouth?

Subtle touches are important, like the shadows that are cast from the glasses onto the lower face. Without them, the glasses would look pasted to the face.

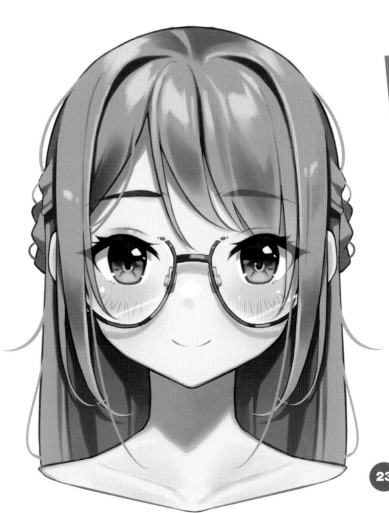

23

Hairstyles

Next to eyes, a character's hairstyle creates the biggest impression. Hair isn't something that just sits on top of a character's head. It's dynamic. It has its own direction and flow. This section will give you the tools to create many popular hairstyles and variations for your original characters.

FRONT VIEW

Hair frames the face and travels down to the shoulders, where it spreads out and becomes less controlled.

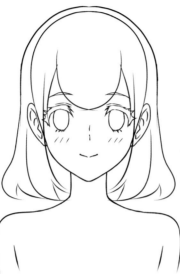

Ruffle the bottom edge of the hair.

Leave some space between the hair and the shoulders for this cut.

The overall shape of the hair is like a bell: rounded on top, widening at the bottom.

Create highlights on the crown of the head with a lighter color.

SIDE VIEW

Here's a different angle for the same hairstyle. If your character moves or turns, the hairstyle has to look the same.

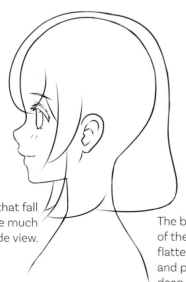

Strands of hair that fall over the ears are much more visible in the side view.

The back of the hair flattens out and pads the deep curve of the neck.

With the side view, you can brush the hair back, to reveal more of the face.

LONG HAIR

Flowing hair can take on a dramatic quality. This is a popular look for schoolgirl characters.

For a character facing left, at a ¾ angle, draw the hair on the far side of the face.

Flowing hair gently wafts through the air with individual strands going in different directions.

The hair whips around the shoulders, as if it were trying to envelop the character.

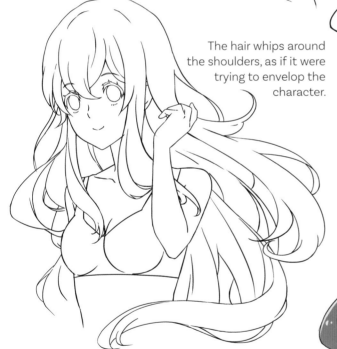

One of the most effective ways to create flowing hair is to show the strands coming together and then moving apart. It results in an underwater, weightless type of look, highly fluid and appealing.

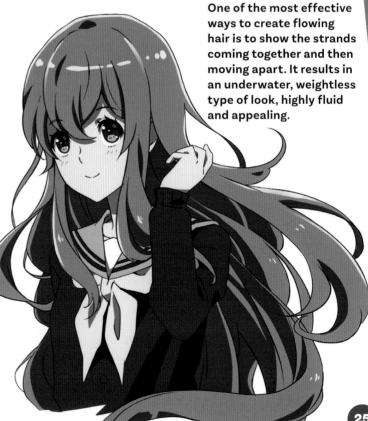

Maintain some definition between the strands so that the hair doesn't look like an undefined mass when colored in.

Bangs separate over the forehead.

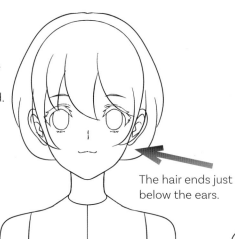

The hair ends just below the ears.

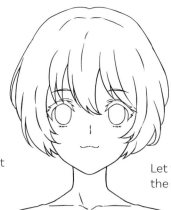

Let the hair overlap the sides of the face.

KEY
Short hair emphasizes its texture, such as choppy, ruffled, wavy, etc.

SHORT HAIR

Short hair tends to frame the face, putting the spotlight on the character's expression. It's often designed for a cute look, but lends itself to many other styles, too.

By separating the bangs into clumps around the eyes, you draw attention to them.

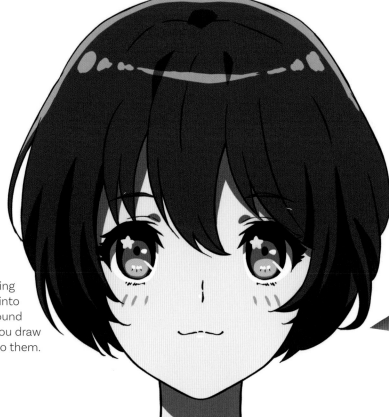

A few random strands of hair add a lifelike look.

VARIATIONS ON SHORT HAIR

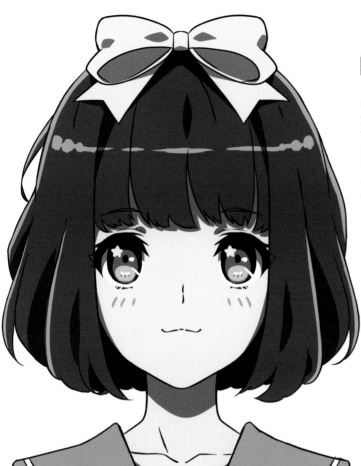

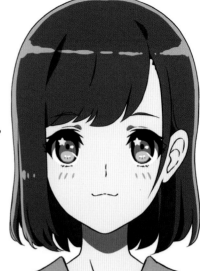

Modest Cut

If you're drawing a meek character, you can't go wrong with this hairstyle. It goes behind one ear, and covers the other.

Drop Cut

This style is layered and full. It is a good choice for friendly characters.

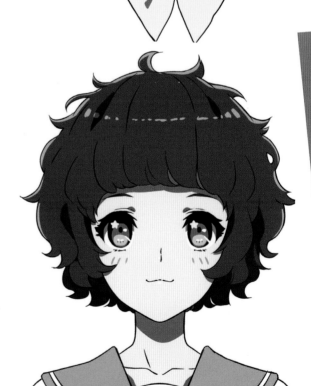

Short & Shaggy

This cut is great for a character with a unique perspective on life.

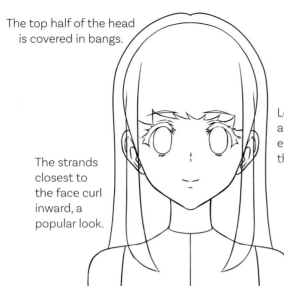

The top half of the head is covered in bangs.

Long strands are drawn on either side of the bangs.

The strands closest to the face curl inward, a popular look.

KEY
Decide how close to the eyes you want the bangs to fall.

Draw lines in the hair to give it texture.

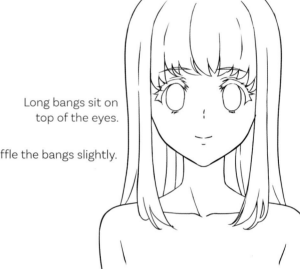

Long bangs sit on top of the eyes.

Ruffle the bangs slightly.

BANGS

Bangs are popular because they go with many styles, as you can see with the variations on the next page. Perhaps some of your favorite anime characters are drawn with them. Therefore you may want to put them in your repertoire.

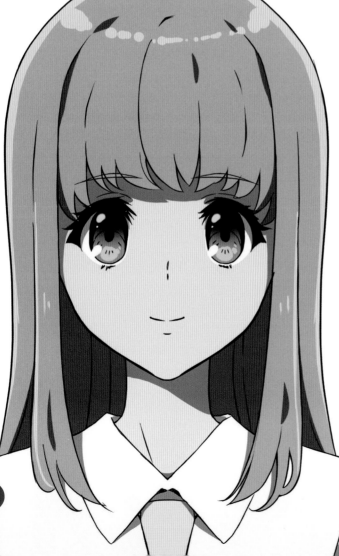

The interior of the hair falls into shadow and is a darker hue than the exterior hair color. This creates a sense of depth.

VARIATIONS ON BANGS

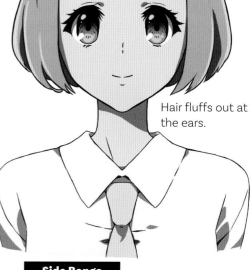

Draw lines to show the flow of the hair.

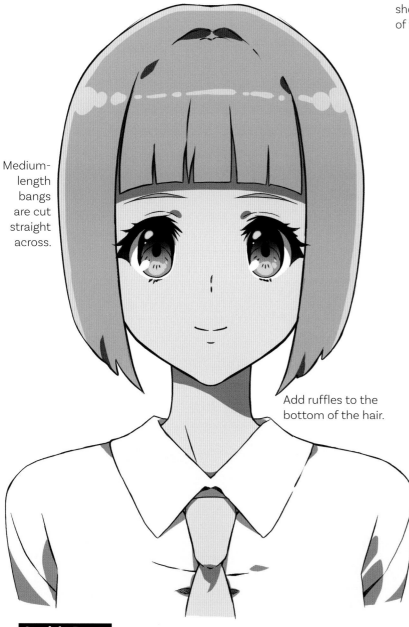

Medium-length bangs are cut straight across.

Add ruffles to the bottom of the hair.

Hair fluffs out at the ears.

Side Bangs

Here the bangs are swept to one side, with a clip holding the hair in place.

Straight Bangs

This is a cheerful style for an upbeat character. It's also very symmetrical.

Bangs with Wavy Hair

Wavy hair won't sit still, and certainly won't take orders. Draw it swerving in different directions. Some of it overlaps the face, randomly.

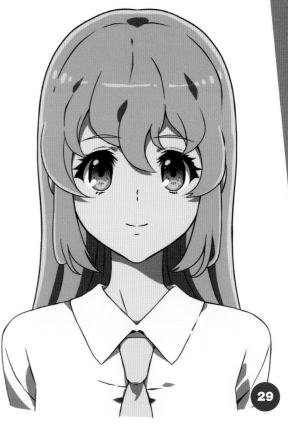

PIGTAILS & PONYTAILS

Nowhere can you find as many pigtails and ponytails as on anime characters—short ones, long ones, wavy ones, flowing ones. Fans expect to see them. Here are some tips for drawing them.

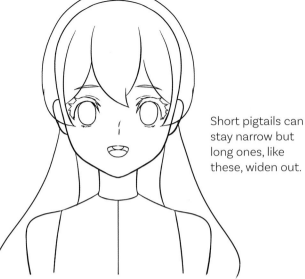

Short pigtails can stay narrow but long ones, like these, widen out.

For a pair of pigtails, make sure they are positioned the same on both sides of the head, which is often behind the ears.

Just like the hair on top of the head, pigtails are drawn as a grouping of individual strands.

The strands open up and come back together, creating a pleasing flow.

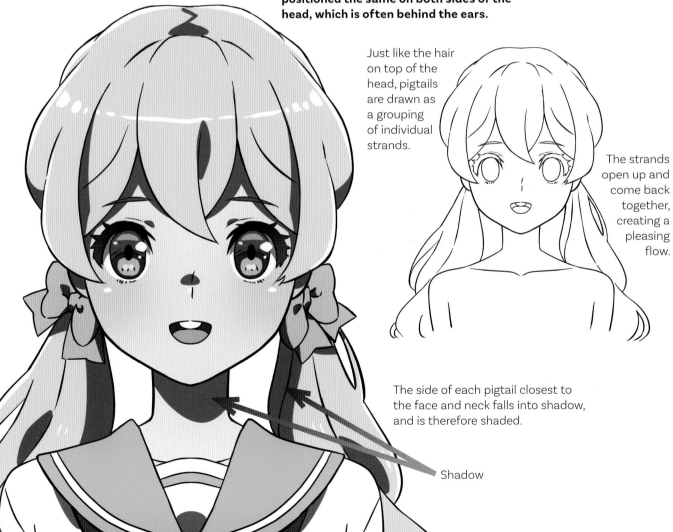

The side of each pigtail closest to the face and neck falls into shadow, and is therefore shaded.

Shadow

VARIATIONS ON PIGTAILS & PONYTAILS

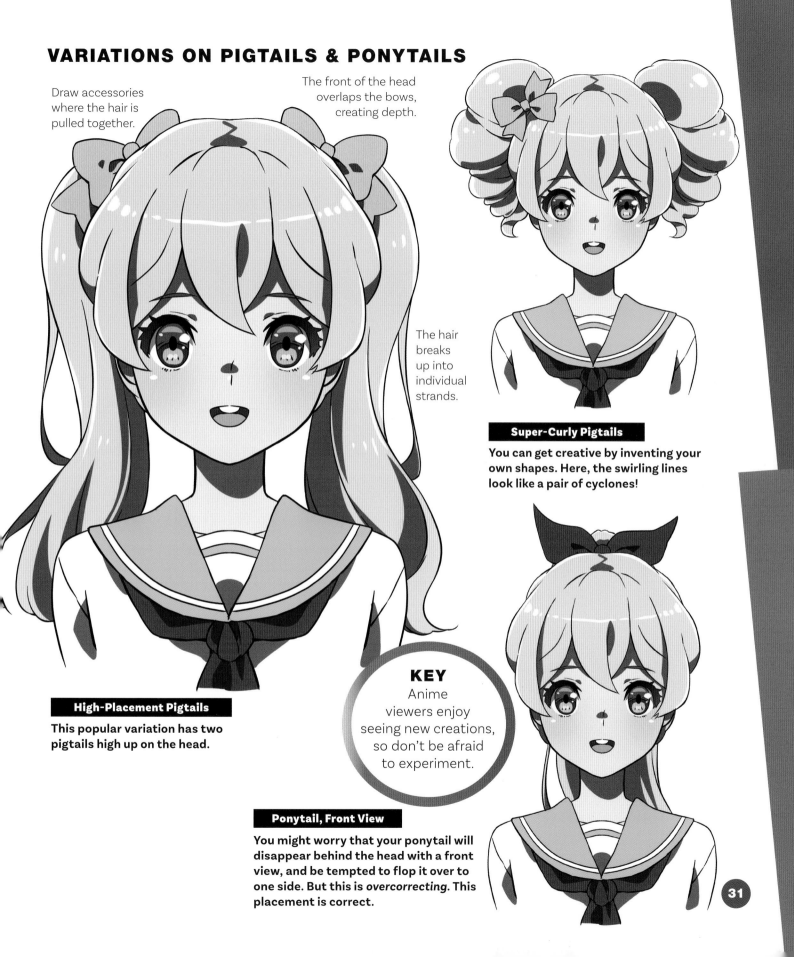

Draw accessories where the hair is pulled together.

The front of the head overlaps the bows, creating depth.

The hair breaks up into individual strands.

Super-Curly Pigtails

You can get creative by inventing your own shapes. Here, the swirling lines look like a pair of cyclones!

High-Placement Pigtails

This popular variation has two pigtails high up on the head.

KEY
Anime viewers enjoy seeing new creations, so don't be afraid to experiment.

Ponytail, Front View

You might worry that your ponytail will disappear behind the head with a front view, and be tempted to flop it over to one side. But this is *overcorrecting*. This placement is correct.

31

Expressions Every Anime Artist Needs To Know

An expression has many functions.
It can communicate an idea, reveal a character's personality, or be a reaction to something. The features of the face work as a unit to produce an expression. Everything affects everything else. Expressions are logical. Once you learn how to draw an expression for one character, you can apply the same techniques to others.

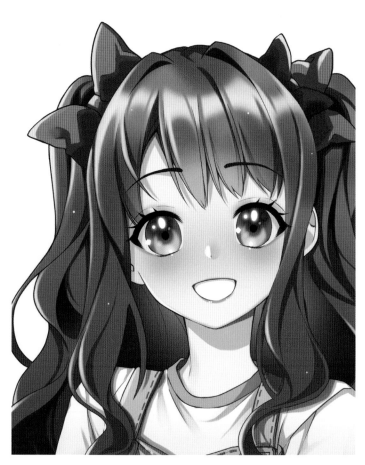
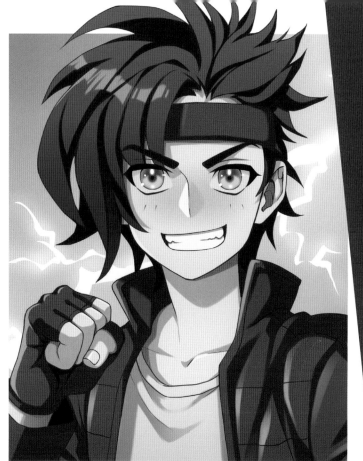

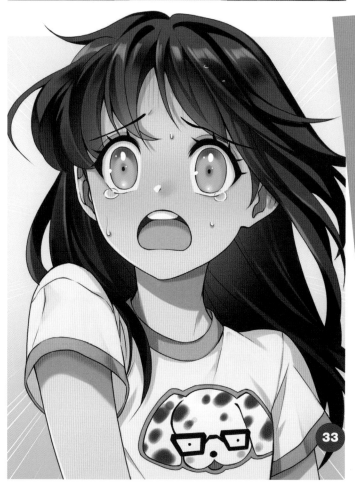

33

Classic Expressions

We'll start off with some of anime's most popular expressions.

CUTE SMILE

There are many types of cute expressions—silly cute, guilty cute, confused cute, to name a few. Here, we'll tackle the basic cute smile.

The first step establishes the facial guidelines.

The head is wide, to make room for big eyes.

The shoulders, which are slightly raised, are part of the expression.

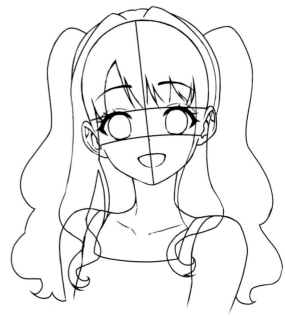

The eyes are the first feature to be drawn. They're the anchor of the face.

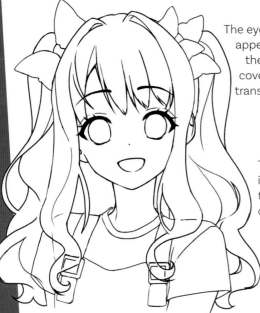

The eyebrows appear as if they were covered by transparent bangs.

The upper lip is horizontal, the lower lip curved.

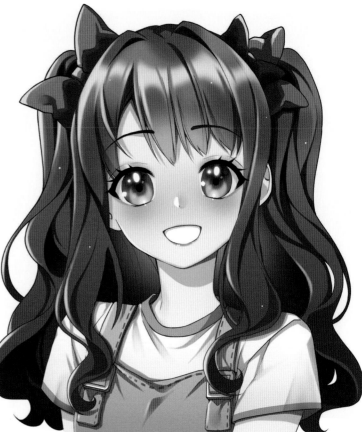

Cute expressions are wide-eyed, straightforward, and welcoming.

SKEPTICAL

If all of your characters think the same, where would the fun be in that? Bring in the skeptical guy. He refuses to go along with the group.

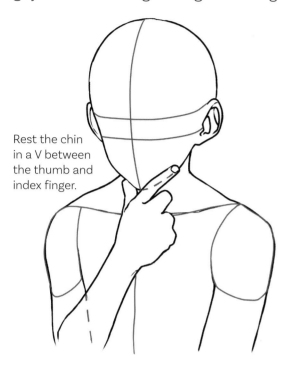

Rest the chin in a V between the thumb and index finger.

Show a lot of eye action: one eyebrow goes up while the other goes down; it creates intensity.

The brim of the cap is pulled to one side.

Ruffled hair and rumpled clothing reflect his state of mind.

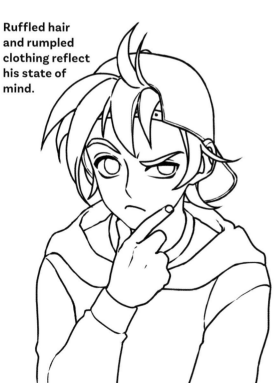

The eyes are focused like a laser beam; draw a small shine in both of them.

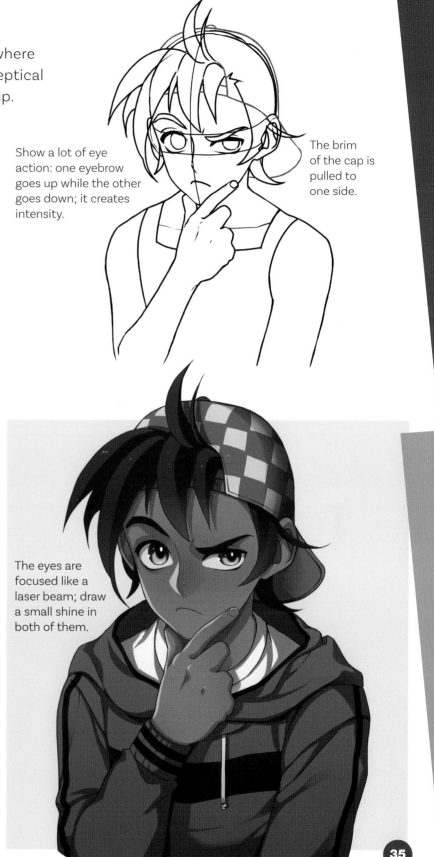

SPEECHLESS!

Wide eyes make her look stunned. The small open mouth gives her a frozen look. The result is a cute-funny look that makes the audience wonder what she's reacting to.

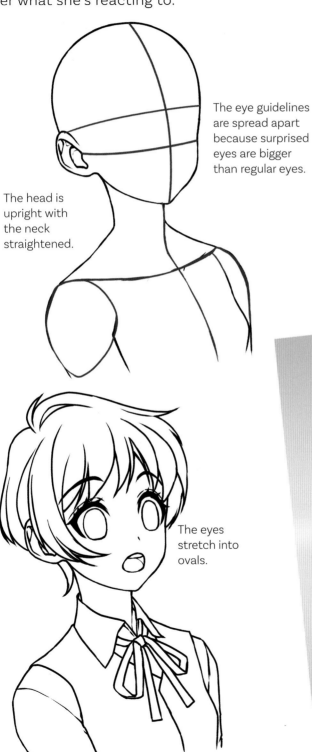

The head is upright with the neck straightened.

The eye guidelines are spread apart because surprised eyes are bigger than regular eyes.

The eyes stretch into ovals.

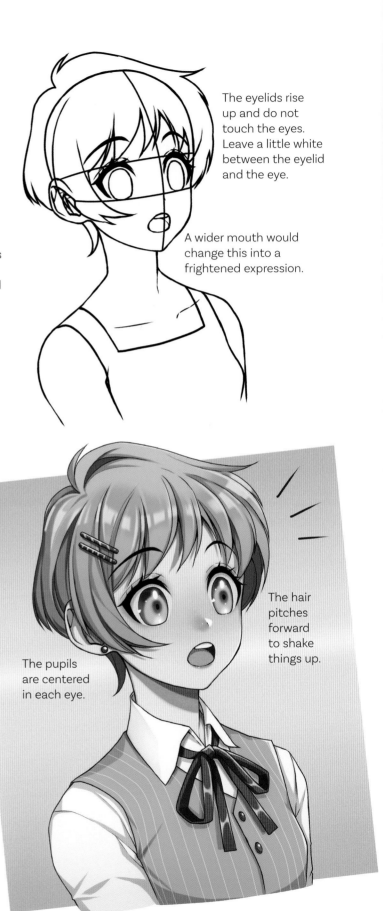

The eyelids rise up and do not touch the eyes. Leave a little white between the eyelid and the eye.

A wider mouth would change this into a frightened expression.

The pupils are centered in each eye.

The hair pitches forward to shake things up.

UPSET

Dramatic relationships are the bread and butter of the anime artist. Here's a good example—an over-the-top expression with big emotions. Someone broke up with her, or she broke up with someone else, or she lost her phone. Whatever it is, this expression is an attention grabber.

The hair whips around the head.

When an expression emphasizes the eyes, you can turn the head toward the viewer for more impact.

Long eyebrows tilt upward and push together.

Draw the upper row of teeth.

KEY
The lower lip rises in the middle.

Background color can heighten emotion. Here, it is green (same as the eyes) with dynamic streaks in it. This makes the expression look even more urgent.

Tears bubble up around the eyes.

Narrow the chin to a delicate point.

Character-Driven Expressions

A character-driven expression isn't a reaction to something, in the way that a surprised look is when opening a gift; rather, it represents a personality type. Two different characters could be smiling, but because their personalities are different, one might have a sneaky smile, while the other could have an honest one.

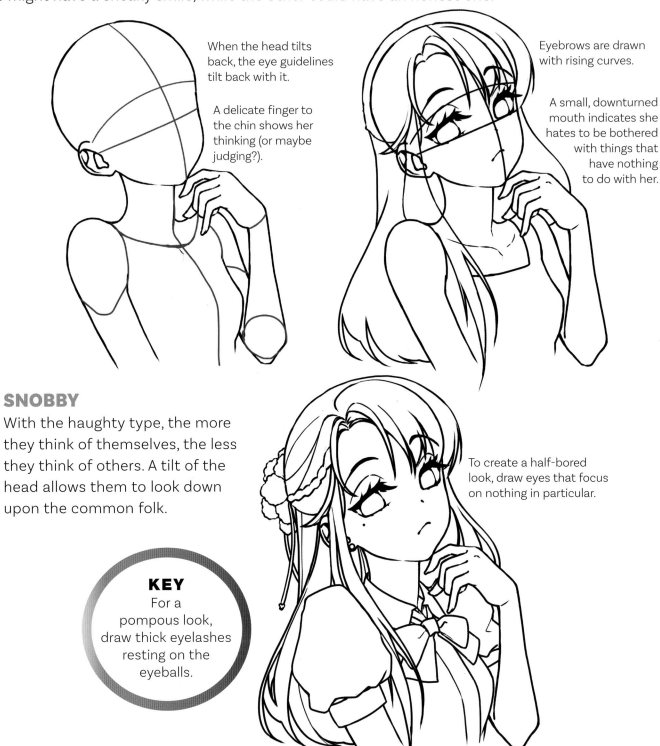

When the head tilts back, the eye guidelines tilt back with it.

A delicate finger to the chin shows her thinking (or maybe judging?).

Eyebrows are drawn with rising curves.

A small, downturned mouth indicates she hates to be bothered with things that have nothing to do with her.

SNOBBY

With the haughty type, the more they think of themselves, the less they think of others. A tilt of the head allows them to look down upon the common folk.

To create a half-bored look, draw eyes that focus on nothing in particular.

KEY
For a pompous look, draw thick eyelashes resting on the eyeballs.

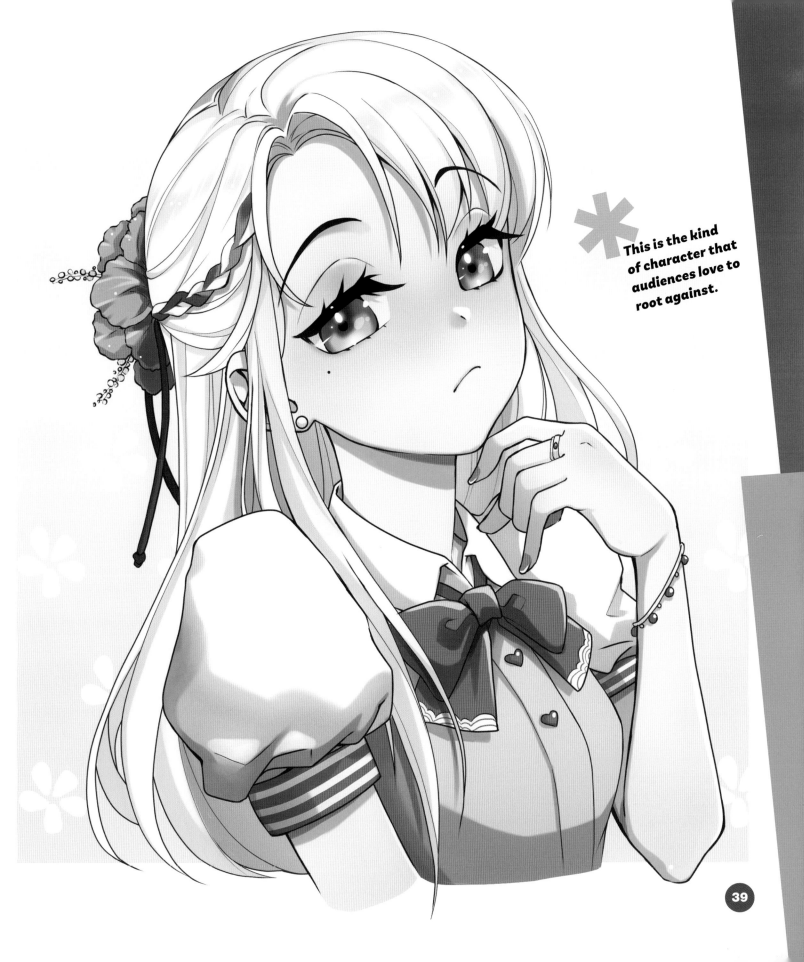

This is the kind
of character that
audiences love to
root against.

FEARLESS

A daring teenager is a popular type among anime fans. He's dynamic, impulsive, and sometimes overestimates his own abilities. Will he succeed or fail? Who knows, but by keeping the audience guessing, you'll keep them interested.

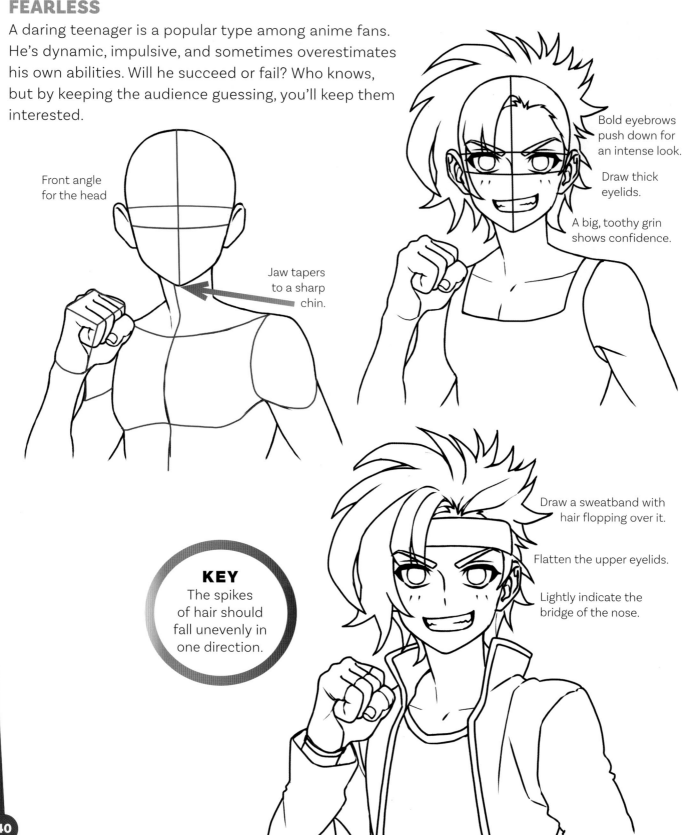

Front angle for the head

Jaw tapers to a sharp chin.

Bold eyebrows push down for an intense look.

Draw thick eyelids.

A big, toothy grin shows confidence.

KEY
The spikes of hair should fall unevenly in one direction.

Draw a sweatband with hair flopping over it.

Flatten the upper eyelids.

Lightly indicate the bridge of the nose.

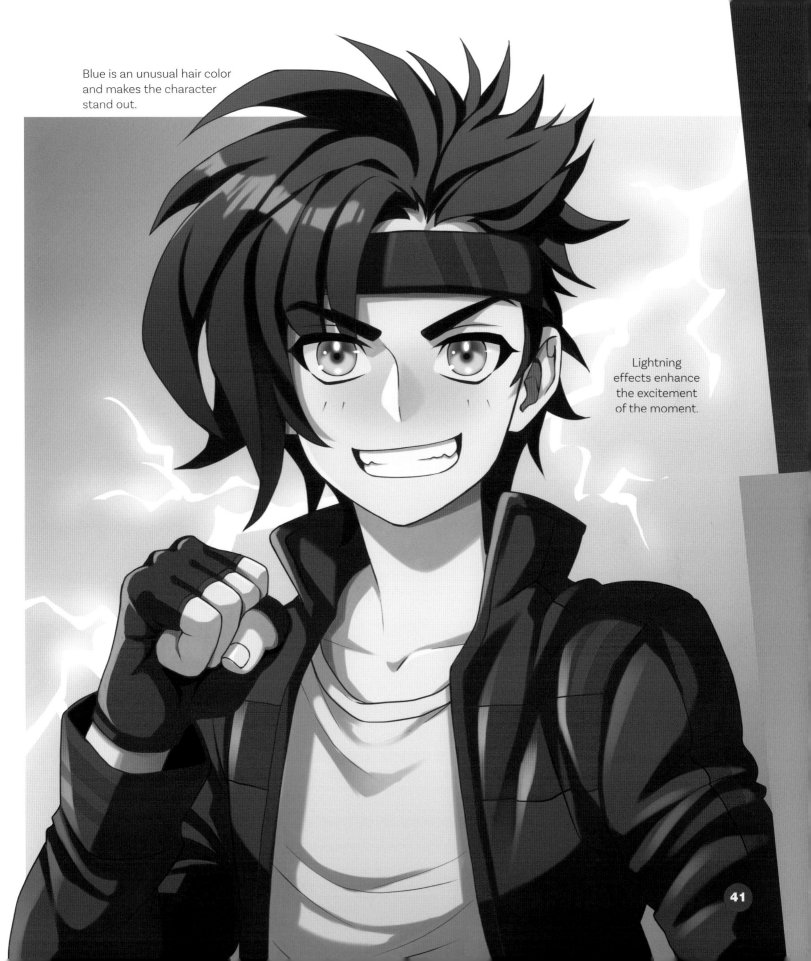

Blue is an unusual hair color and makes the character stand out.

Lightning effects enhance the excitement of the moment.

41

BUSYBODY

The busybody is delighted to hear embarrassing news about her friends. She's sure to tell everybody who hasn't heard—in confidence, of course.

Body language strengthens her expression. She stops, turns, and glances back when she hears a secret being shared.

Bring the shoulder up.

Tuck the eyeballs into the corners of the eyes.

The two things to emphasize are an eager smile and wide eyes.

The higher the eyebrows, the more curious she looks.

Lively hair goes with a lively personality.

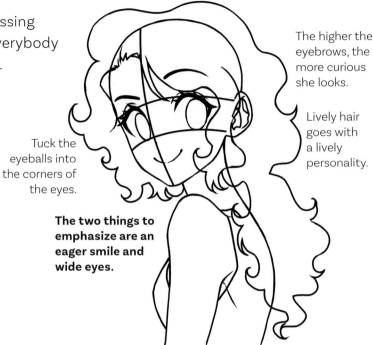

Draw the hair away from her ear—the ear that never stops listening!

Emphasize a contoured line along the front of the face to soften her look.

Bring the back of the hair forward, which adds depth to the head.

Leave plenty of white in each eye to give her an alert look.

RESENTFUL

Resentful characters plot revenge. School stories are often based on rivalries. This type doesn't play fair, and therefore gives the audience someone to root against!

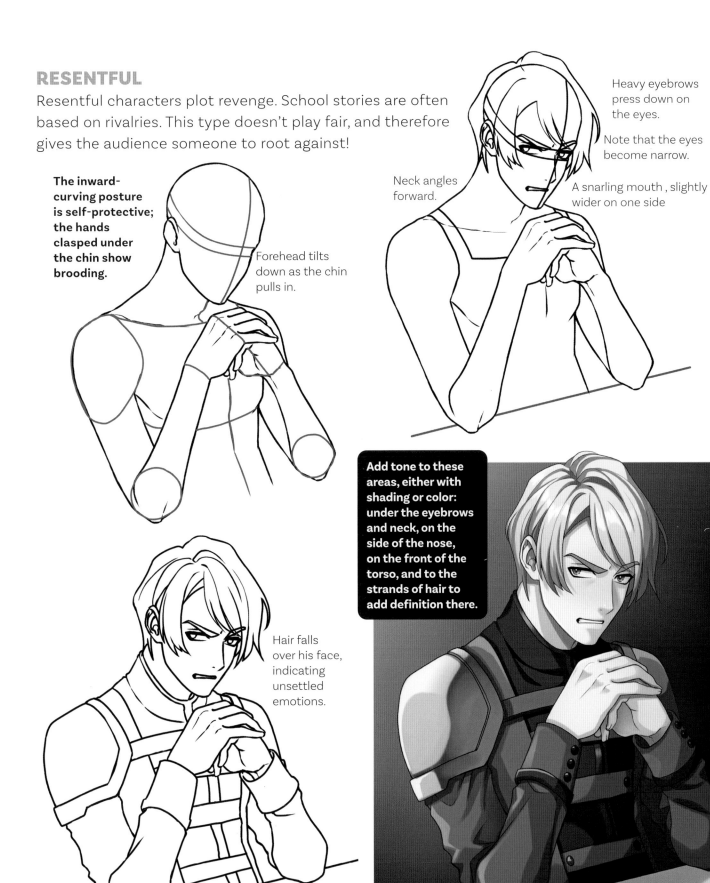

The inward-curving posture is self-protective; the hands clasped under the chin show brooding.

Forehead tilts down as the chin pulls in.

Heavy eyebrows press down on the eyes.

Note that the eyes become narrow.

Neck angles forward.

A snarling mouth, slightly wider on one side

Add tone to these areas, either with shading or color: under the eyebrows and neck, on the side of the nose, on the front of the torso, and to the strands of hair to add definition there.

Hair falls over his face, indicating unsettled emotions.

Exaggerated Expressions

Over-the-top characters are an anime audience favorite. Mishaps, embarrassments, frayed nerves—they're great for visual punchlines. Humor in anime is rarely subtle, so be sure to exaggerate these character types.

The head, guidelines, and pose are balanced. Comedy is symmetrical.

Deep shadows under the eyes

Steeply angled eyebrows

Tiny dots for pupils indicate rage.

Draw a mouth that's so wide it would scare an orthodontist.

Eliminate the nose.

OVER THE TOP

An effective way to highlight a humorous expression is to simplify the character but turn up the volume. This front view shows humorous fury.

Add red-hot blush marks to the forehead.

The red shapes are a famous special effect that conveys stress.

HILARITY

One of the most effective features of a laughing pose are rounded shoulders, which rise and fall with each giggle.

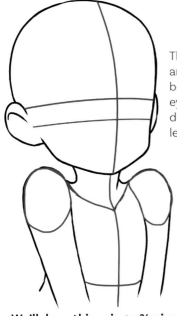

The eye guidelines are close together because "laughing eyes" scrunch down and take up less room.

We'll draw this using a ¾ view.

The pigtails are in motion.

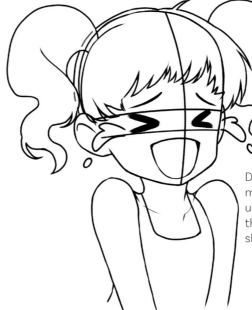

The eyebrows are angled upward.

For eyes, draw two Vs on their sides.

Draw a giant, simplified mouth shape. The upper lip is horizontal, the bottom lip is shaped like a U.

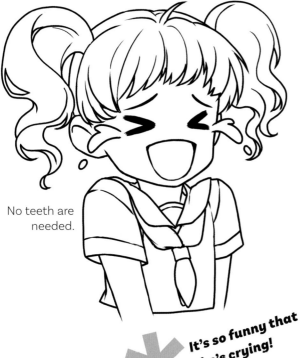

No teeth are needed.

It's so funny that she's crying!

Add blush color between the eyes.

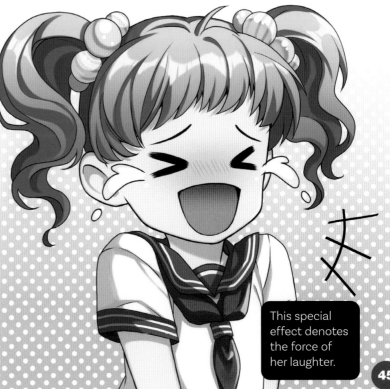

This special effect denotes the force of her laughter.

45

REJECTED

This interesting expression is underutilized by many artists. It shows someone who's down but getting ready to prove herself.

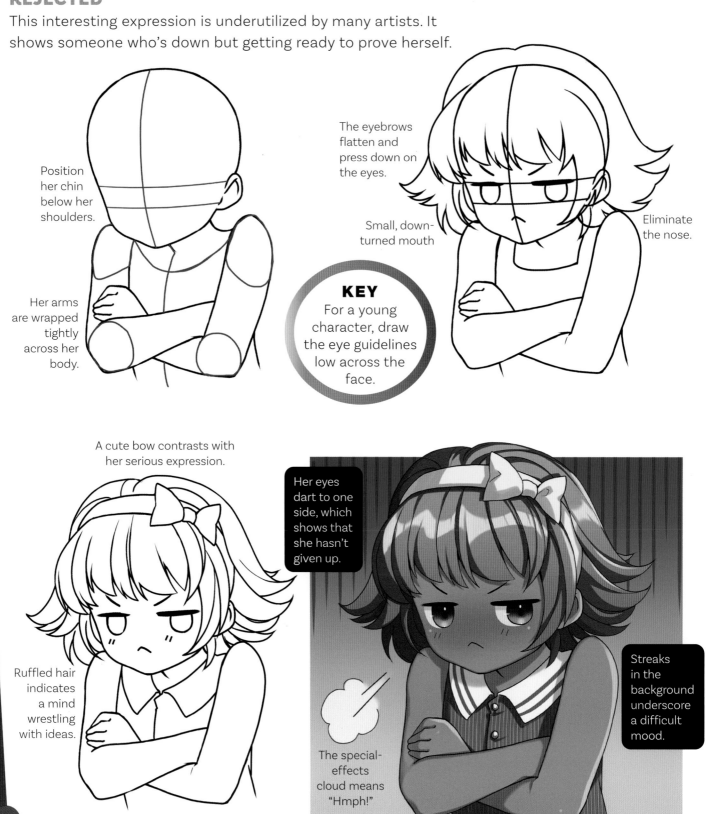

Position her chin below her shoulders.

Her arms are wrapped tightly across her body.

The eyebrows flatten and press down on the eyes.

Small, down-turned mouth

Eliminate the nose.

KEY
For a young character, draw the eye guidelines low across the face.

A cute bow contrasts with her serious expression.

Ruffled hair indicates a mind wrestling with ideas.

Her eyes dart to one side, which shows that she hasn't given up.

The special-effects cloud means "Hmph!"

Streaks in the background underscore a difficult mood.

ALL CHOKED UP

This is another interesting expression because it shows a character juggling two impulses at once. He's trying to hold back tears while talking, and not altogether successfully.

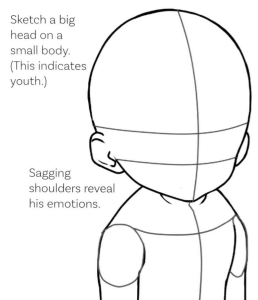

Sketch a big head on a small body. (This indicates youth.)

Sagging shoulders reveal his emotions.

The horizontal guidelines are drawn toward the bottom of the face because he's looking down.

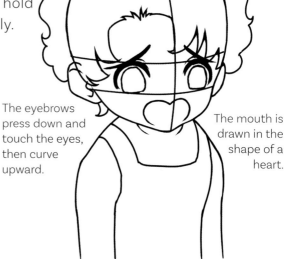

The eyebrows press down and touch the eyes, then curve upward.

The mouth is drawn in the shape of a heart.

The character looks straight ahead but doesn't focus on anything. He's in boo-hoo land.

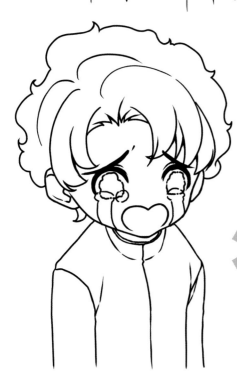

To create emotional eyes, draw them oversized.

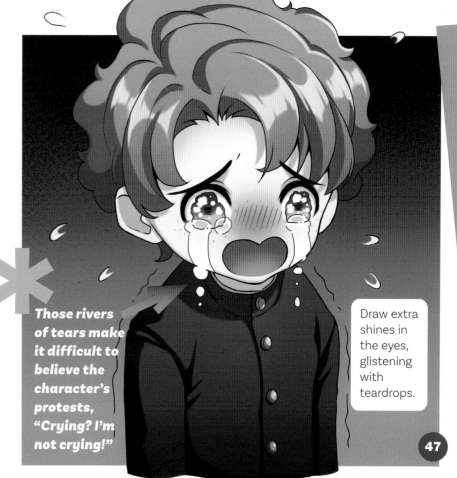

Those rivers of tears make it difficult to believe the character's protests, "Crying? I'm not crying!"

Draw extra shines in the eyes, glistening with teardrops.

47

Figure Drawing Basics for Anime

Figure drawing consists of two things: constructing the body and drawing poses. And that affects nearly every character. By starting with a solid foundation, you can create a figure that looks right. And when your drawing looks right at the beginning, it will look right at the end. Sound good? Let's continue.

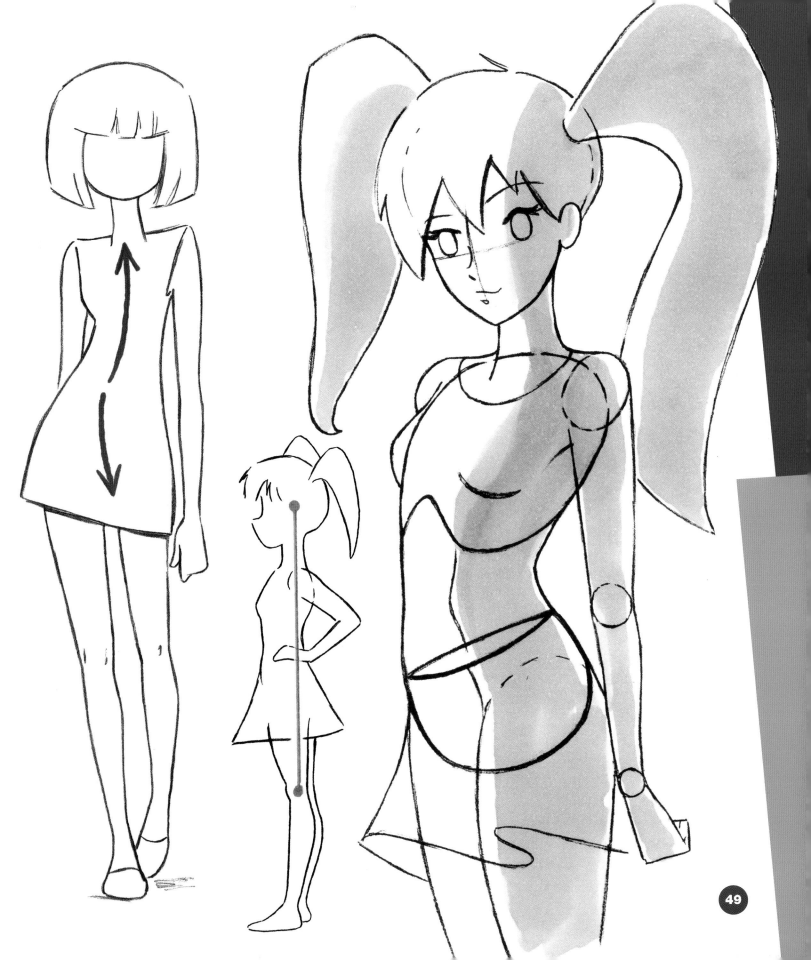

THE BASIC PROPORTIONS OF THE HUMAN BODY

Proportions are a fantastic tool for drawing the human body. By noticing a few simple measurements, you can be confident that your character looks correct.

FRONT VIEW

The front view is the basis for drawing the body. Once you master it, the other angles become easier to draw.

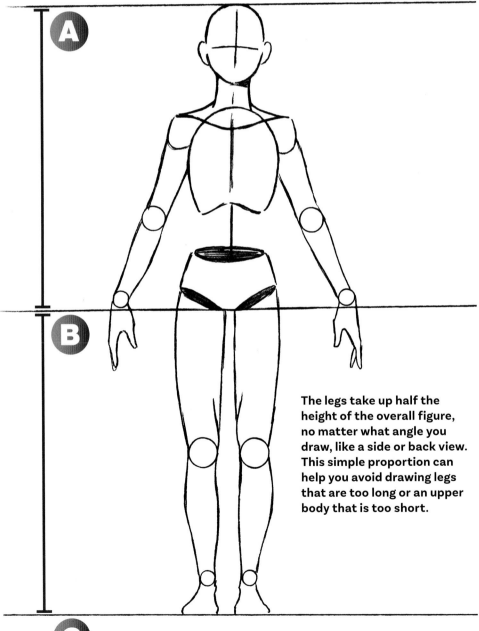

The distance from A to B is the same as from B to C.

The legs take up half the height of the overall figure, no matter what angle you draw, like a side or back view. This simple proportion can help you avoid drawing legs that are too long or an upper body that is too short.

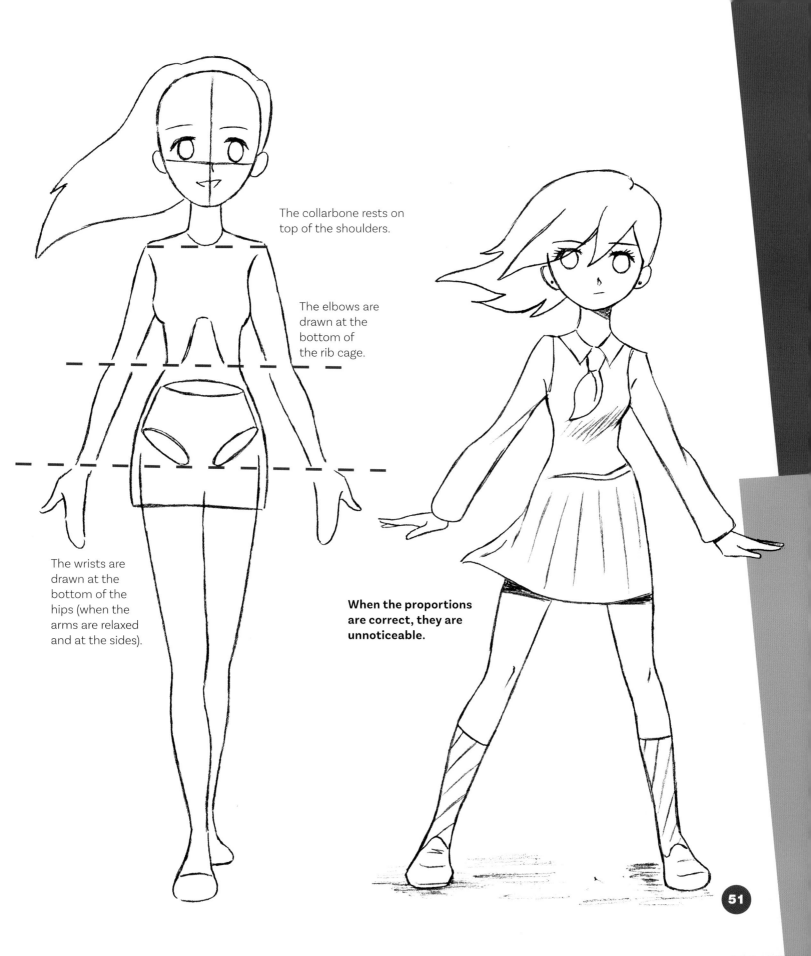

The collarbone rests on top of the shoulders.

The elbows are drawn at the bottom of the rib cage.

The wrists are drawn at the bottom of the hips (when the arms are relaxed and at the sides).

When the proportions are correct, they are unnoticeable.

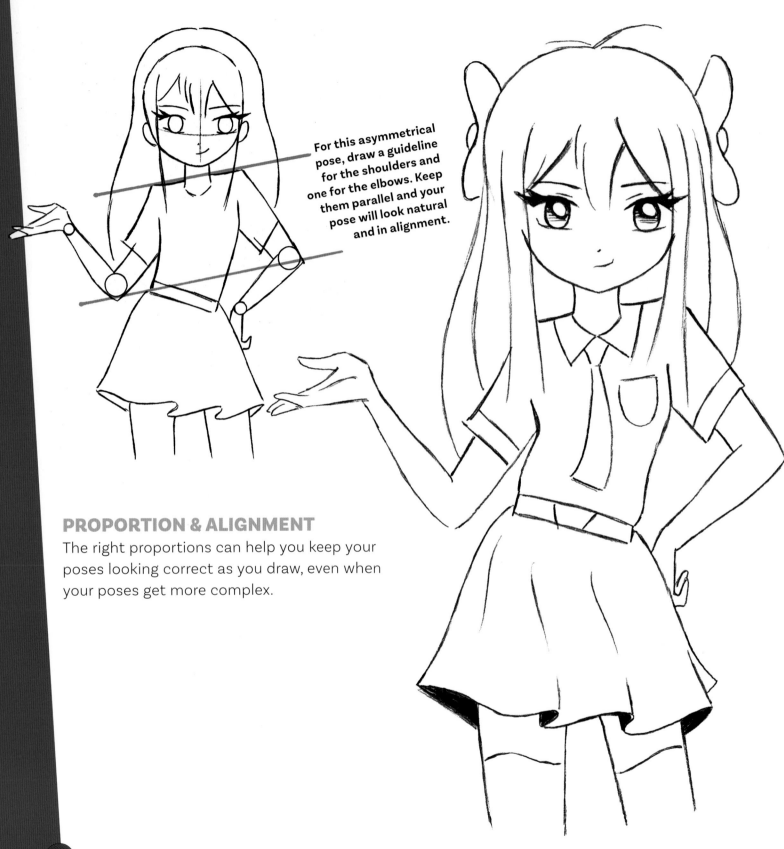

For this asymmetrical pose, draw a guideline for the shoulders and one for the elbows. Keep them parallel and your pose will look natural and in alignment.

PROPORTION & ALIGNMENT

The right proportions can help you keep your poses looking correct as you draw, even when your poses get more complex.

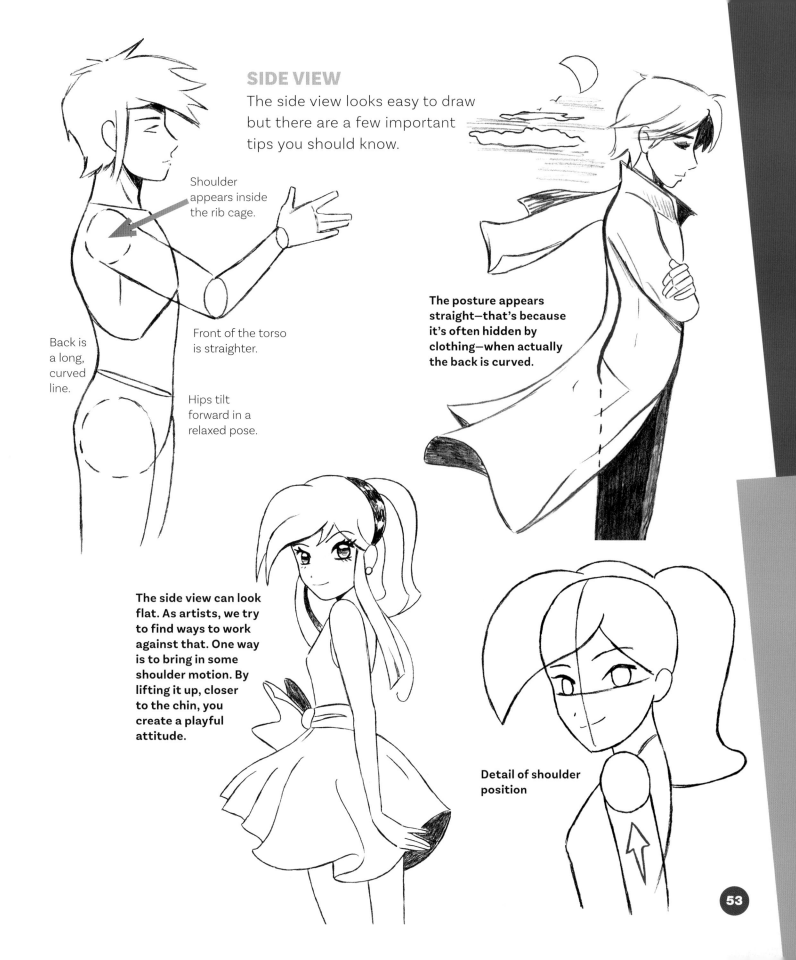

SIDE VIEW

The side view looks easy to draw but there are a few important tips you should know.

Shoulder appears inside the rib cage.

Back is a long, curved line.

Front of the torso is straighter.

Hips tilt forward in a relaxed pose.

The posture appears straight—that's because it's often hidden by clothing—when actually the back is curved.

The side view can look flat. As artists, we try to find ways to work against that. One way is to bring in some shoulder motion. By lifting it up, closer to the chin, you create a playful attitude.

Detail of shoulder position

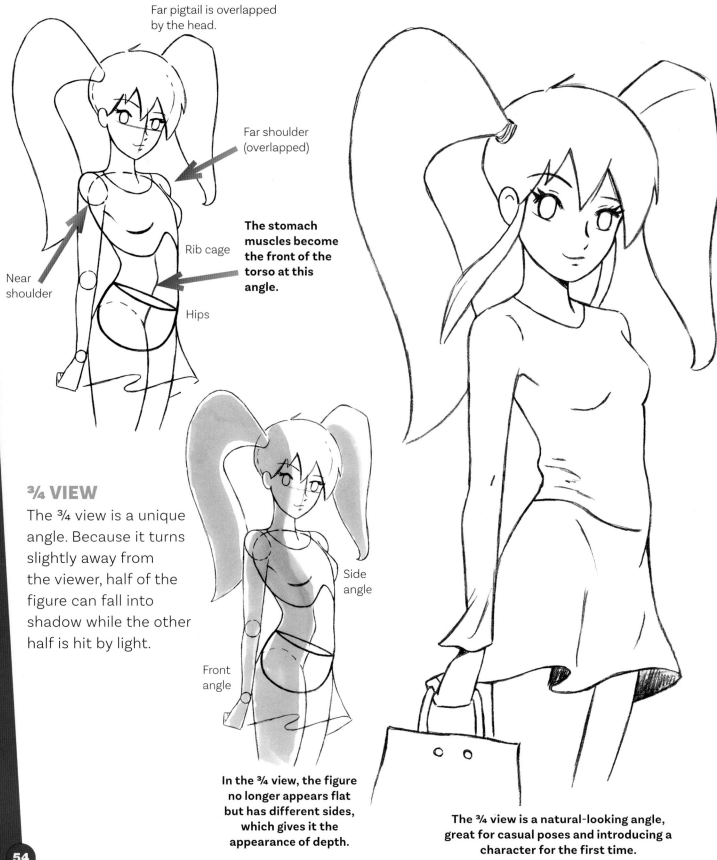

Far pigtail is overlapped by the head.

Far shoulder (overlapped)

The stomach muscles become the front of the torso at this angle.

Rib cage

Near shoulder

Hips

¾ VIEW

The ¾ view is a unique angle. Because it turns slightly away from the viewer, half of the figure can fall into shadow while the other half is hit by light.

Side angle

Front angle

In the ¾ view, the figure no longer appears flat but has different sides, which gives it the appearance of depth.

The ¾ view is a natural-looking angle, great for casual poses and introducing a character for the first time.

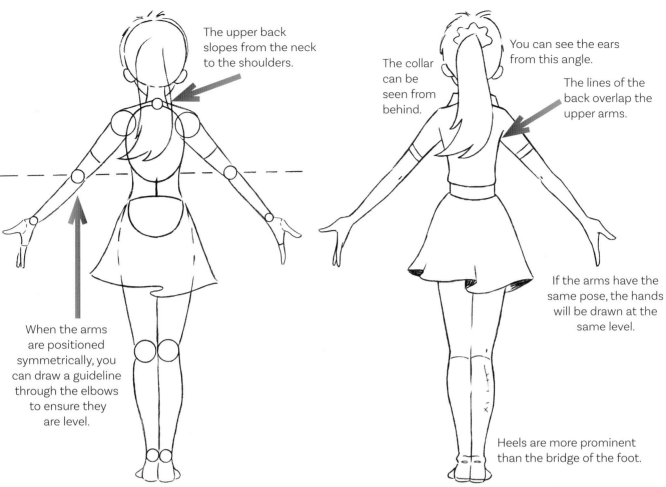

The upper back slopes from the neck to the shoulders.

When the arms are positioned symmetrically, you can draw a guideline through the elbows to ensure they are level.

The collar can be seen from behind.

You can see the ears from this angle.

The lines of the back overlap the upper arms.

If the arms have the same pose, the hands will be drawn at the same level.

Heels are more prominent than the bridge of the foot.

BACK VIEW

The back view is actually one of the easiest angles to master. A large area that isn't well defined, it doesn't require much detail. Instead, try for a good, solid construction and an appealing pose.

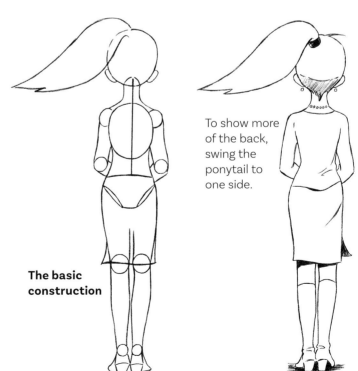

The basic construction

To show more of the back, swing the ponytail to one side.

Poses: The Basics

Sometimes a beginner may think they only want to draw characters, not poses. The problem is that every time you draw a character, it's in a pose, one way or the other. The good news is that by following a few easy tips, you can learn to strengthen the poses you've been drawing.

SYMMETRY

To create poses, we'll turn to the principle of symmetry. A figure is symmetrical when both sides of the body are posed the same way, like both hands on the hips. When you break symmetry in a pose (make it asymmetrical), you add interest.

Symmetrical **Asymmetrical**

In the symmetrical pose (left), the positions of the arms and legs on both sides mirror one another. The center pose breaks symmetry, with the left leg extending and no longer matching the right; also, the right arm is overlapped by the dress. The final pose also breaks symmetry, with the right leg bending inward and the arm positions differing from one another.

MORE TIPS

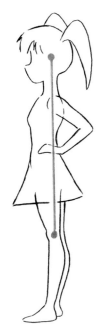

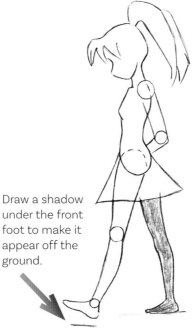

Draw a shadow under the front foot to make it appear off the ground.

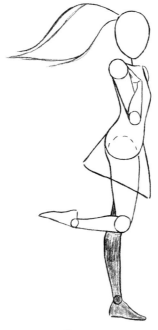

In a standing pose (side view), the knee is aligned with the center of the head, as indicated by the blue line.

People tend to focus on the front leg in a walking pose. But the back leg is doing just as much work by pushing back at an angle.

Small gestures can communicate feelings. By pointing the toe, we create a surprised attitude.

A casual pose is drawn with an offhand stance, which looks spontaneous rather than purposeful.

DIFFERENT POSTURES FOR DIFFERENT AGES

Characters of different ages stand differently. This signals to the viewer that the character is a child, teenager, or adult. It also help to define a character's attitude and energy level.

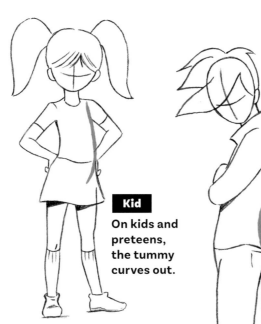

Kid

On kids and preteens, the tummy curves out.

Teenager

A somewhat slumped stance helps define this age group.

Adult

An adult's posture is generally more balanced. It begins with a level collarbone, which establishes the look.

The Dynamic Figure—How It Works in Practice

Every time the body moves, different parts instantly adjust in order to keep it in alignment. For example, a running pose involves more than legs moving quickly. The arms also have to be pumping to maintain the action. Sometimes, when the body moves in one direction, another area must offset it by moving in the other direction.

RUNNING, FRONT VIEW

The torso twists and turns in a front view of a person running.

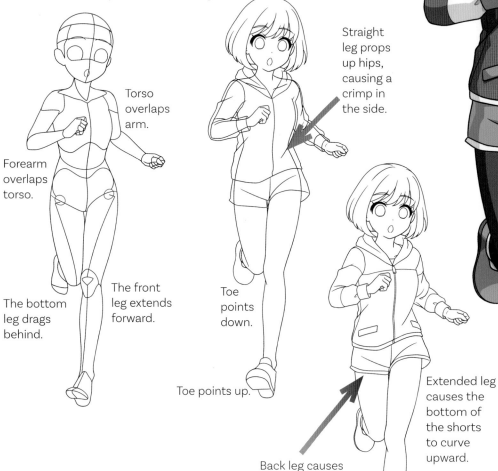

Torso overlaps arm.

Forearm overlaps torso.

The bottom leg drags behind.

The front leg extends forward.

Straight leg props up hips, causing a crimp in the side.

Toe points down.

Toe points up.

Back leg causes shorts to curve downward.

Extended leg causes the bottom of the shorts to curve upward.

The clothes move with the runner's strides.

RUNNING, BACK VIEW

Because running is more dynamic than walking, show more twist to the upper body.

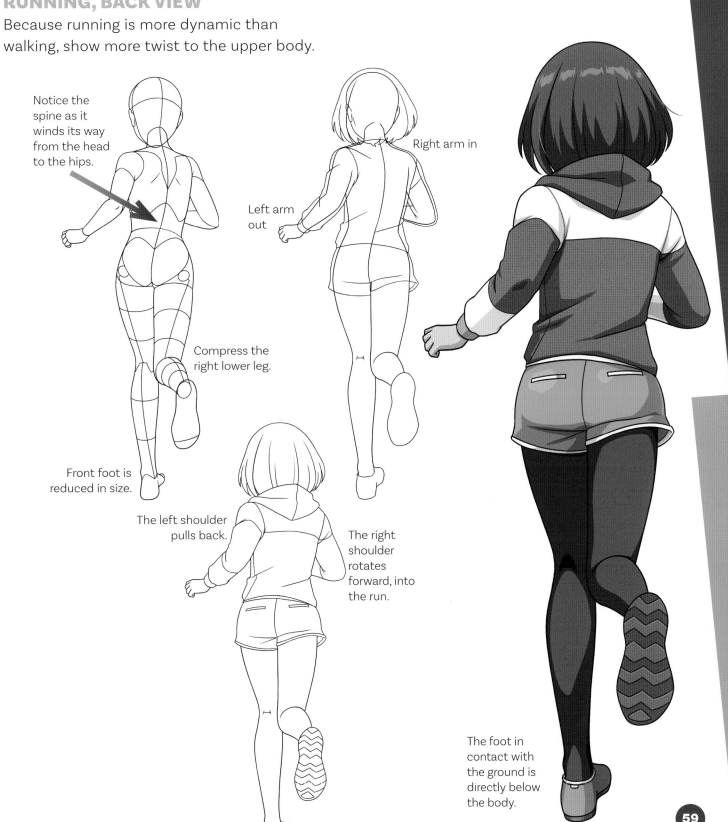

Notice the spine as it winds its way from the head to the hips.

Left arm out

Right arm in

Compress the right lower leg.

Front foot is reduced in size.

The left shoulder pulls back.

The right shoulder rotates forward, into the run.

The foot in contact with the ground is directly below the body.

Hand Positions

Hands are easier to draw if you give them a purpose, like holding something. A hand position communicates an attitude. To simplify them, focus on one or two key elements and underplay the rest. Let's give it a try.

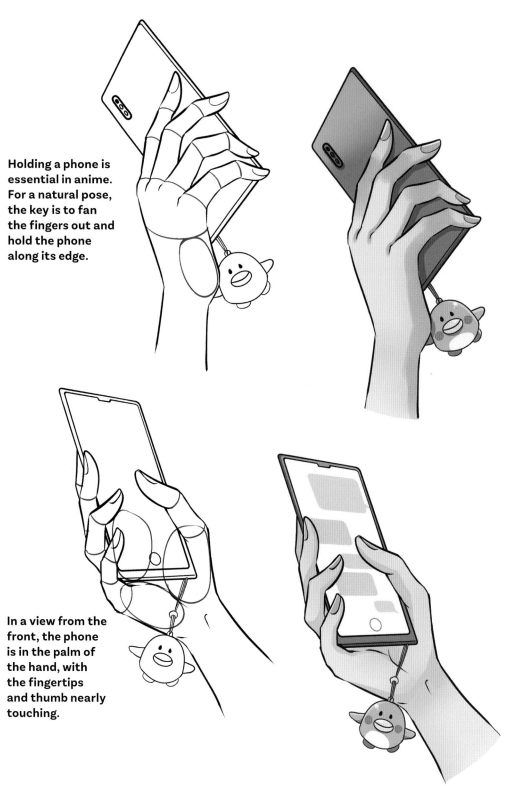

Holding a phone is essential in anime. For a natural pose, the key is to fan the fingers out and hold the phone along its edge.

In a view from the front, the phone is in the palm of the hand, with the fingertips and thumb nearly touching.

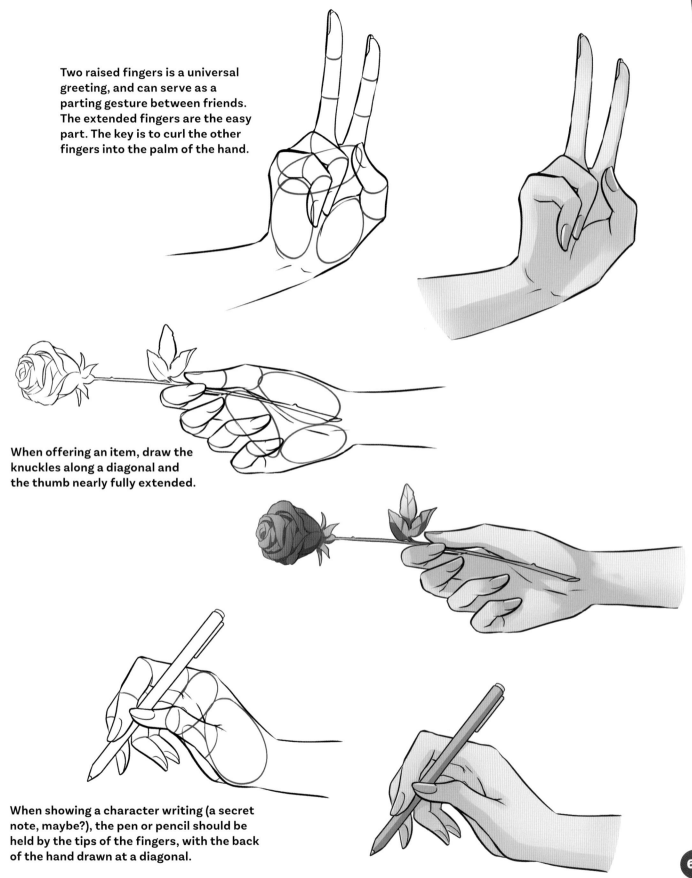

Two raised fingers is a universal greeting, and can serve as a parting gesture between friends. The extended fingers are the easy part. The key is to curl the other fingers into the palm of the hand.

When offering an item, draw the knuckles along a diagonal and the thumb nearly fully extended.

When showing a character writing (a secret note, maybe?), the pen or pencil should be held by the tips of the fingers, with the back of the hand drawn at a diagonal.

61

The Do's & Don'ts of Figure Drawing

When an artist draws a pose that doesn't seem to be working, the temptation is to draw it over and over again. Instead, you should hit the pause button and try to see what isn't working. Once you understand *why* the following techniques work, they will be easier to use and to commit to memory.

LEANING AGAINST A WALL

When someone leans against a wall, the back touches the wall only with the shoulder blades and not with the entire back.

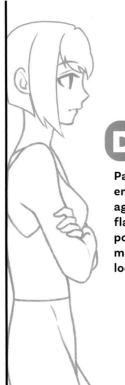

DON'T!

Pasting the entire back against the wall flattens out the posture and makes the pose look tense.

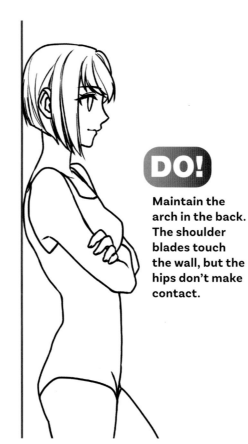

DO!

Maintain the arch in the back. The shoulder blades touch the wall, but the hips don't make contact.

DONE!

Now the pose is natural and breezy. When something looks right, it appears as if it couldn't have been any other way!

AVOIDING TANGENTS

A tangent occurs when something in a picture unintentionally touches something else. This usually causes a visual distraction.

DON'T!

The girl is flat against the window frame—distracting.

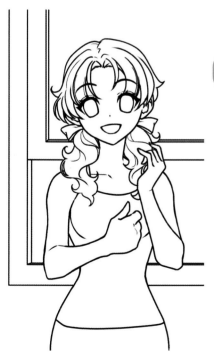

DO!

By shifting the figure to the right, the tangents disappear. As a result, the drawing is more effective.

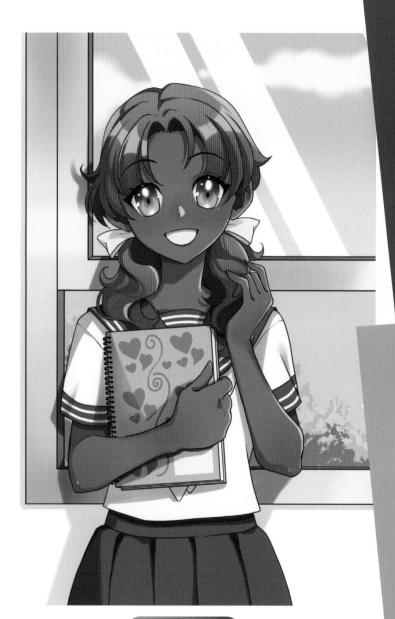

DONE!

In contrast to the first step, the character stands out against the background.

DRAWING NATURAL LOOKING ARMS

When you draw a character with their arms at their sides, the temptation is to straighten them out for a relaxed look. Is that a good idea? No. Here's why.

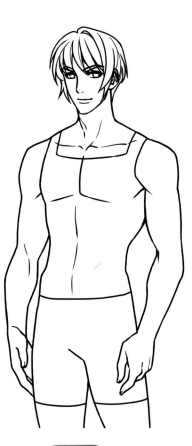

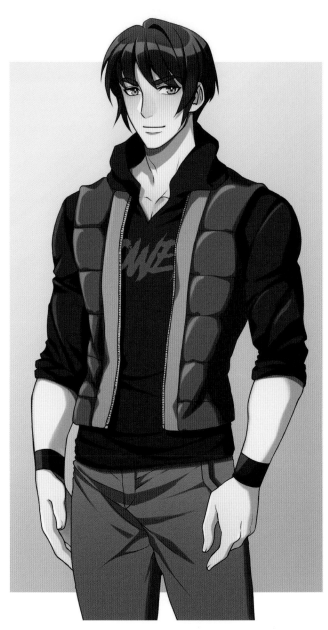

DON'T!

Arms are always slightly bent when relaxed. It would take effort to keep them straight like this in real life. And the viewer can sense the tension.

DO!

Put in a little bend at the elbow, and now they look as casual as the rest of the pose.

DONE!

Bring the arms slightly forward so they appear consistent with the rest of the pose.

ADJUSTING A POSE

The body works as a unit. An easygoing pose, with one leg crossed over the other, will cause a chain reaction throughout the body. If an artist doesn't allow the pose to reconfigure itself, it will look odd.

The upper body is completely straight, as if both feet were a shoulder length apart.

Shoulders are drawn perfectly even.

Torso is vertical and stiff.

Both elbows are level.

Hips are flat.

He doesn't look relaxed to me!

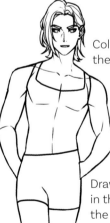

The right leg props up the body, causing the right side to compensate.

Collarbone tilts to the right.

Shoulders tilt down and to the right.

Left elbow is higher than the right one.

Draw a deep bend in the right side of the waist.

KEY
Drawing an asymmetrical leg pose causes the upper body to be asymmetrical as well.

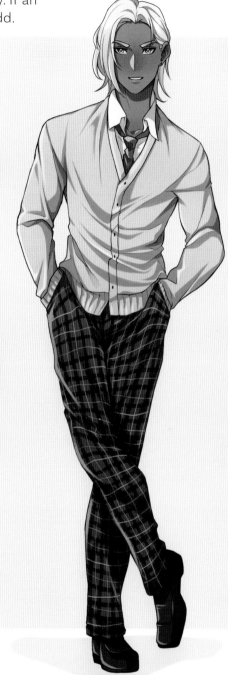

DONE!

When a character shifts to a comfortable stance, the clothes pull and show creases, which creates a natural look.

POSITIONING THE BELTLINE

It's not just what your characters wear but how they wear it that counts. Nowhere is this more important than the beltline, which can determine how casual or formal a character looks. We'll tackle school uniforms and jeans.

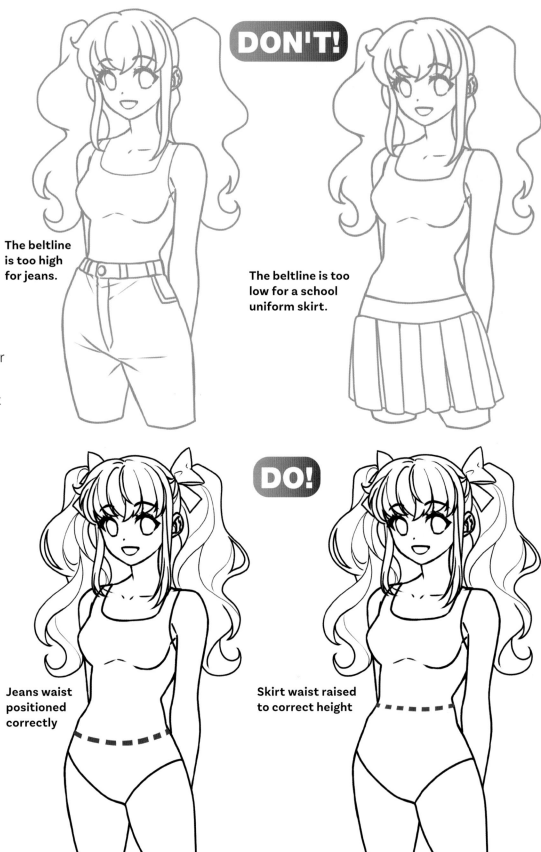

DON'T!

The beltline is too high for jeans.

The beltline is too low for a school uniform skirt.

DO!

Jeans waist positioned correctly

Skirt waist raised to correct height

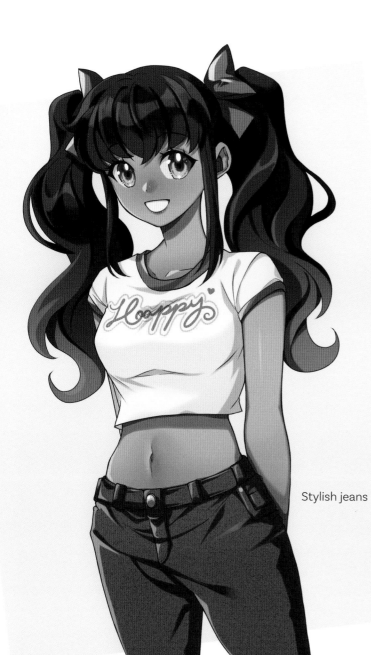

Stylish jeans

Where you draw the beltline helps establish the look of the rest of the outfit.

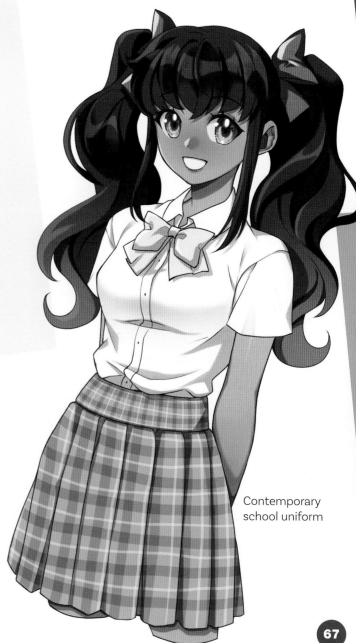

Contemporary school uniform

WALKING

When it comes to art technique, a lot of emphasis is placed on avoiding a stiff pose. But there are times when straight legs work better than bent ones. The walk, in a profile, is one such case.

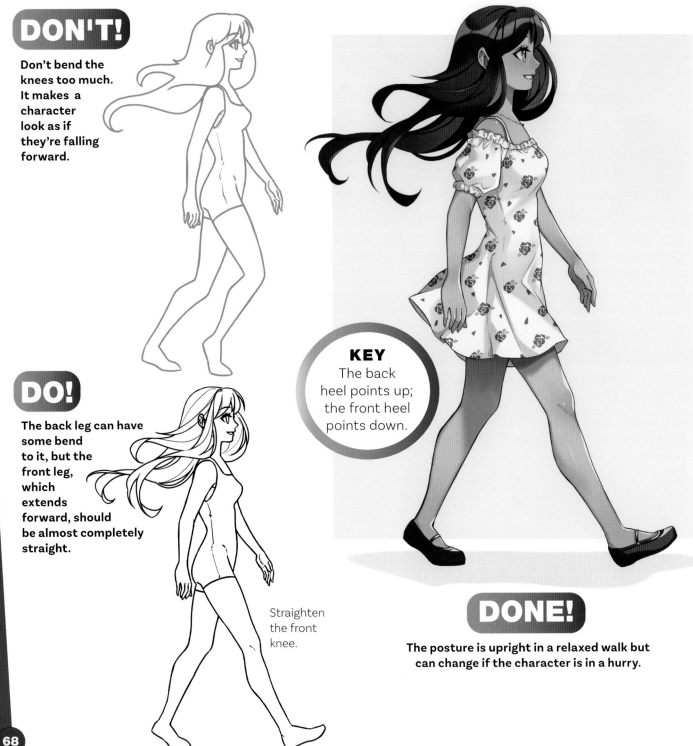

DON'T!

Don't bend the knees too much. It makes a character look as if they're falling forward.

DO!

The back leg can have some bend to it, but the front leg, which extends forward, should be almost completely straight.

Straighten the front knee.

KEY
The back heel points up; the front heel points down.

DONE!

The posture is upright in a relaxed walk but can change if the character is in a hurry.

THE PROMINENT CURVE

The most prominent curve in the body, and the one responsible for creating a natural-looking posture, is the lower back.

The front and the back of the torso are drawn with straight lines—not too interesting.

If you were to draw a straight line down the back, the body would stiffen. It needs a curve to create visual rhythm. Without it, the character doesn't look relaxed.

Add a small curve above the hips, and the same pose looks natural.

A flowing back line brings ordinary standing poses to life.

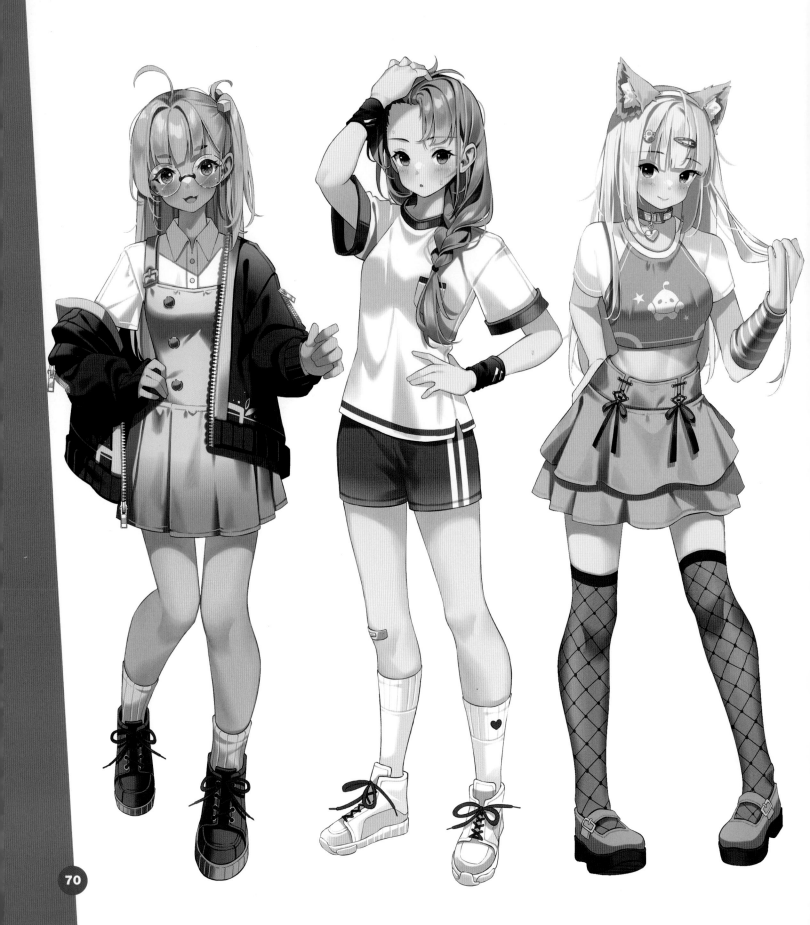

Anime artists create outfits by selecting items that highlight the character's personality and function in a story, as well as further develop their personality. You're the artist here. What is the takeaway you want the viewer to have when they look at your character? The outfit you choose will go a long way toward answering that question.

Creating Outfits

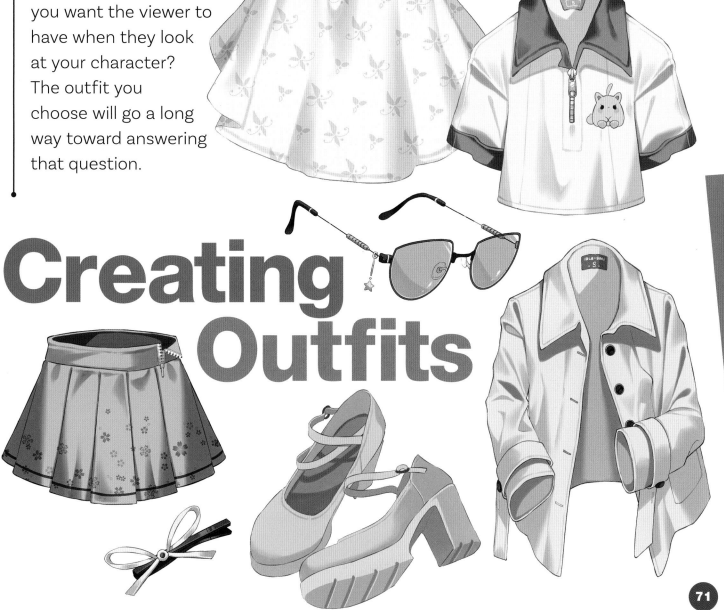

Famous Schoolgirl Uniform

The school uniform immediately tells us who the character is as well as her location. The more the outfit tells us about a character, the stronger the character will be.

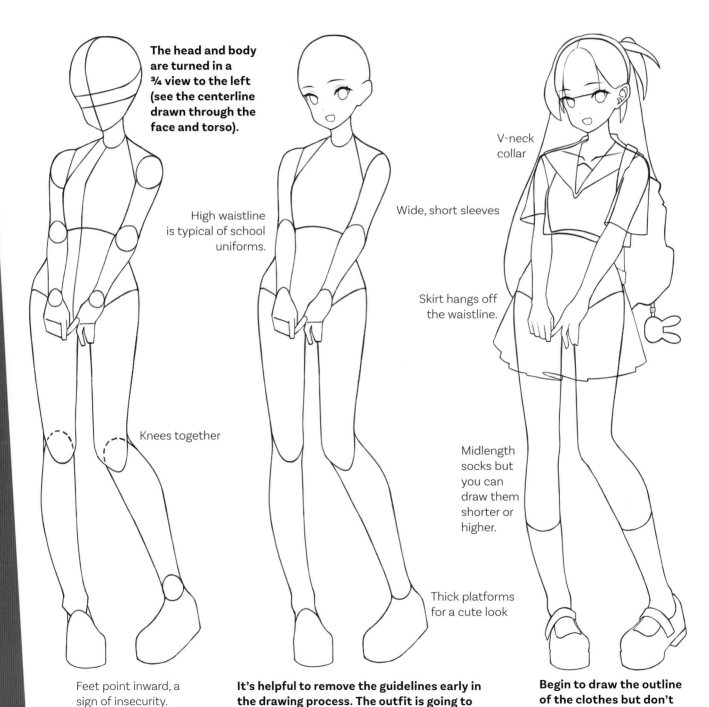

The head and body are turned in a ¾ view to the left (see the centerline drawn through the face and torso).

High waistline is typical of school uniforms.

Wide, short sleeves

V-neck collar

Skirt hangs off the waistline.

Knees together

Midlength socks but you can draw them shorter or higher.

Thick platforms for a cute look

Feet point inward, a sign of insecurity.

It's helpful to remove the guidelines early in the drawing process. The outfit is going to add more lines and it could get cluttered.

Begin to draw the outline of the clothes but don't get too detailed yet.

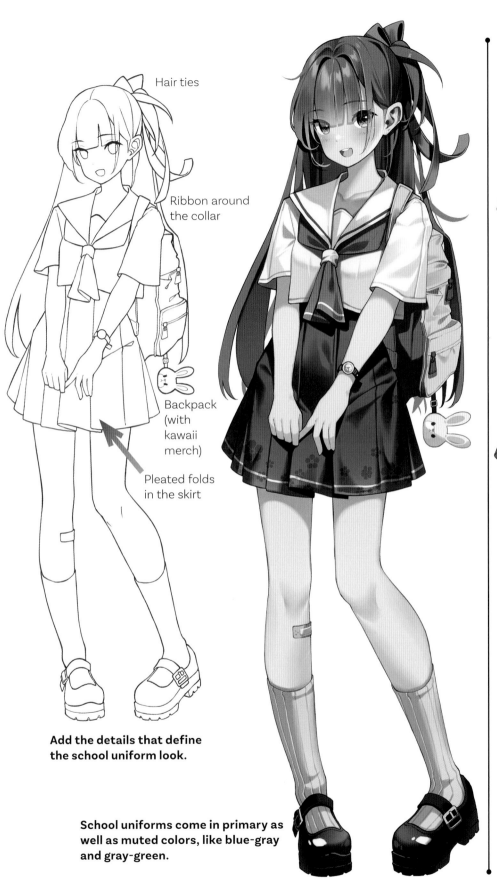

Hair ties

Ribbon around the collar

Backpack (with kawaii merch)

Pleated folds in the skirt

Add the details that define the school uniform look.

School uniforms come in primary as well as muted colors, like blue-gray and gray-green.

Slender tie

Skirt with wide folds and different color

Carrying case

Casual shoes

After-School Outfit

There's more to life than wearing school uniforms. Pushing back against a regimented look brings us to after-school clothing. It shows the viewer another side of your character and allows you the freedom to be inventive and expressive.

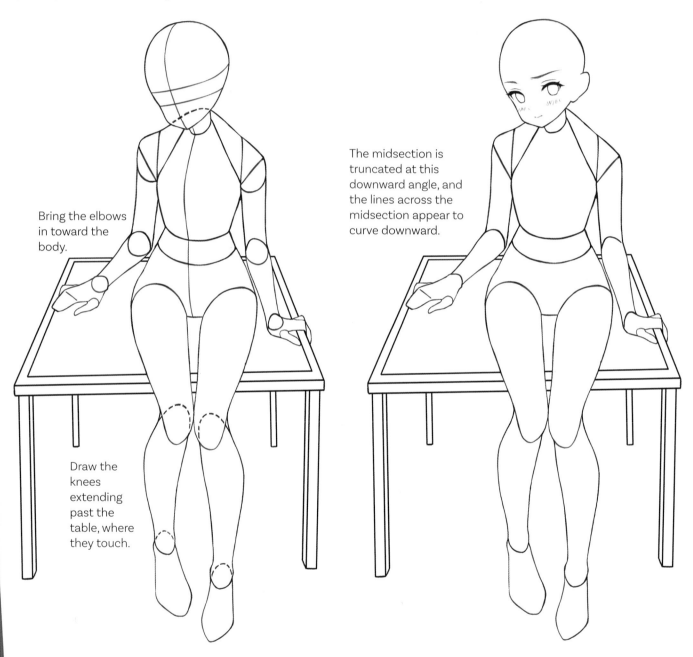

Bring the elbows in toward the body.

The midsection is truncated at this downward angle, and the lines across the midsection appear to curve downward.

Draw the knees extending past the table, where they touch.

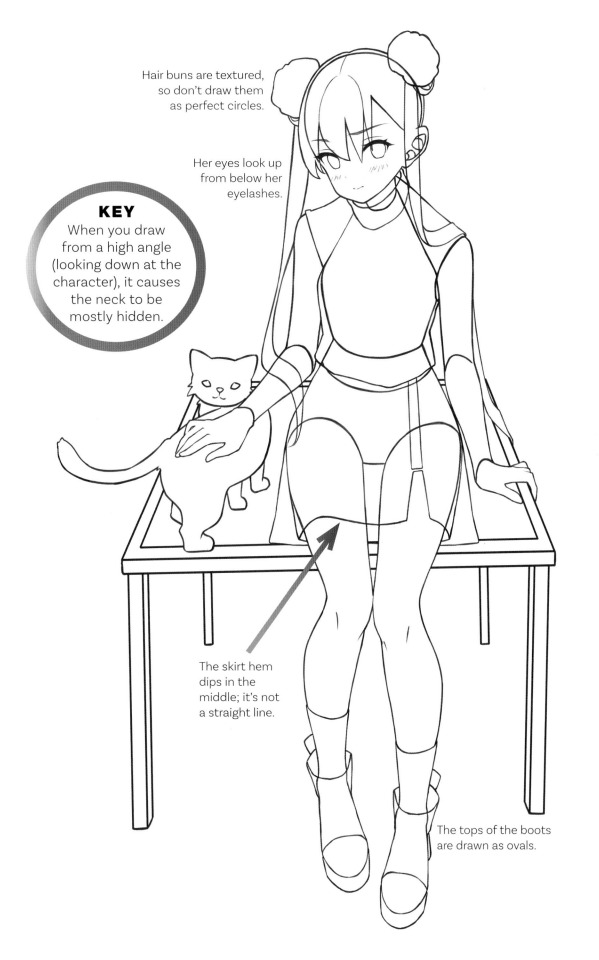

Hair buns are textured, so don't draw them as perfect circles.

Her eyes look up from below her eyelashes.

KEY
When you draw from a high angle (looking down at the character), it causes the neck to be mostly hidden.

The skirt hem dips in the middle; it's not a straight line.

The tops of the boots are drawn as ovals.

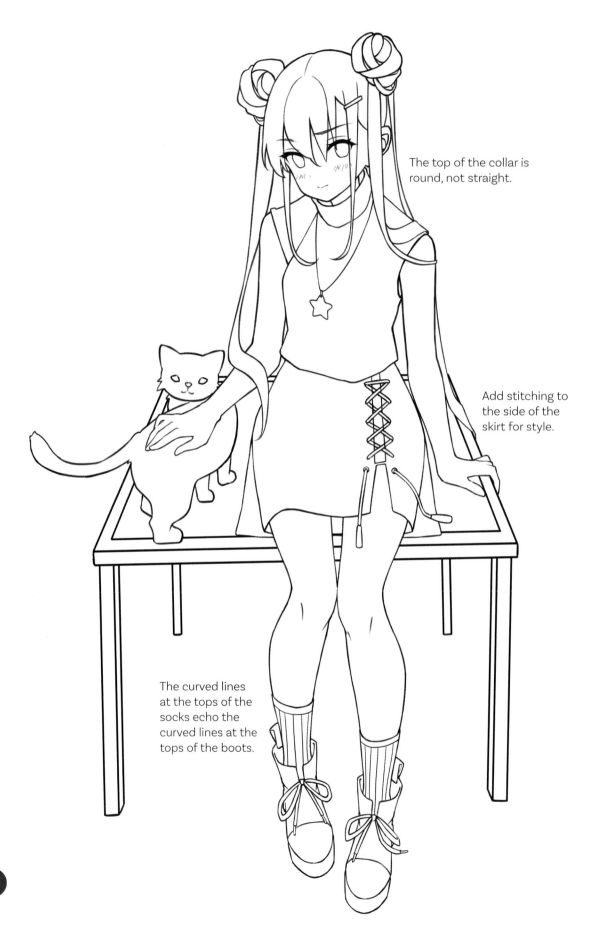

The top of the collar is round, not straight.

Add stitching to the side of the skirt for style.

The curved lines at the tops of the socks echo the curved lines at the tops of the boots.

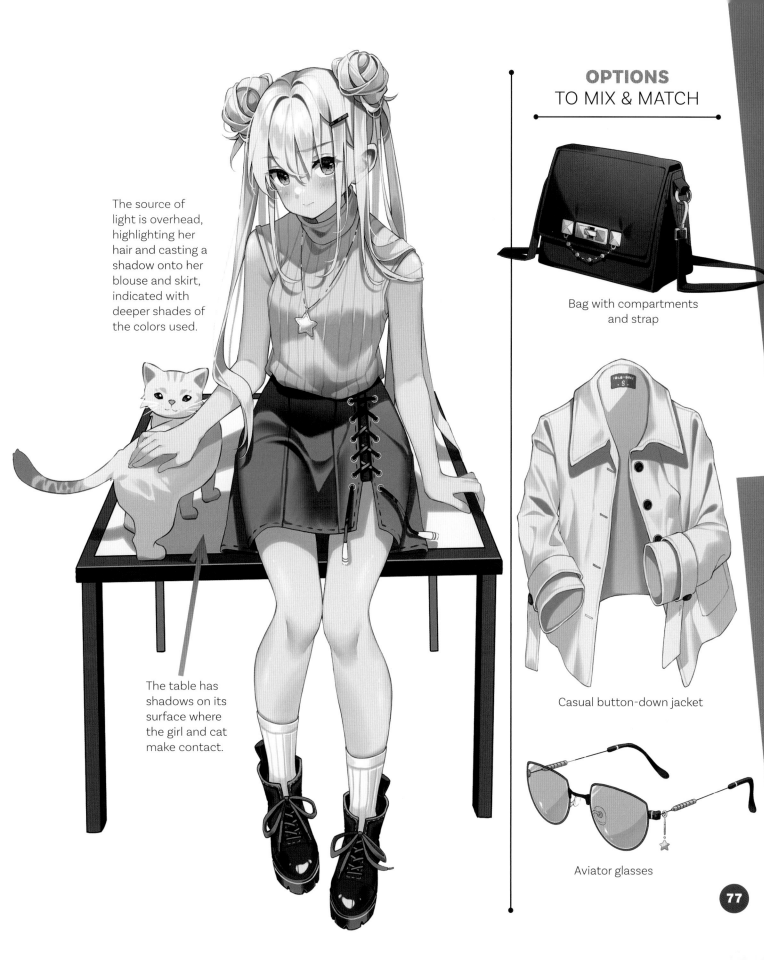

The source of light is overhead, highlighting her hair and casting a shadow onto her blouse and skirt, indicated with deeper shades of the colors used.

The table has shadows on its surface where the girl and cat make contact.

OPTIONS
TO MIX & MATCH

Bag with compartments and strap

Casual button-down jacket

Aviator glasses

Anime Fashion Follower

This character type follows all the latest trends. Her closet is filled with every cool outfit and accessory. But she has nothing left for gas money!

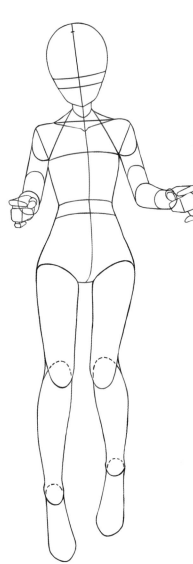

Perspective at work: the left forearm faces directly front and seems to have all but disappeared. Because the right arm turns out slightly, it's not as compressed.

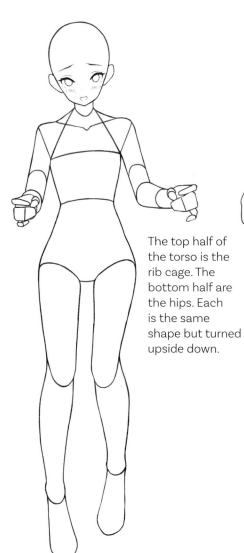

The top half of the torso is the rib cage. The bottom half are the hips. Each is the same shape but turned upside down.

Turning the feet inward makes the character look light on her toes.

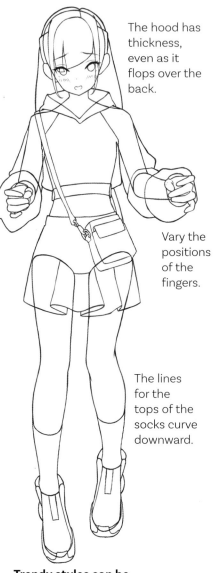

The hood has thickness, even as it flops over the back.

Vary the positions of the fingers.

The lines for the tops of the socks curve downward.

Trendy styles can be inventive, like a sweatshirt that turns into a midriff.

Her hair ribbon mimics cat ears, very popular in anime.

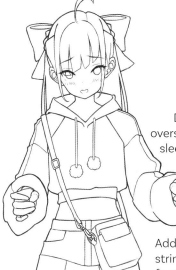

Draw oversized sleeves.

Add pull strings for the hood and a small purse angled across her chest.

Using bright colors makes patterns stand out, like on the purse.

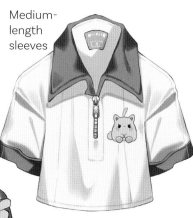

Medium-length sleeves

Brightly colored trim for interest

Shorts that are almost as wide as the skirt

Frilly socks with clunky shoes

Artistic Type

She could be a potter, illustrator, or graphic designer. Or maybe an anime artist. She wears comfortable clothing that isn't cookie-cutter. The look supports a character with a breezy, creative personality.

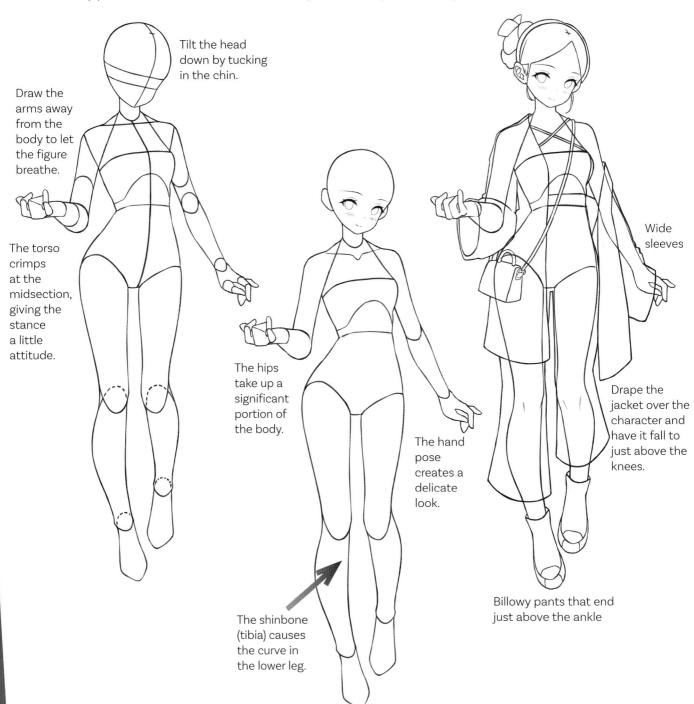

Tilt the head down by tucking in the chin.

Draw the arms away from the body to let the figure breathe.

The torso crimps at the midsection, giving the stance a little attitude.

The hips take up a significant portion of the body.

The hand pose creates a delicate look.

The shinbone (tibia) causes the curve in the lower leg.

Wide sleeves

Drape the jacket over the character and have it fall to just above the knees.

Billowy pants that end just above the ankle

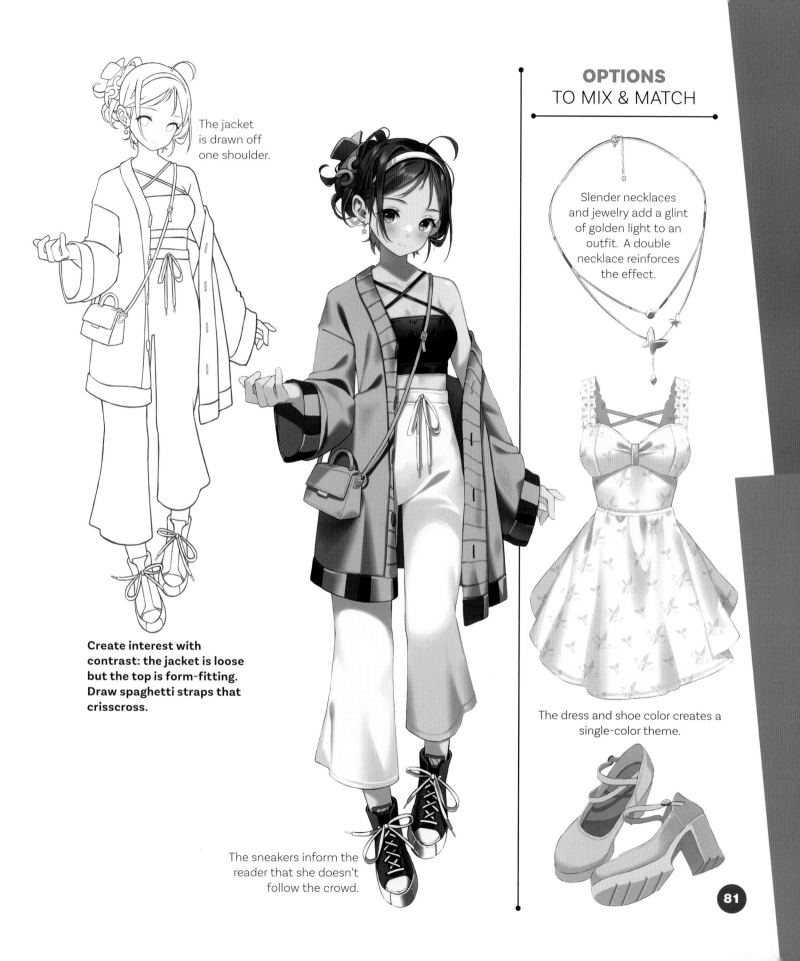

The jacket is drawn off one shoulder.

Create interest with contrast: the jacket is loose but the top is form-fitting. Draw spaghetti straps that crisscross.

The sneakers inform the reader that she doesn't follow the crowd.

Slender necklaces and jewelry add a glint of golden light to an outfit. A double necklace reinforces the effect.

The dress and shoe color creates a single-color theme.

81

Best Friend Outfit

A main character usually has a close friend they open up to with their problems. This is an important character. In keeping with her role, she wears outfits that make her look easygoing—someone you could talk to.

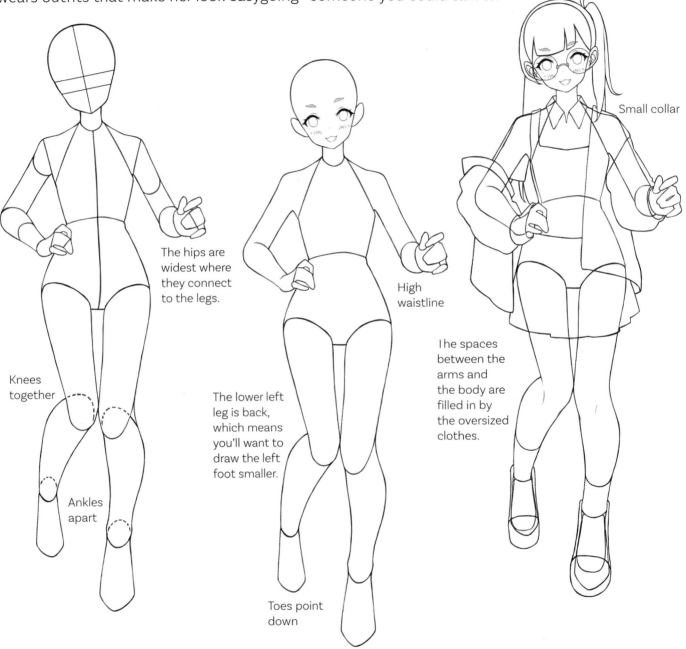

The hips are widest where they connect to the legs.

Knees together

Ankles apart

The lower left leg is back, which means you'll want to draw the left foot smaller.

Toes point down

High waistline

Small collar

The spaces between the arms and the body are filled in by the oversized clothes.

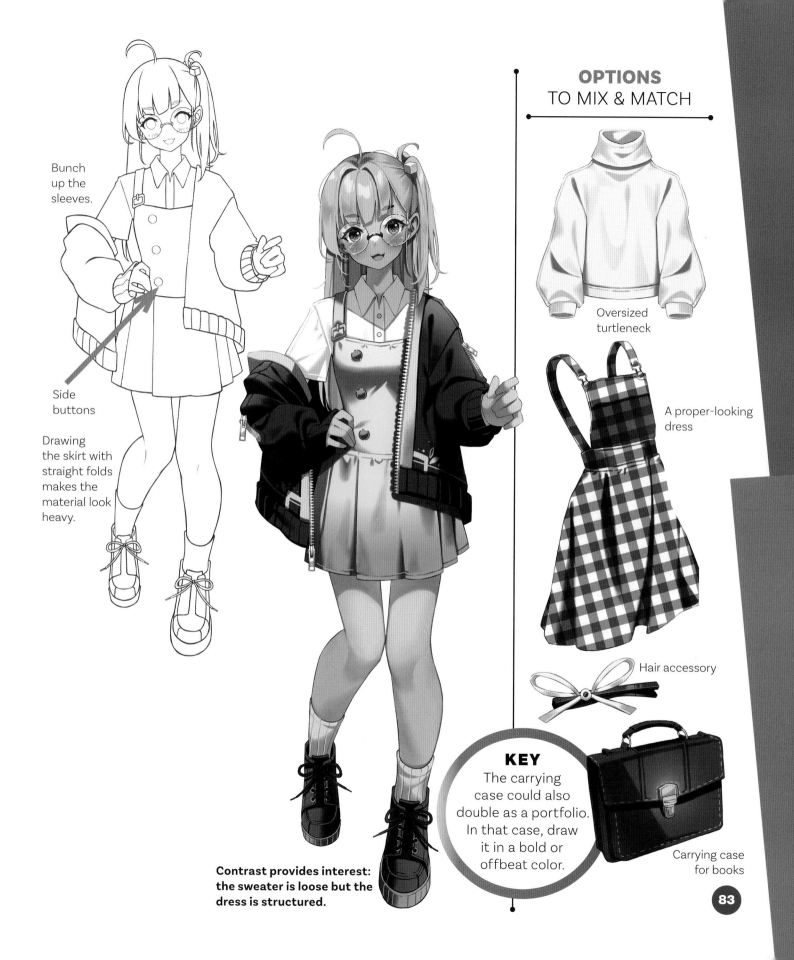

Bunch up the sleeves.

Side buttons

Drawing the skirt with straight folds makes the material look heavy.

Contrast provides interest: the sweater is loose but the dress is structured.

Oversized turtleneck

A proper-looking dress

Hair accessory

KEY
The carrying case could also double as a portfolio. In that case, draw it in a bold or offbeat color.

Carrying case for books

The Costume Change

Artists associate their character with a specific outfit. But anime stories take place over time and in different locations. Unless your character is always in school, for example, you're going to need to come up with a change of clothing.

KEEPING IT IN CHARACTER

There are generally two ways to make a costume change. The first is where you change the character's main outfit for one that's along the same lines, like an athletic type who changes into a breezy, casual outfit.

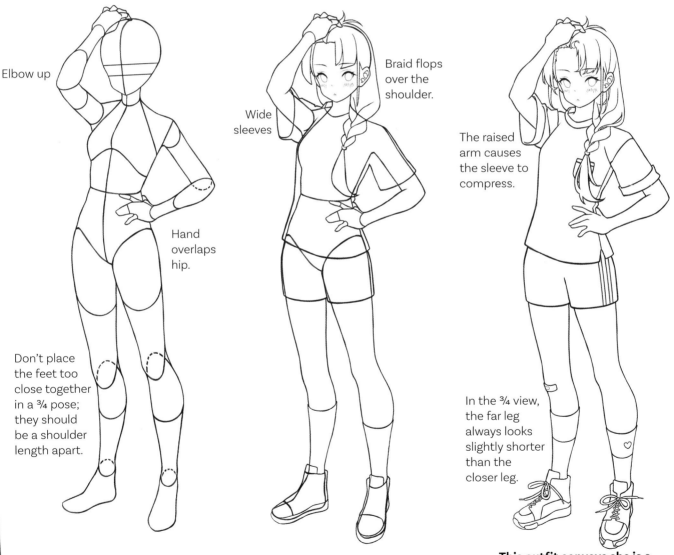

Elbow up

Hand overlaps hip.

Don't place the feet too close together in a ¾ pose; they should be a shoulder length apart.

Braid flops over the shoulder.

Wide sleeves

The raised arm causes the sleeve to compress.

In the ¾ view, the far leg always looks slightly shorter than the closer leg.

This outfit conveys she is a member of a sports team.

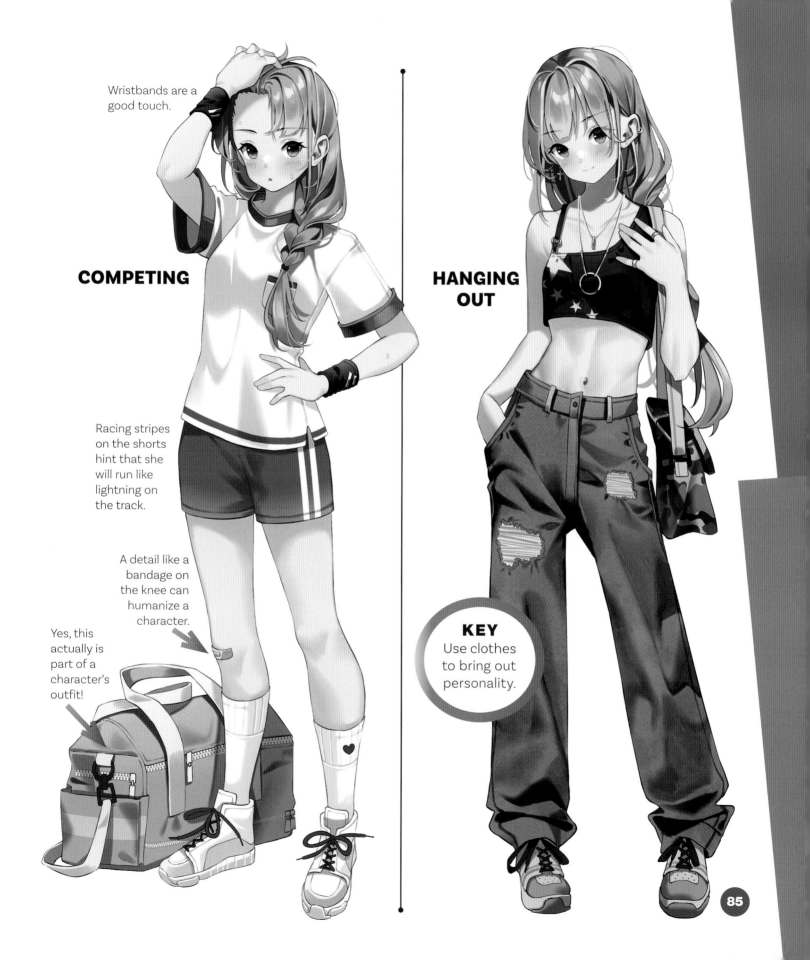

Wristbands are a good touch.

COMPETING

Racing stripes on the shorts hint that she will run like lightning on the track.

A detail like a bandage on the knee can humanize a character.

Yes, this actually is part of a character's outfit!

HANGING OUT

KEY
Use clothes to bring out personality.

OUT OF CHARACTER

The other type of costume change is one that creates a different personality type, as shown here, from schoolgirl to a kemonomimi-style cat girl.

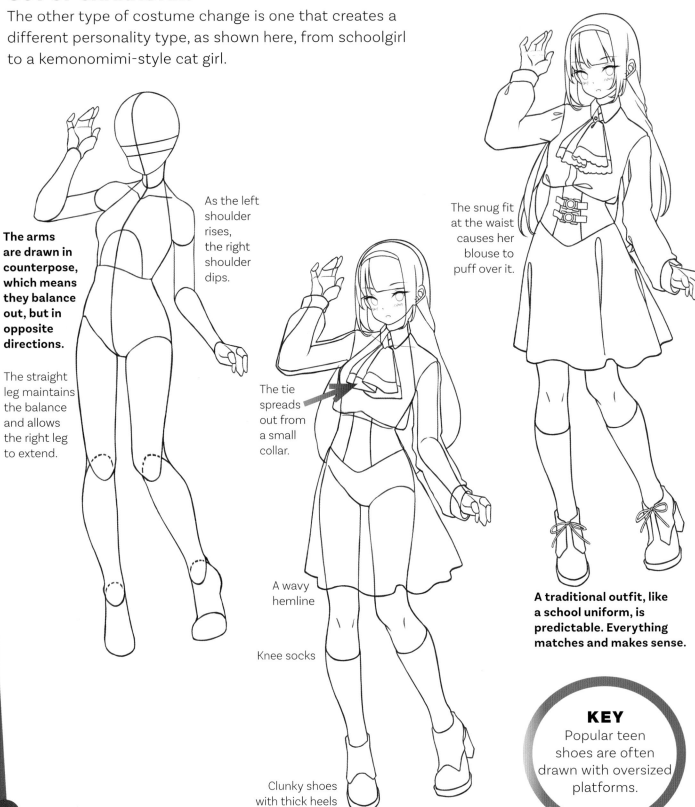

The arms are drawn in counterpose, which means they balance out, but in opposite directions.

The straight leg maintains the balance and allows the right leg to extend.

As the left shoulder rises, the right shoulder dips.

The tie spreads out from a small collar.

A wavy hemline

Knee socks

Clunky shoes with thick heels

The snug fit at the waist causes her blouse to puff over it.

A traditional outfit, like a school uniform, is predictable. Everything matches and makes sense.

KEY
Popular teen shoes are often drawn with oversized platforms.

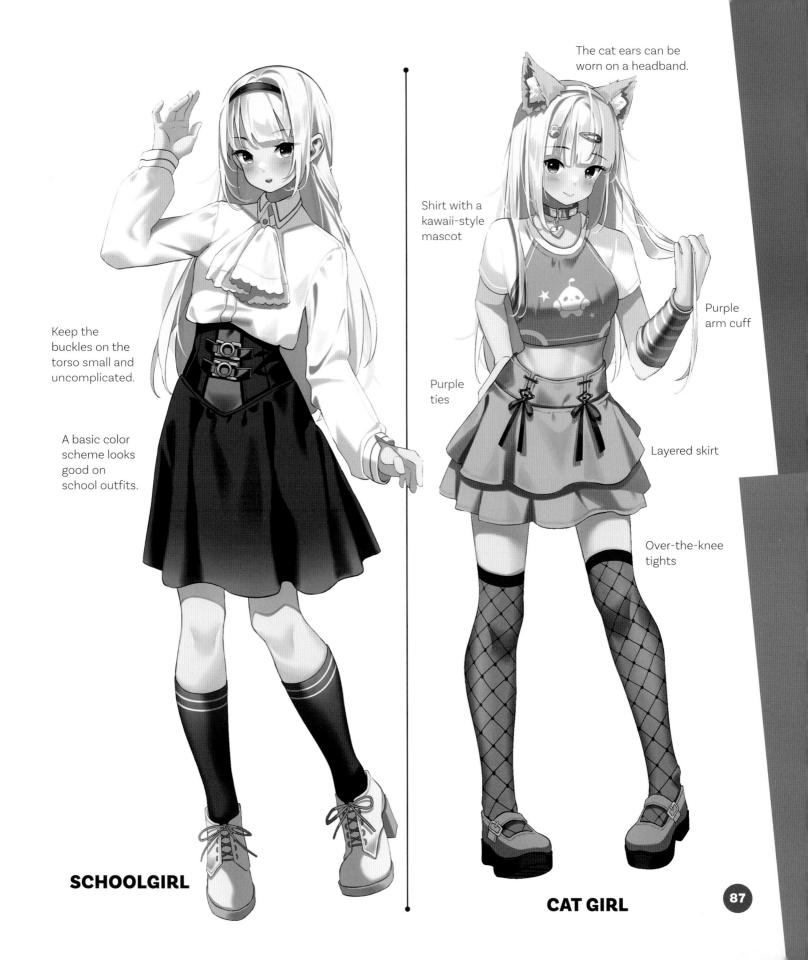

The cat ears can be worn on a headband.

Keep the buckles on the torso small and uncomplicated.

A basic color scheme looks good on school outfits.

Shirt with a kawaii-style mascot

Purple ties

Purple arm cuff

Layered skirt

Over-the-knee tights

SCHOOLGIRL

CAT GIRL

The purpose of drawing a pose is to capture a moment and dramatize it. Every pose has elements of posture, balance, and flow.

When you decide on a pose, it's best to plot it out in the early stages, like these steps, before you begin to refine it. This will free you up to get more creative in the later steps. That's the progression we'll work on in this chapter.

Amazing Poses Step By Step

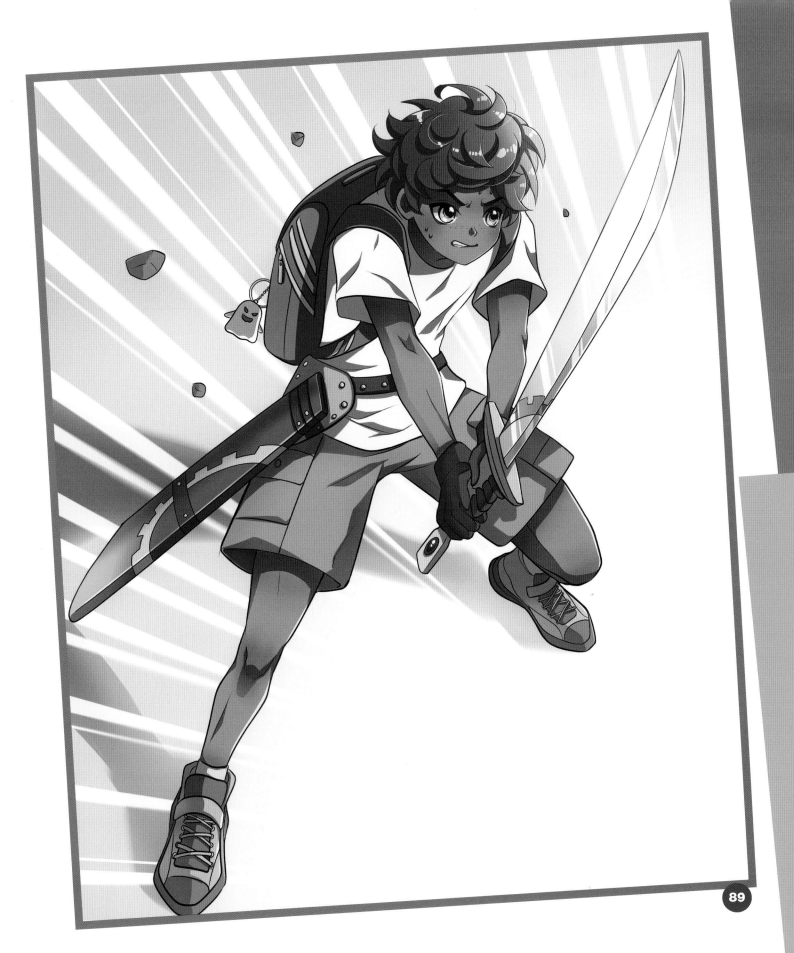

Devious Pose

Anime features lots of glamorous villains. This character combines a sly expression with a dramatic pose and a flashy outfit.

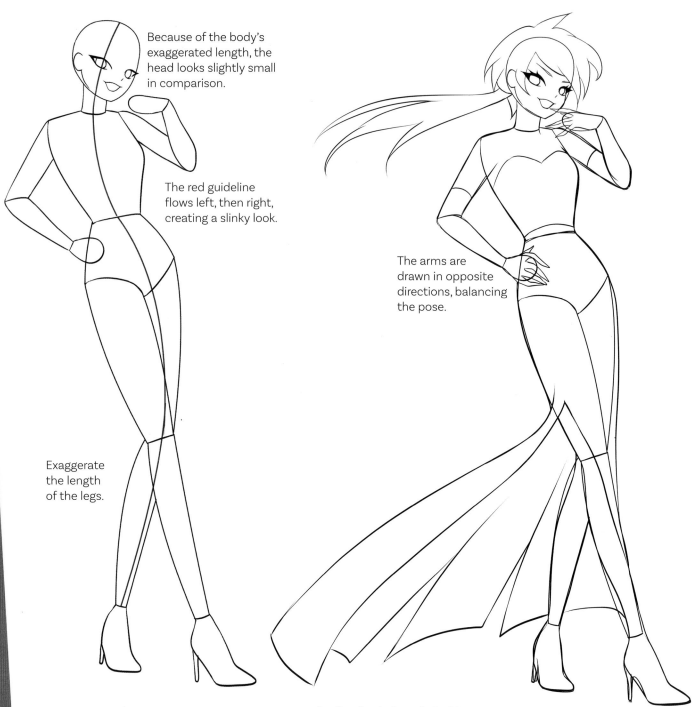

Because of the body's exaggerated length, the head looks slightly small in comparison.

The red guideline flows left, then right, creating a slinky look.

Exaggerate the length of the legs.

The arms are drawn in opposite directions, balancing the pose.

The flowing hair and clothing give the impression of motion when the pose doesn't actually have any (artist's trick!).

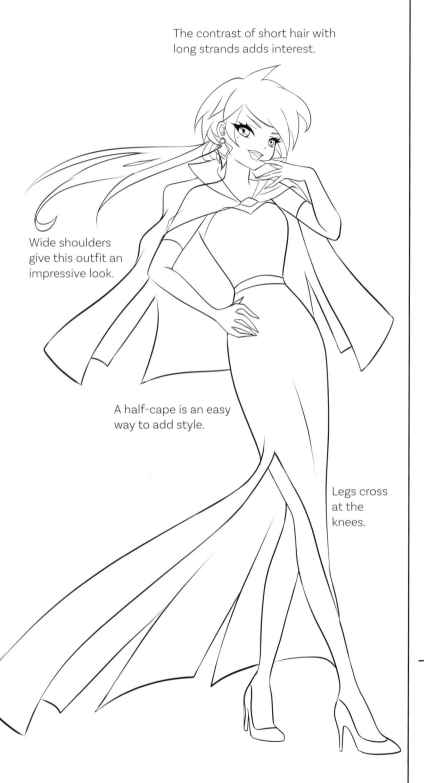

The contrast of short hair with long strands adds interest.

Wide shoulders give this outfit an impressive look.

A half-cape is an easy way to add style.

Legs cross at the knees.

CREATING STABLE POSES

Here are three types of flowing lines you can use to build stronger poses:

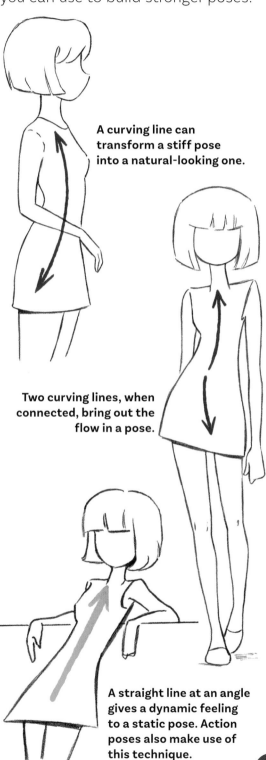

A curving line can transform a stiff pose into a natural-looking one.

Two curving lines, when connected, bring out the flow in a pose.

A straight line at an angle gives a dynamic feeling to a static pose. Action poses also make use of this technique.

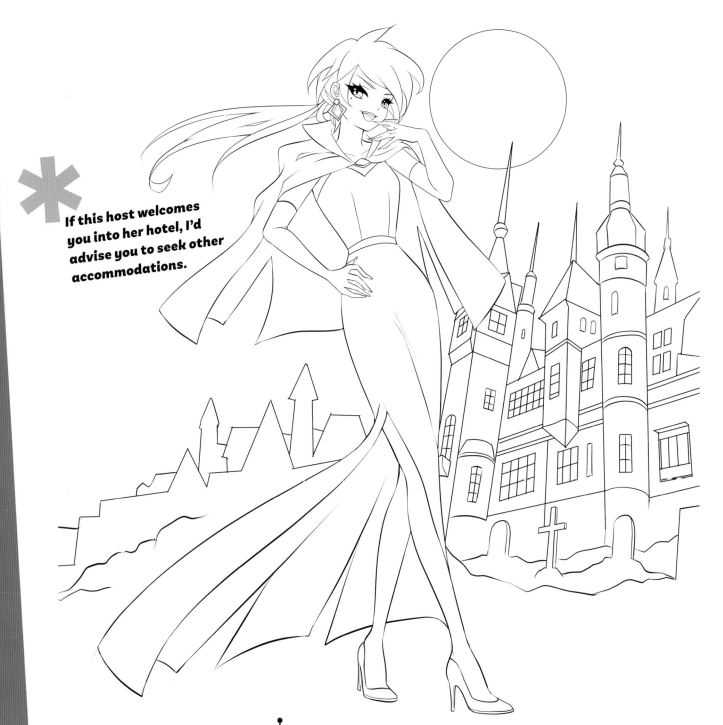

Using Background Details to Enhance the Pose

1. The castle is perched on a hill, making it look powerful and isolated.

2. The spires ascend to the sky. Not very welcoming.

3. The left side of the page features silhouetted castle tops, causing the viewer's eye to focus on the closer ones, which have more detail.

KEY
The color palette also supports the evil theme, with deep, moody hues of purple, red, and black.

Master villains are in command. Even the clouds are pulled into her orbit.

* The full moon represents an omen, like, you're going to be turned into a frog.

Joyful Run

Joyfulness is like a beautiful sunset that's here and then gone. That's what makes it special. Let's find out how a pose can capture the moment.

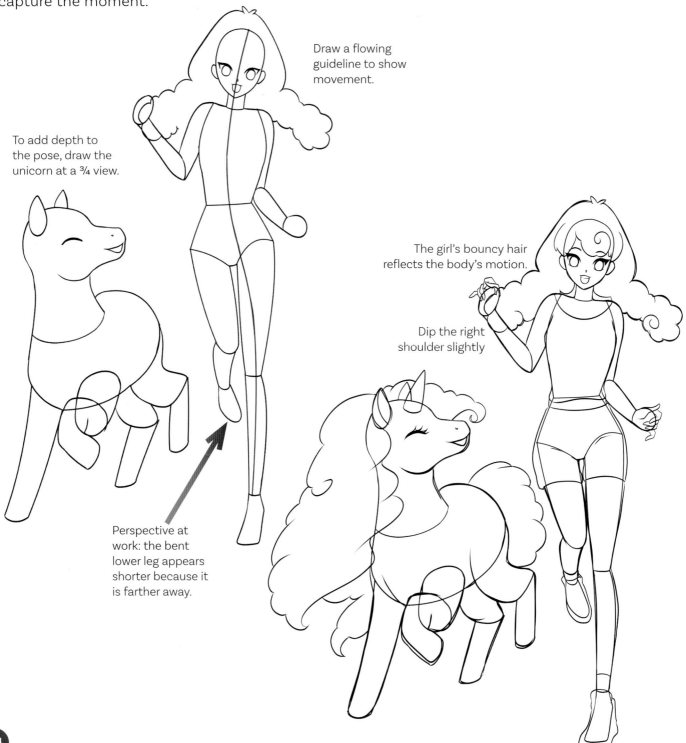

Draw a flowing guideline to show movement.

To add depth to the pose, draw the unicorn at a ¾ view.

The girl's bouncy hair reflects the body's motion.

Dip the right shoulder slightly

Perspective at work: the bent lower leg appears shorter because it is farther away.

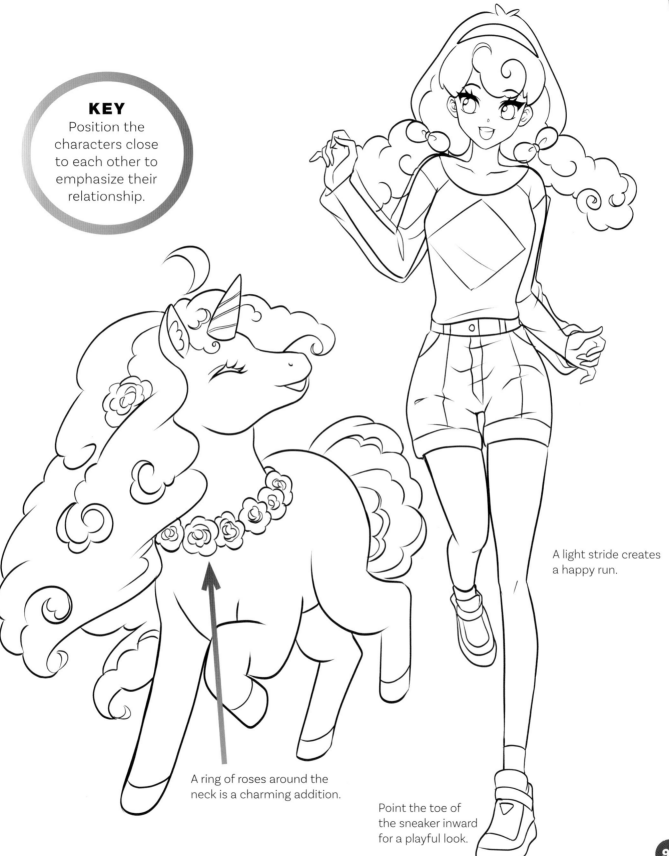

A ring of roses around the neck is a charming addition.

A light stride creates a happy run.

Point the toe of the sneaker inward for a playful look.

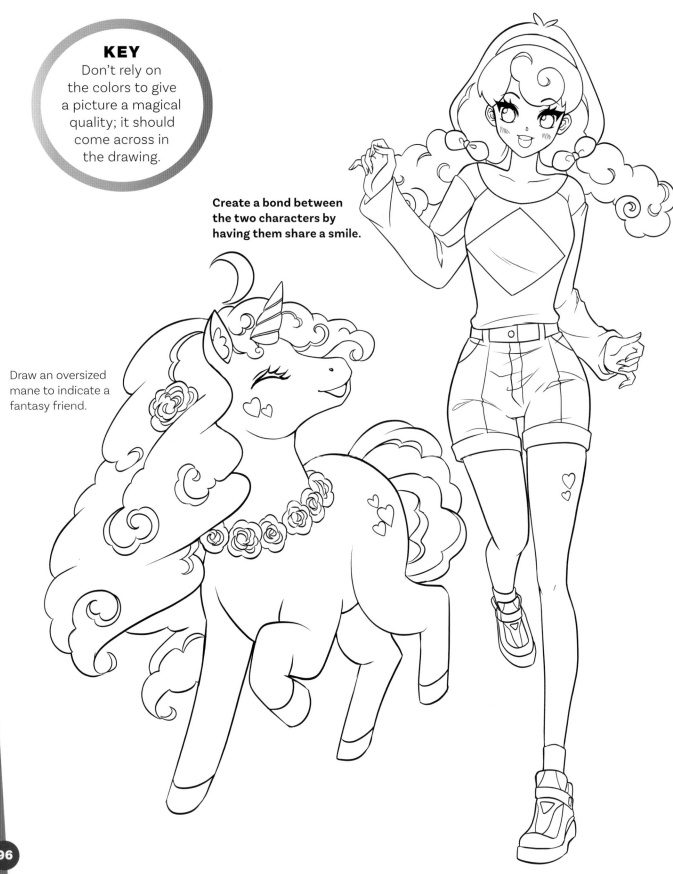

Create a bond between the two characters by having them share a smile.

Draw an oversized mane to indicate a fantasy friend.

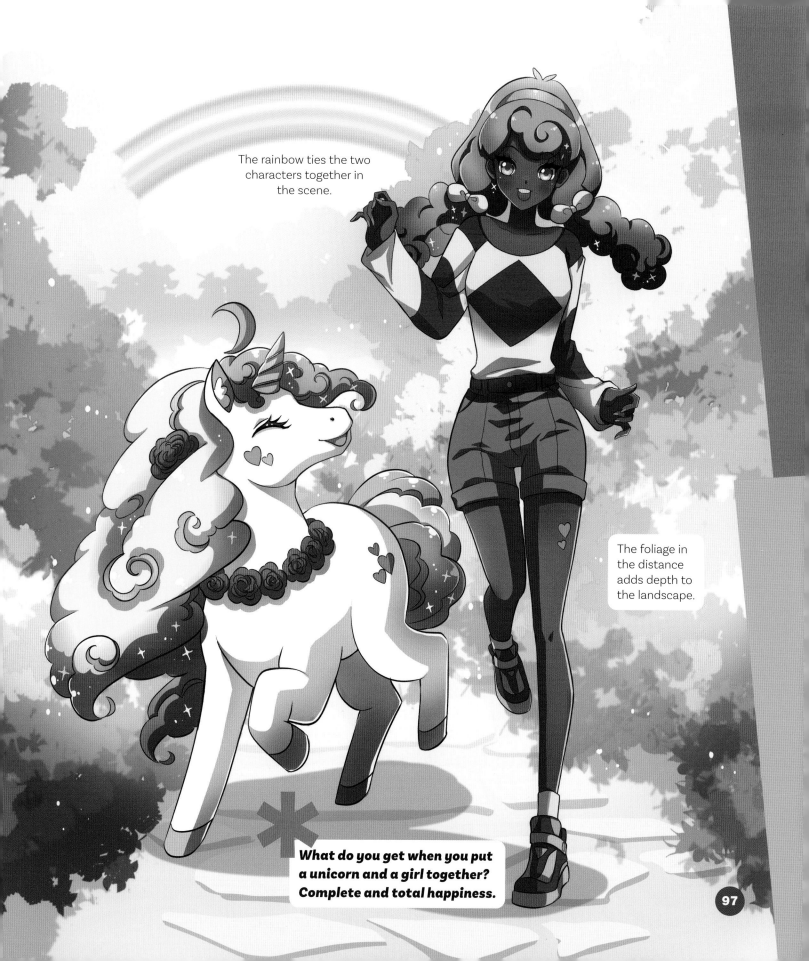

The rainbow ties the two characters together in the scene.

The foliage in the distance adds depth to the landscape.

What do you get when you put a unicorn and a girl together? Complete and total happiness.

The Heroic Pose

One of the most beloved character types in anime is the young hero. Draw the body bent forward at the waist for a classic fighting stance.

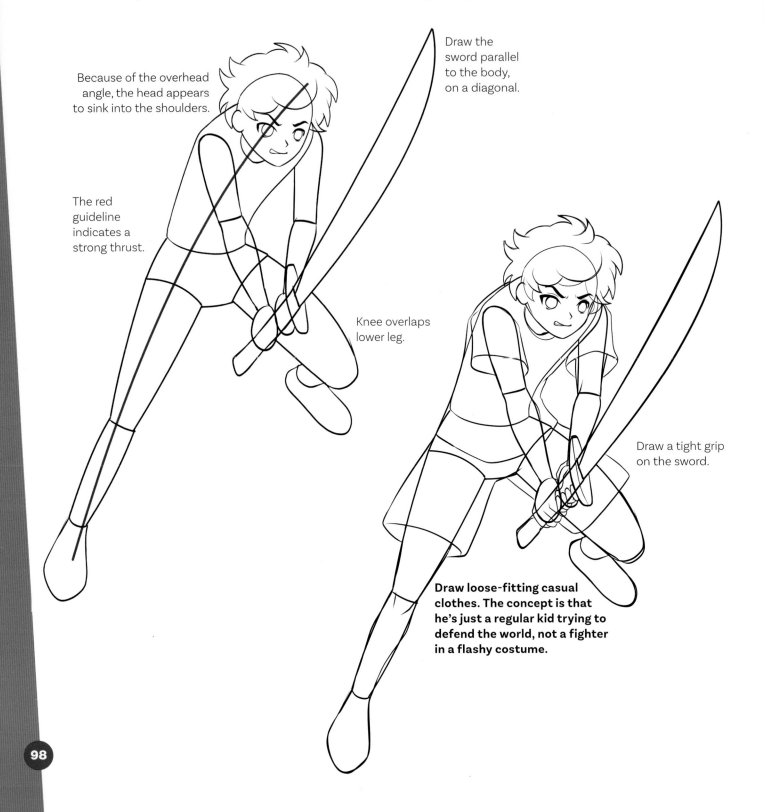

Because of the overhead angle, the head appears to sink into the shoulders.

Draw the sword parallel to the body, on a diagonal.

The red guideline indicates a strong thrust.

Knee overlaps lower leg.

Draw a tight grip on the sword.

Draw loose-fitting casual clothes. The concept is that he's just a regular kid trying to defend the world, not a fighter in a flashy costume.

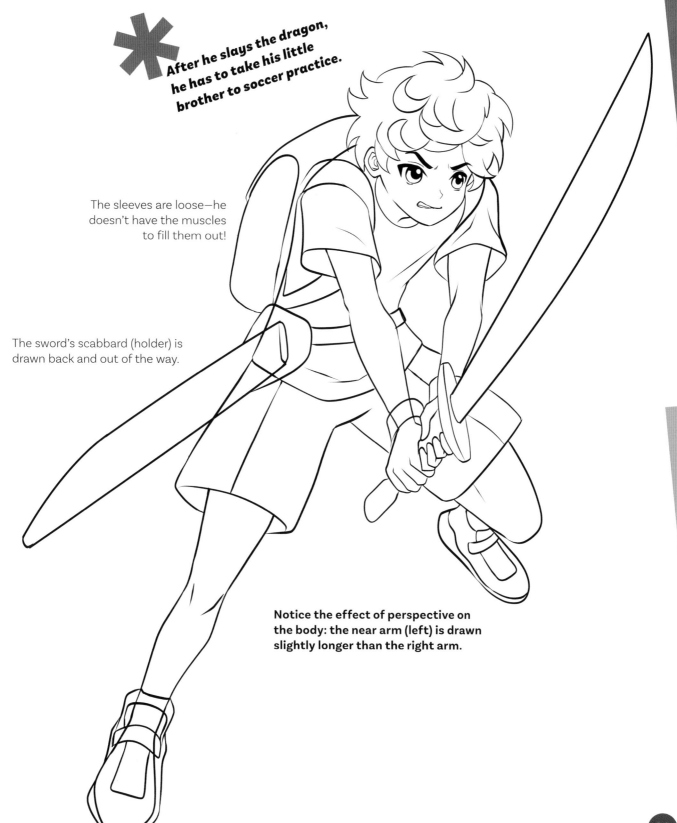

*After he slays the dragon, he has to take his little brother to soccer practice.

The sleeves are loose—he doesn't have the muscles to fill them out!

The sword's scabbard (holder) is drawn back and out of the way.

Notice the effect of perspective on the body: the near arm (left) is drawn slightly longer than the right arm.

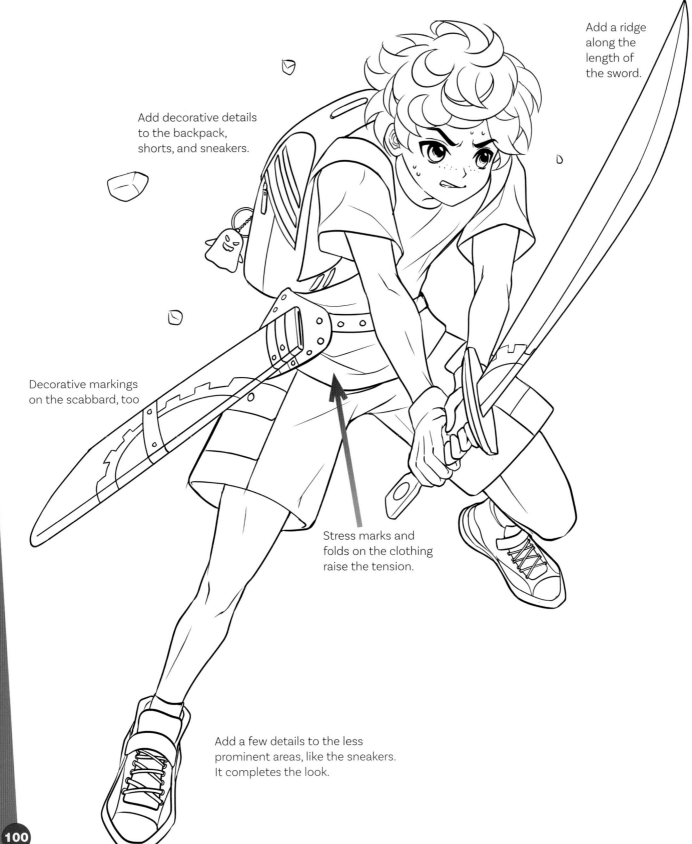

Add a ridge along the length of the sword.

Add decorative details to the backpack, shorts, and sneakers.

Decorative markings on the scabbard, too

Stress marks and folds on the clothing raise the tension.

Add a few details to the less prominent areas, like the sneakers. It completes the look.

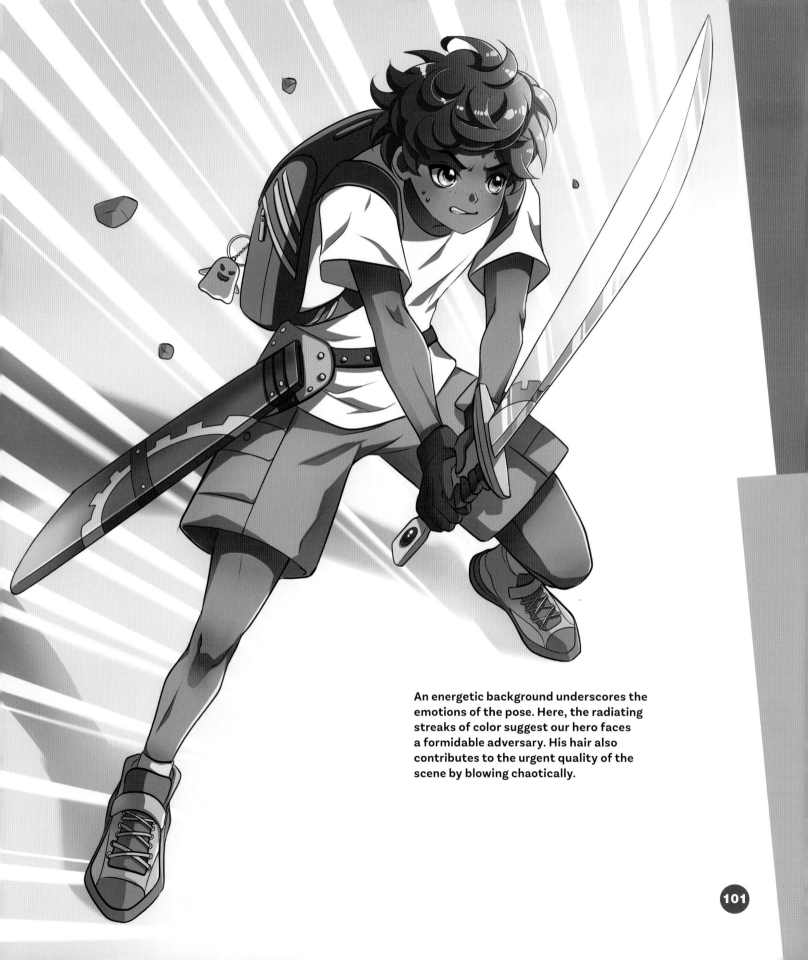

An energetic background underscores the emotions of the pose. Here, the radiating streaks of color suggest our hero faces a formidable adversary. His hair also contributes to the urgent quality of the scene by blowing chaotically.

Caught in a Magical Spell

Special effects are not static, and neither are the poses of the characters who are caught in them. Therefore, draw her off-balance.

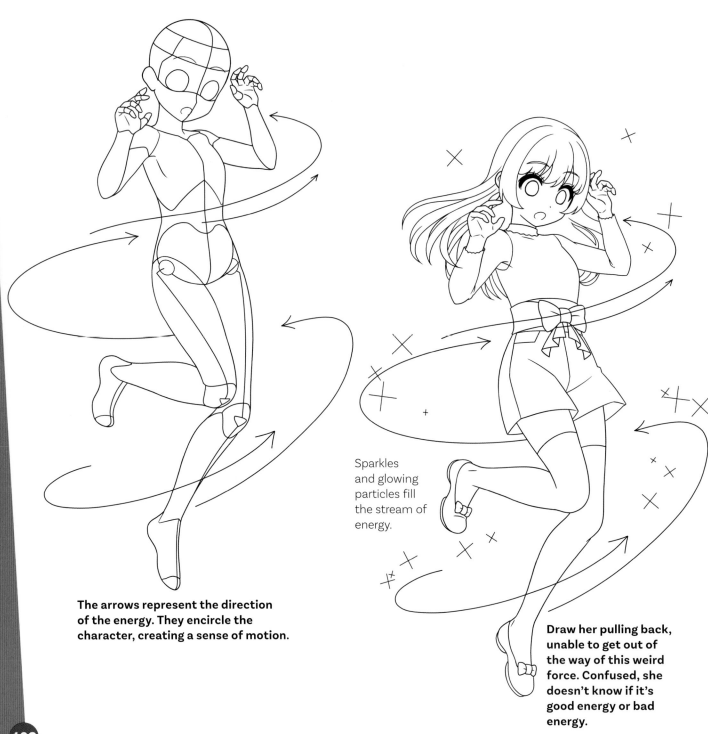

Sparkles and glowing particles fill the stream of energy.

The arrows represent the direction of the energy. They encircle the character, creating a sense of motion.

Draw her pulling back, unable to get out of the way of this weird force. Confused, she doesn't know if it's good energy or bad energy.

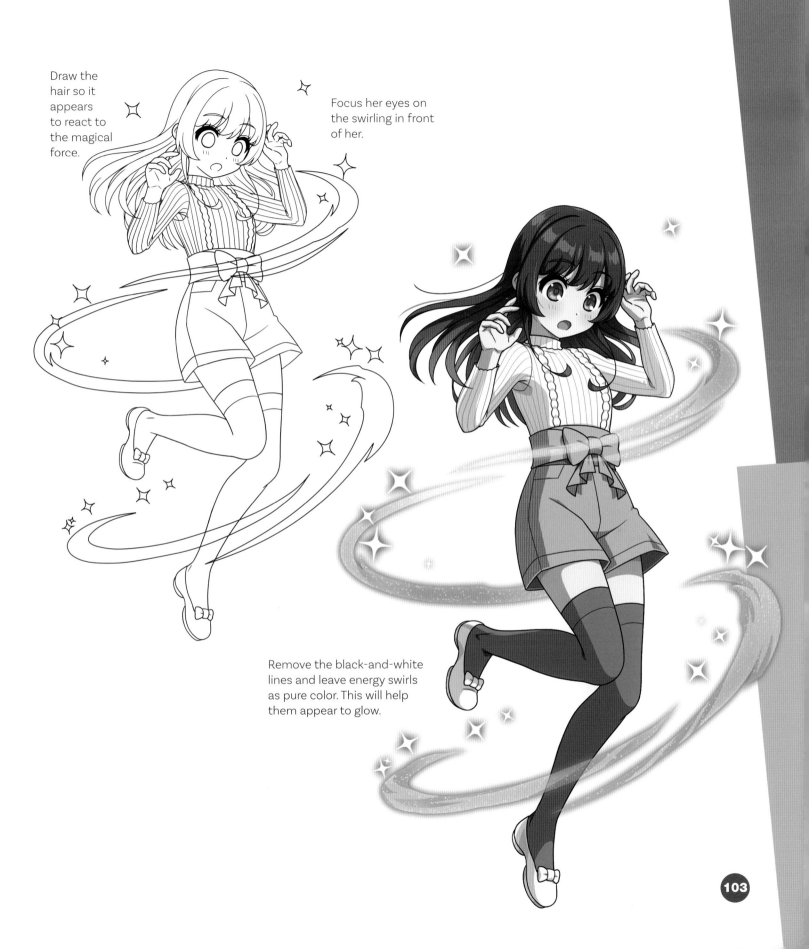

Draw the hair so it appears to react to the magical force.

Focus her eyes on the swirling in front of her.

Remove the black-and-white lines and leave energy swirls as pure color. This will help them appear to glow.

Floating

One of the most dramatic poses in anime is a character held aloft by an unseen force. It's tricky, though—her posture has to indicate that a supernatural force has taken hold. The red guideline is the key.

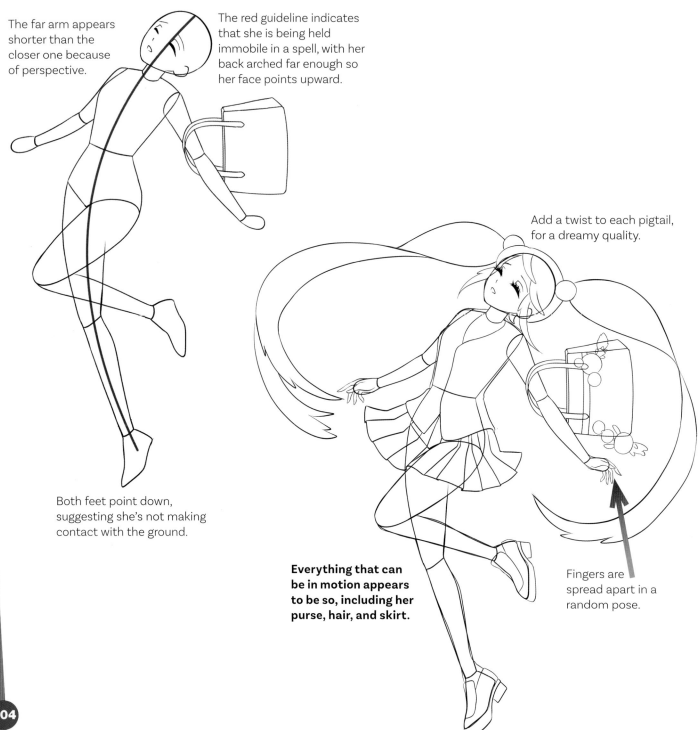

The far arm appears shorter than the closer one because of perspective.

The red guideline indicates that she is being held immobile in a spell, with her back arched far enough so her face points upward.

Add a twist to each pigtail, for a dreamy quality.

Both feet point down, suggesting she's not making contact with the ground.

Everything that can be in motion appears to be so, including her purse, hair, and skirt.

Fingers are spread apart in a random pose.

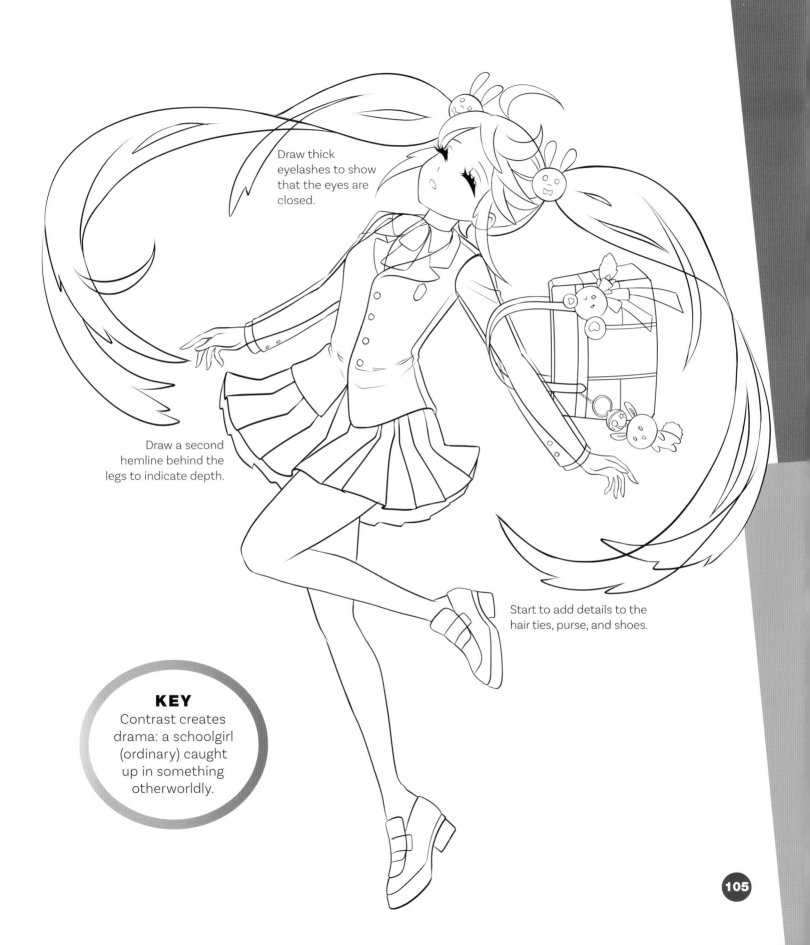

Draw thick eyelashes to show that the eyes are closed.

Draw a second hemline behind the legs to indicate depth.

Start to add details to the hair ties, purse, and shoes.

KEY
Contrast creates drama: a schoolgirl (ordinary) caught up in something otherworldly.

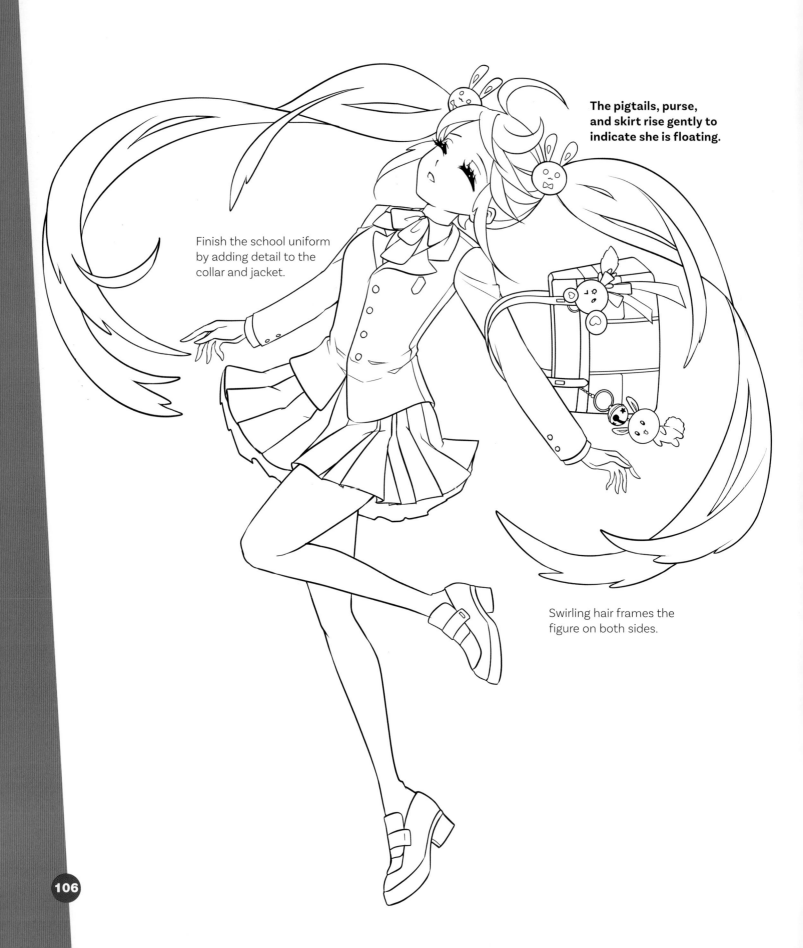

The pigtails, purse, and skirt rise gently to indicate she is floating.

Finish the school uniform by adding detail to the collar and jacket.

Swirling hair frames the figure on both sides.

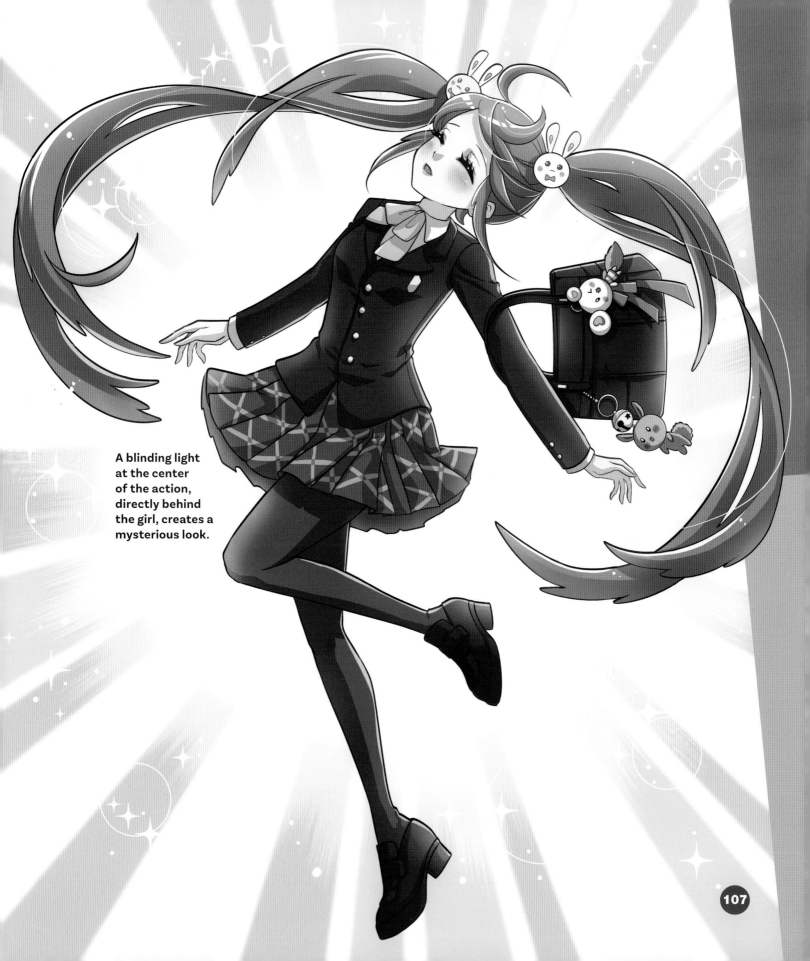

A blinding light at the center of the action, directly behind the girl, creates a mysterious look.

Charming Pose

This character's pose is derived from the flowing red guideline.
It flows left, it flows right, and retains its pinpoint balance.

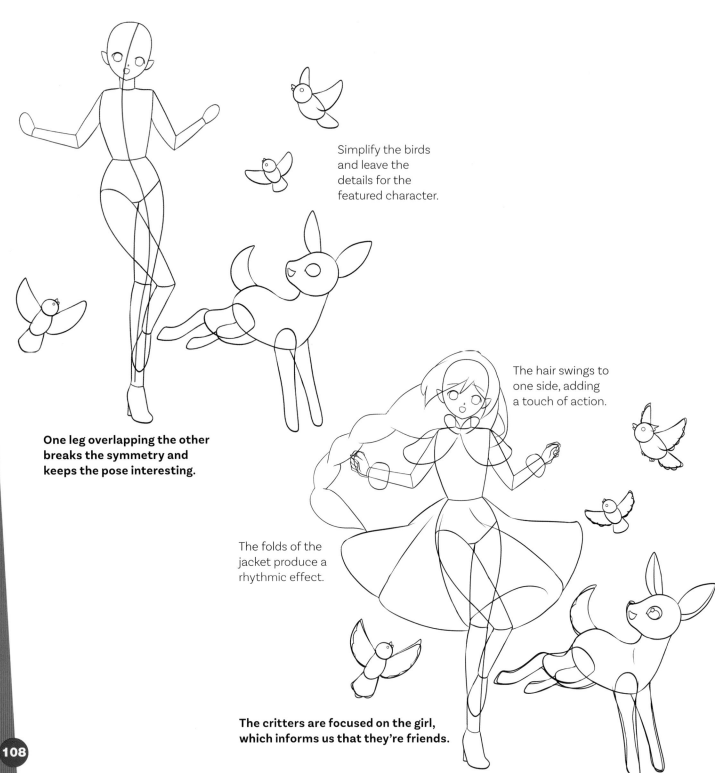

Simplify the birds and leave the details for the featured character.

One leg overlapping the other breaks the symmetry and keeps the pose interesting.

The hair swings to one side, adding a touch of action.

The folds of the jacket produce a rhythmic effect.

The critters are focused on the girl, which informs us that they're friends.

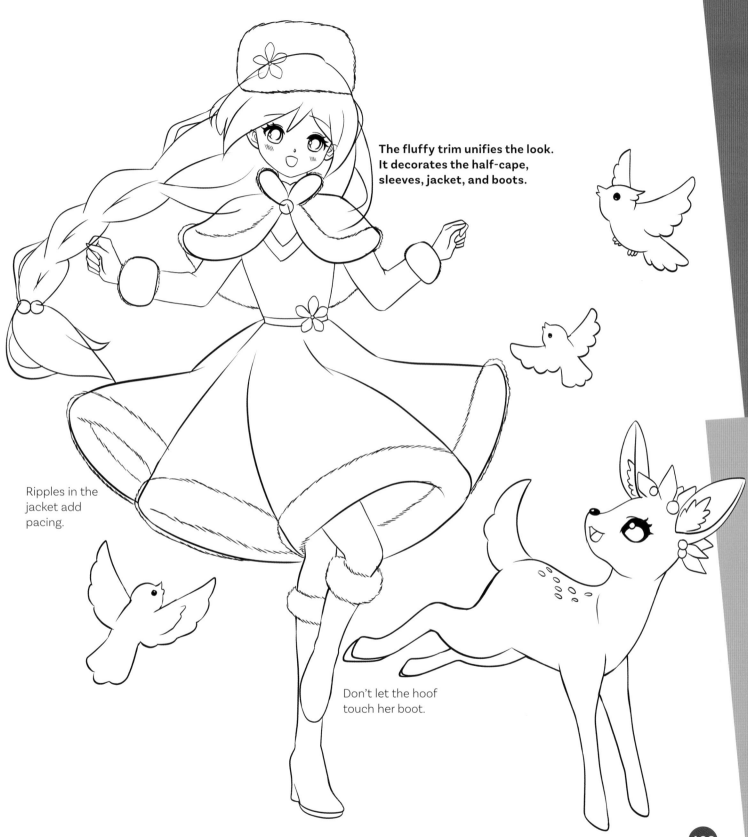

The fluffy trim unifies the look. It decorates the half-cape, sleeves, jacket, and boots.

Ripples in the jacket add pacing.

Don't let the hoof touch her boot.

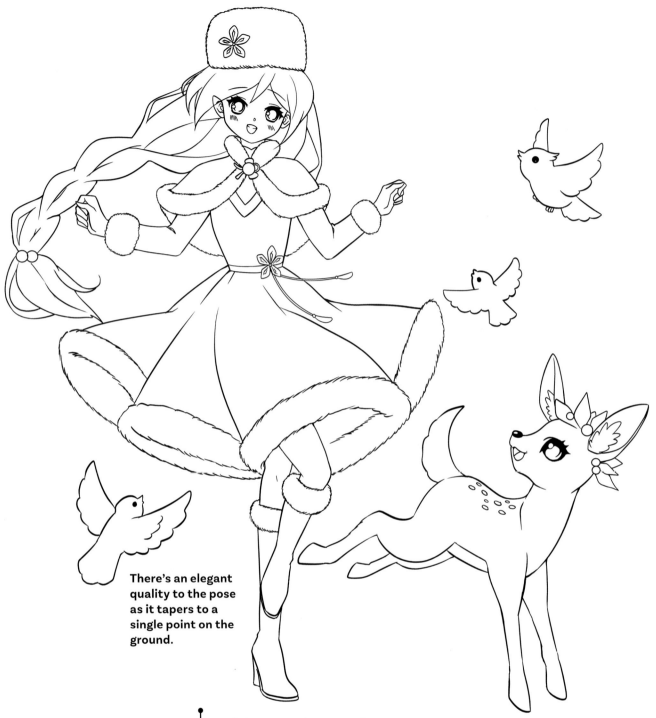

There's an elegant quality to the pose as it tapers to a single point on the ground.

Adding Color and Interest to a Snowy Scene

1. The trees are silhouetted.

2. There are only a few colors in this scene, which causes the more colorful characters to stand out

3. The girl's hair color ties in to that of the fawn's coat.

4. White snow reflects the white trim of her jacket.

5. Green-blue highlights in the ice play off the colors of her jacket.

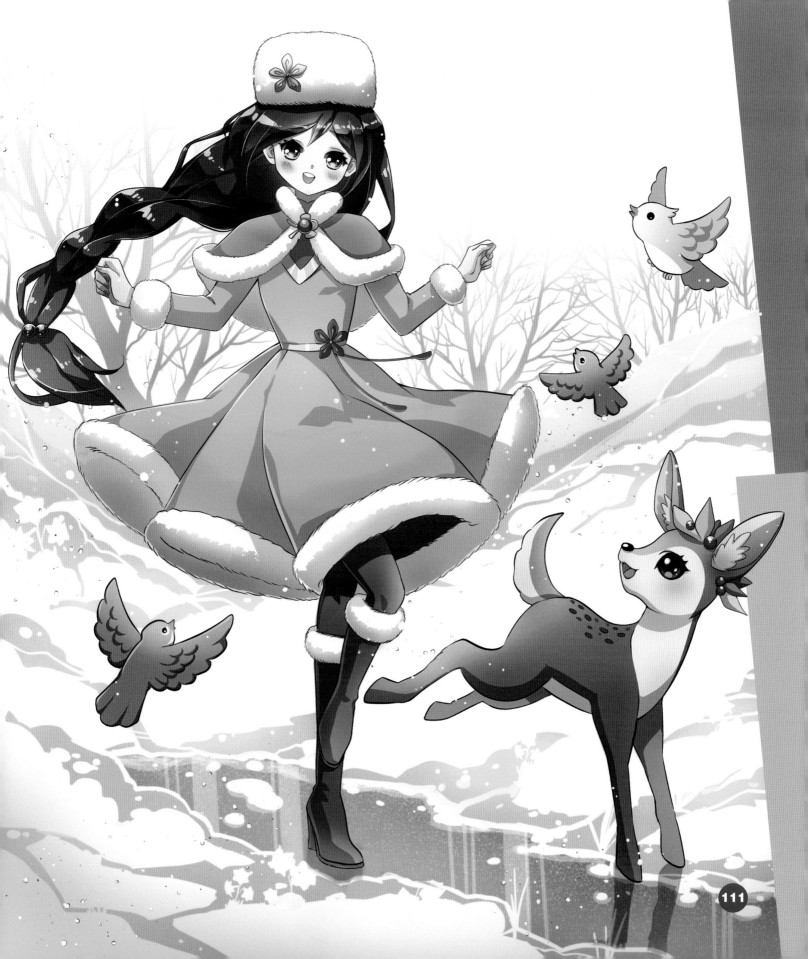

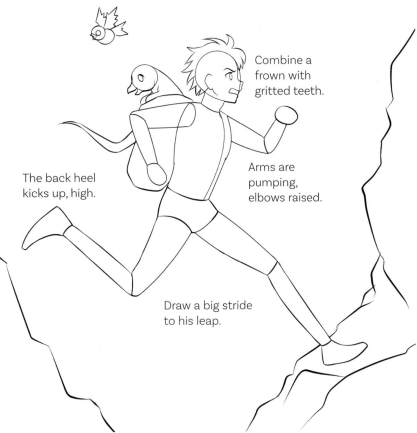

Combine a frown with gritted teeth.

The back heel kicks up, high.

Arms are pumping, elbows raised.

Draw a big stride to his leap.

Danger Run

It's a rule of thumb in anime that if your hero is in an all-out run, something bad is chasing him. This is a very different run from trying to get to the bus on time. The arms are pumping and the legs are reaching. As he leaps between cliffs, he's thinking, "I will not make fun of a monster ever again!"

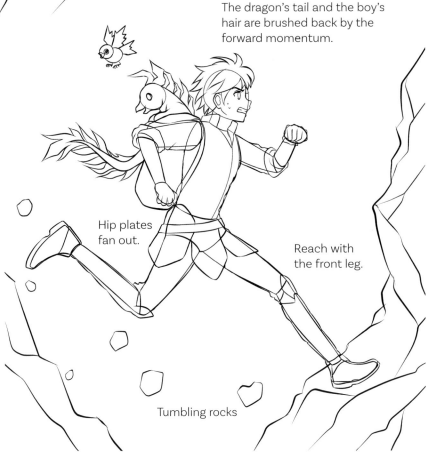

The dragon's tail and the boy's hair are brushed back by the forward momentum.

Hip plates fan out.

Reach with the front leg.

Tumbling rocks

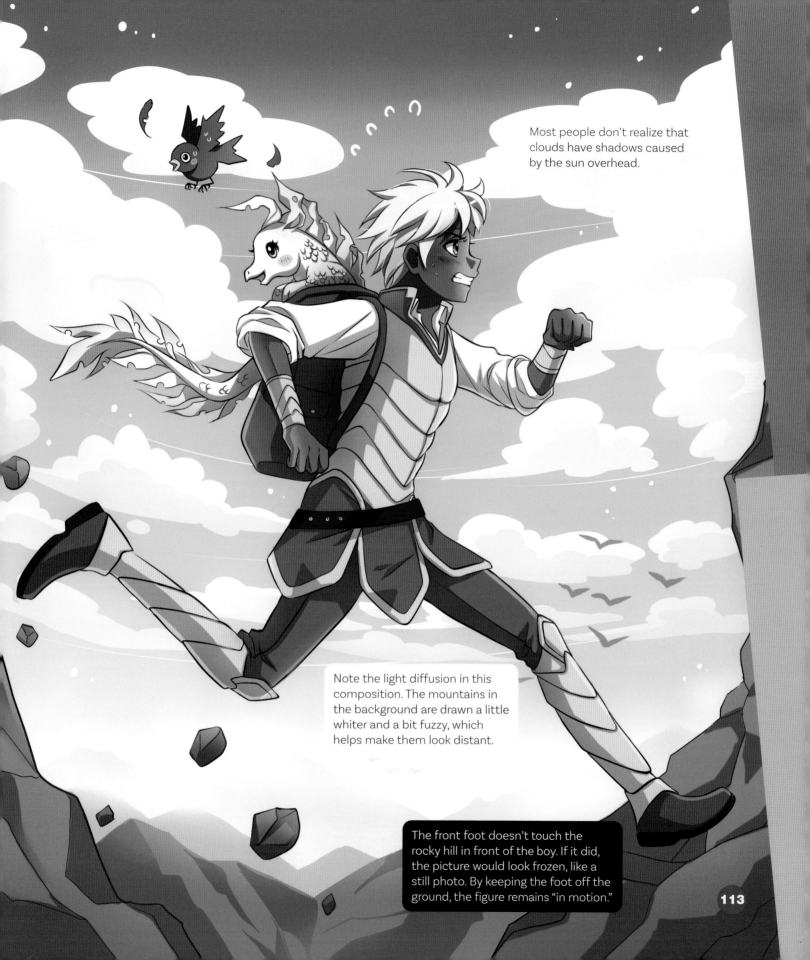

Most people don't realize that clouds have shadows caused by the sun overhead.

Note the light diffusion in this composition. The mountains in the background are drawn a little whiter and a bit fuzzy, which helps make them look distant.

The front foot doesn't touch the rocky hill in front of the boy. If it did, the picture would look frozen, like a still photo. By keeping the foot off the ground, the figure remains "in motion."

113

Defeated Warrior Pose

If every hero were triumphant in battle, audiences would yawn. Therefore, it's important to also show setbacks. This is where the warrior pulls inward to summon all of her strength. The viewer will be watching intently, not sure if she can win.

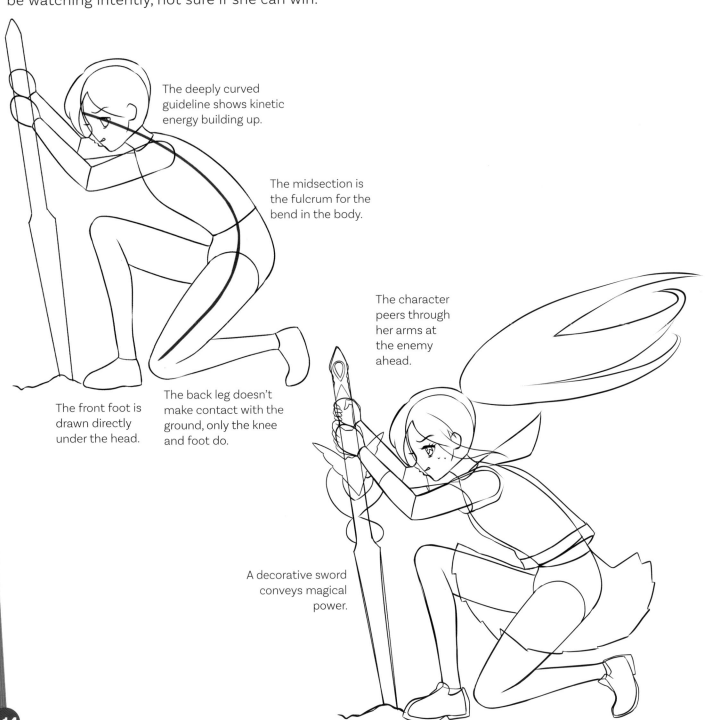

The deeply curved guideline shows kinetic energy building up.

The midsection is the fulcrum for the bend in the body.

The character peers through her arms at the enemy ahead.

The front foot is drawn directly under the head.

The back leg doesn't make contact with the ground, only the knee and foot do.

A decorative sword conveys magical power.

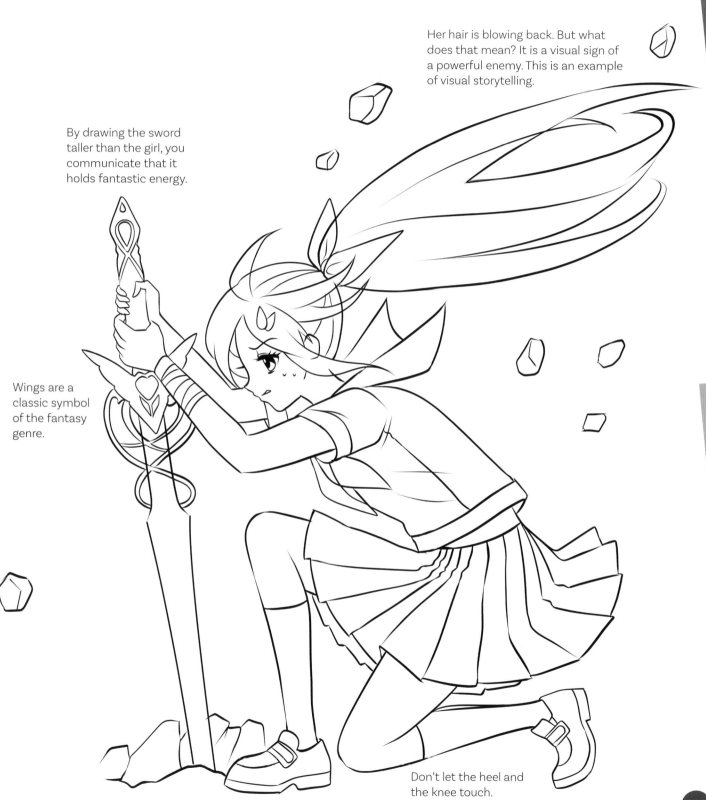

Her hair is blowing back. But what does that mean? It is a visual sign of a powerful enemy. This is an example of visual storytelling.

By drawing the sword taller than the girl, you communicate that it holds fantastic energy.

Wings are a classic symbol of the fantasy genre.

Don't let the heel and the knee touch.

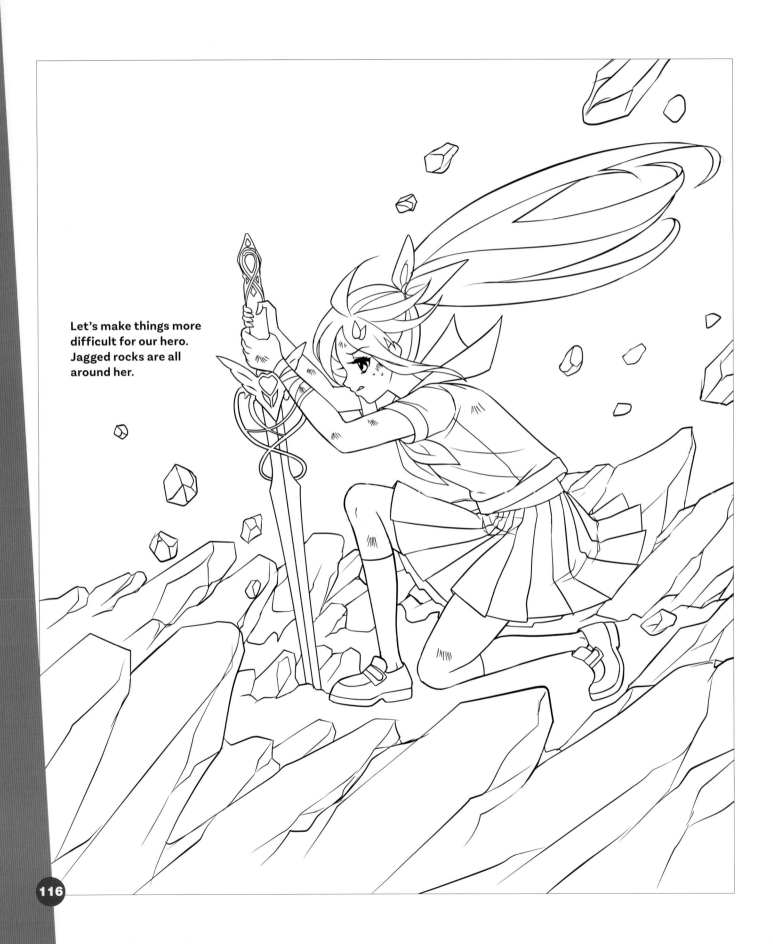

Let's make things more difficult for our hero. Jagged rocks are all around her.

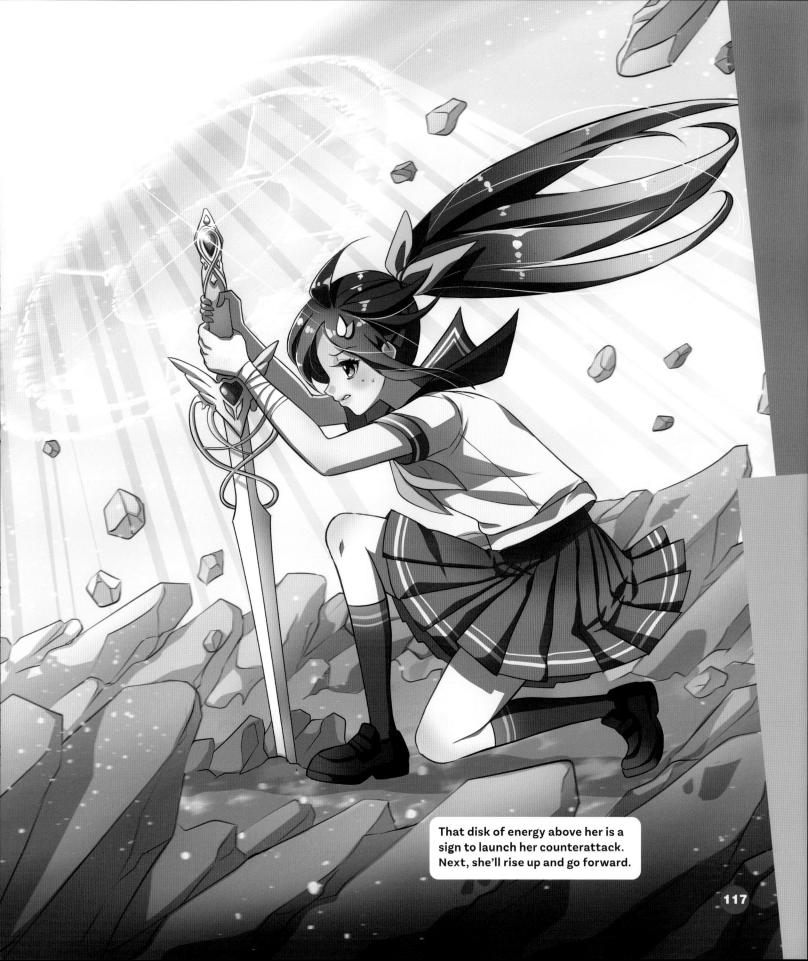

That disk of energy above her is a sign to launch her counterattack. Next, she'll rise up and go forward.

117

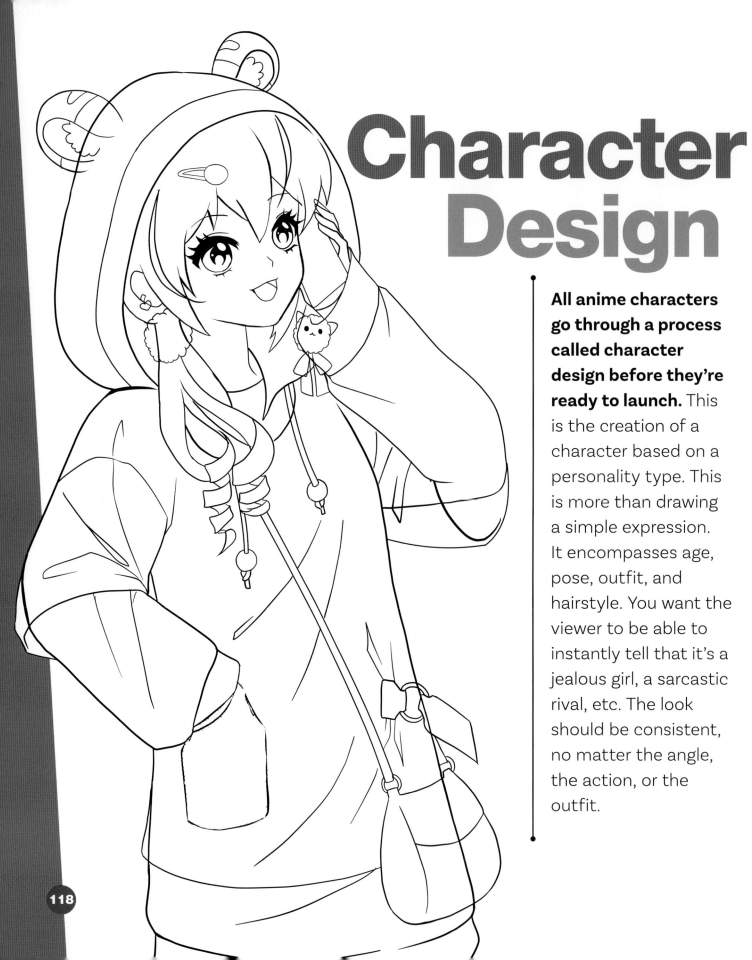

Character Design

All anime characters go through a process called character design before they're ready to launch. This is the creation of a character based on a personality type. This is more than drawing a simple expression. It encompasses age, pose, outfit, and hairstyle. You want the viewer to be able to instantly tell that it's a jealous girl, a sarcastic rival, etc. The look should be consistent, no matter the angle, the action, or the outfit.

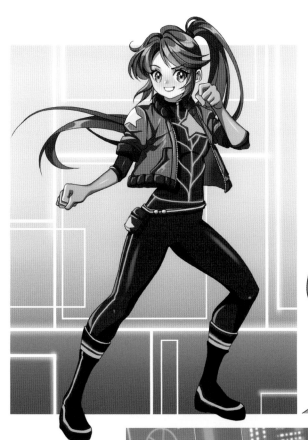

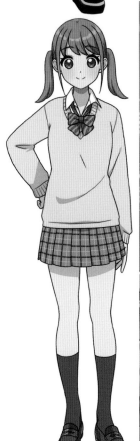

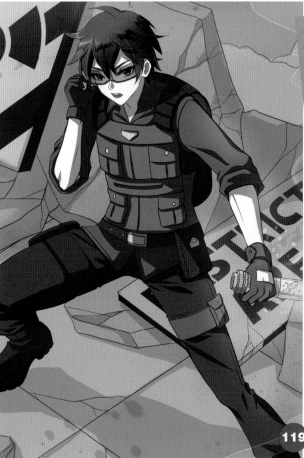

Your Character: A 360 and Beyond

In the first chapter, Getting Started, we learned how to turn the head at different angles while retaining a consistent look. But the body has personality, too. So, we're going to put it all together and try a few simple turnarounds of the entire figure—with an adorable anime creature who exudes personality.

FRONT VIEW

The body is as cute as the head. Everything is symmetrical in a front view—the left side of the face and body is the same as the right side.

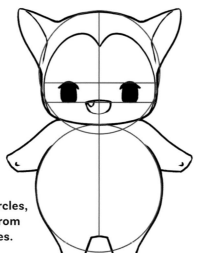
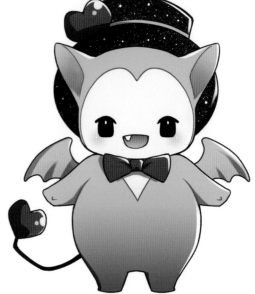

This little guy is based on two circles, as you can see from the red guidelines.

¾ VIEW

By turning our little guy to the right, the centerline (the red line running down the middle of the figure) shifts to the right, so the guideline now curves and indicates plumpness.

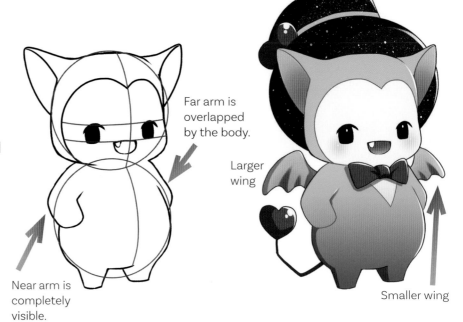

Far arm is overlapped by the body.

Larger wing

Near arm is completely visible.

Smaller wing

SIDE VIEW

We started with a front angle, which is a flat view (doesn't show depth). Next, we turned to a ¾ view, which does show depth. Continuing to turn our little friend, we end up in a side view, which, once again, is a flat look, but pleasing in its simplicity.

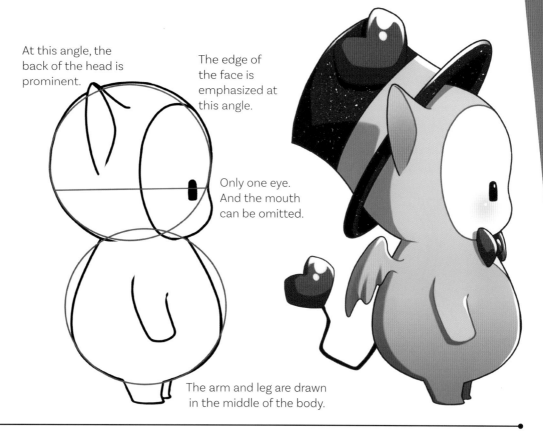

At this angle, the back of the head is prominent.

The edge of the face is emphasized at this angle.

Only one eye. And the mouth can be omitted.

The arm and leg are drawn in the middle of the body.

BACK VIEW

This view stresses posture, because so much is hidden that the posture becomes a more important element by default. This character has a funny posture in that he's leaning forward. This is also a symmetrical pose.

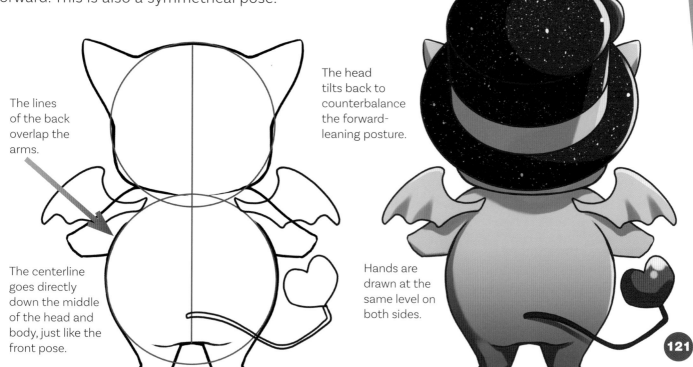

The lines of the back overlap the arms.

The centerline goes directly down the middle of the head and body, just like the front pose.

The head tilts back to counterbalance the forward-leaning posture.

Hands are drawn at the same level on both sides.

121

UNUSUAL ANGLES

Unique angles focus on the character from the viewer's vantage point. In these examples, the viewer is looking *up* at the character in one drawing, and *down* in the other. In both cases, you'll use the technique of *overlapping* to make the poses work.

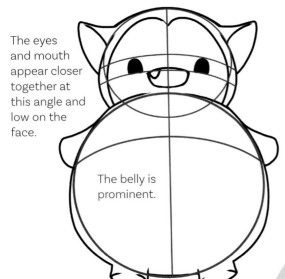

The eyes and mouth appear closer together at this angle and low on the face.

The belly is prominent.

You can see the underside of the feet at this angle.

Here, the viewer is looking up at the character. The body overlaps the bottom of the face, and the head overlaps the hat.

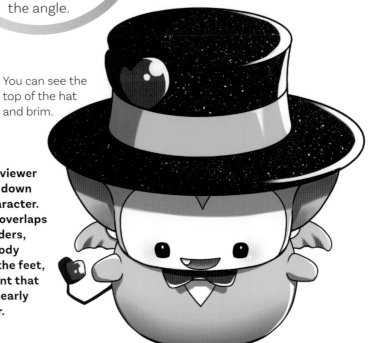

The arms and legs appear reduced in size.

KEY
Your character may be different from this one, but the same concepts apply to a greater or lesser degree based on body type and severity of the angle.

The body is smaller in relation to the head.

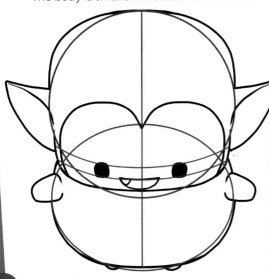

You can see the top of the hat and brim.

Here, the viewer is looking down at the character. The head overlaps the shoulders, and the body overlaps the feet, to the point that the feet nearly disappear.

Choosing Your Character's Age

Have you ever had difficulty defining the age of a character? Just a few years can make a big difference, like a twelve-year-old versus a seventeen-year-old. Changing hairstyles and clothes may not be enough. But once you know the technique, it's easy. It's not about the details, it's about the proportions. Let's take a look.

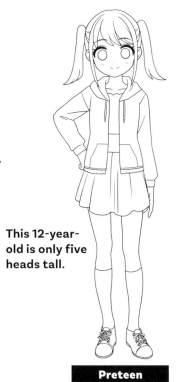

This 12-year-old is only five heads tall.

Preteen

Nice but simple hairdo—not elaborate

Big eyes that take up a larger proportion of the face

The torso is somewhat undersized.

Small hands and feet

There are subtle differences that cue the audience that this is a young character, a preteen.

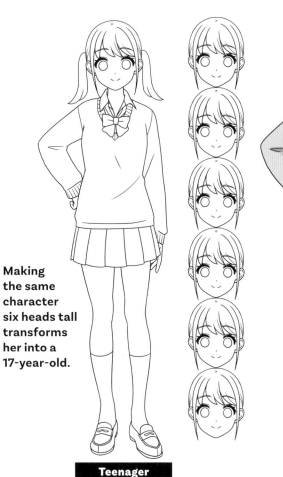

Making the same character six heads tall transforms her into a 17-year-old.

Teenager

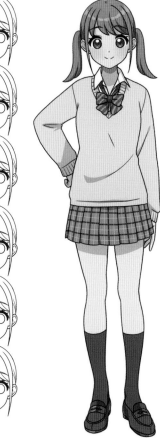

Age shows with different proportions, such as longer arms and legs, wider hips and shoulders, and the outfits worn. In other words, an older character is different from the younger one, not just an older version of it.

123

Choosing a Personality

A personality is what an audience remembers about a character. A personality may have various aspects, but one should stand out. If you need three sentences to describe your character, it may be too complex. Characters with clearly defined personalities help drive a story forward. And it's the personality profile that helps an artist, like yourself, figure out how to draw it.

KEY
Characters should have a core personality trait. When you draw your character with a different expression, it's temporary; eventually, a character returns to their basic nature. That maintains the integrity of the character.

THE NICE GUY

Nice guys finish first—at least sometimes. They add an engaging, honest quality to a cast of characters.

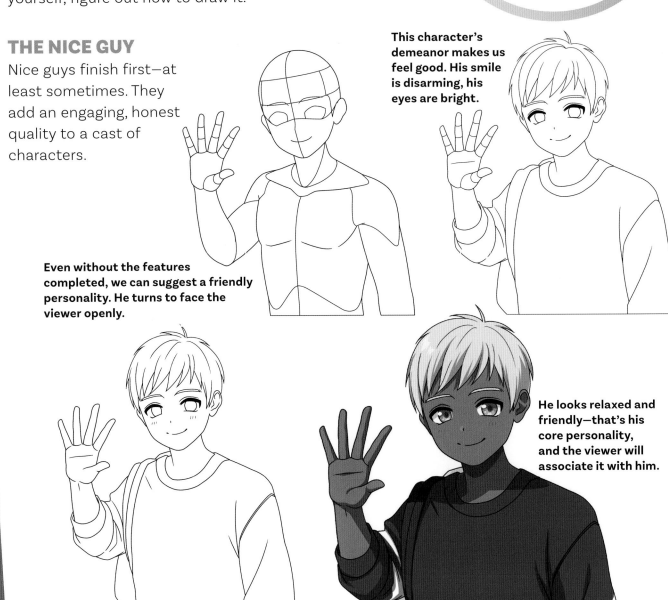

This character's demeanor makes us feel good. His smile is disarming, his eyes are bright.

Even without the features completed, we can suggest a friendly personality. He turns to face the viewer openly.

He looks relaxed and friendly—that's his core personality, and the viewer will associate it with him.

His expression isn't complicated. He isn't hiding anything.

STRESSED GUY

Here, we give our character an anxious personality.

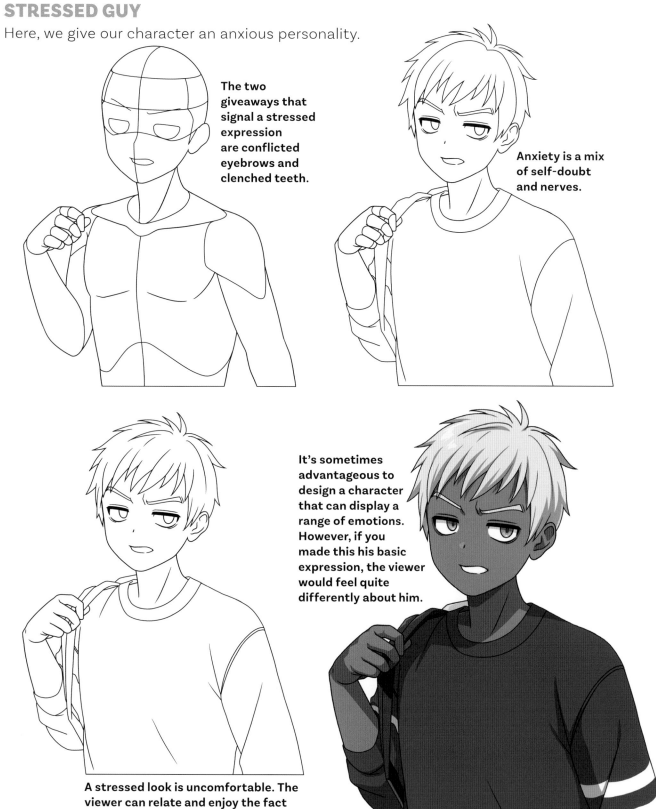

The two giveaways that signal a stressed expression are conflicted eyebrows and clenched teeth.

Anxiety is a mix of self-doubt and nerves.

It's sometimes advantageous to design a character that can display a range of emotions. However, if you made this his basic expression, the viewer would feel quite differently about him.

A stressed look is uncomfortable. The viewer can relate and enjoy the fact that it isn't happening to them!

Signature Poses

The way a character stands says a lot about who they are. That gives you another tool for designing characters. You can also bring in gestures to make your drawings much more entertaining and effective. We'll start with a couple of humorous character types and see how their poses define who they are.

PRIMA DONNA

What do you think of when you think of a prima donna? Someone with a high opinion of herself? She should look demanding. Her pose should demonstrate that she expects the spotlight to always be pointed at her.

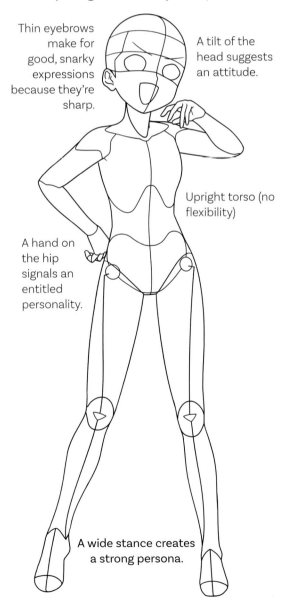

Thin eyebrows make for good, snarky expressions because they're sharp.

A tilt of the head suggests an attitude.

Upright torso (no flexibility)

A hand on the hip signals an entitled personality.

A wide stance creates a strong persona.

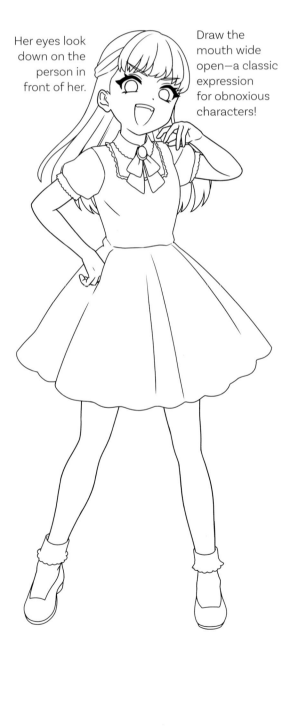

Her eyes look down on the person in front of her.

Draw the mouth wide open—a classic expression for obnoxious characters!

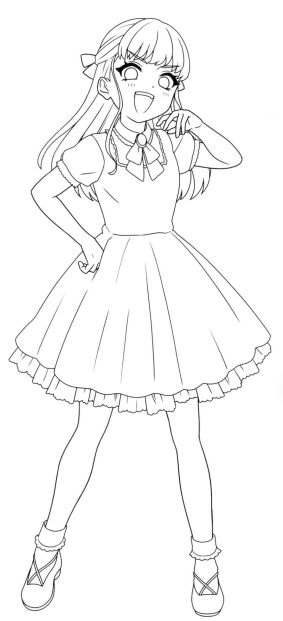

A neat and frilly outfit usually denotes a nice person. And that's why it's funny—because she isn't one!

Her personality is revved up. Looks like she has a chance to get even with someone!

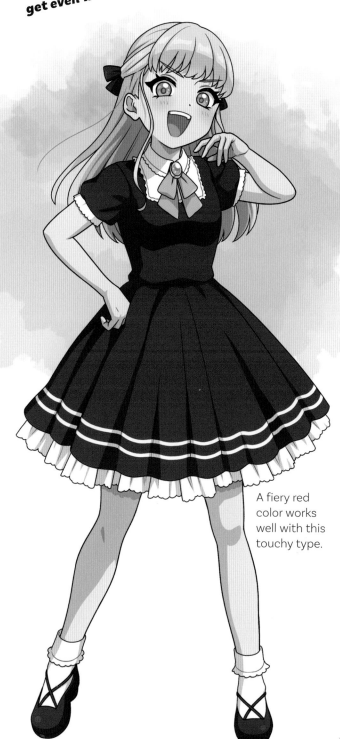

A fiery red color works well with this touchy type.

CLUELESS TEEN

Sometimes a character's personality may not suggest a clear pose. In such a case, a spontaneous pose might also work. If your character is a little confused, you could decide to follow that lead and draw a pose that also looks confused and without a clear thrust.

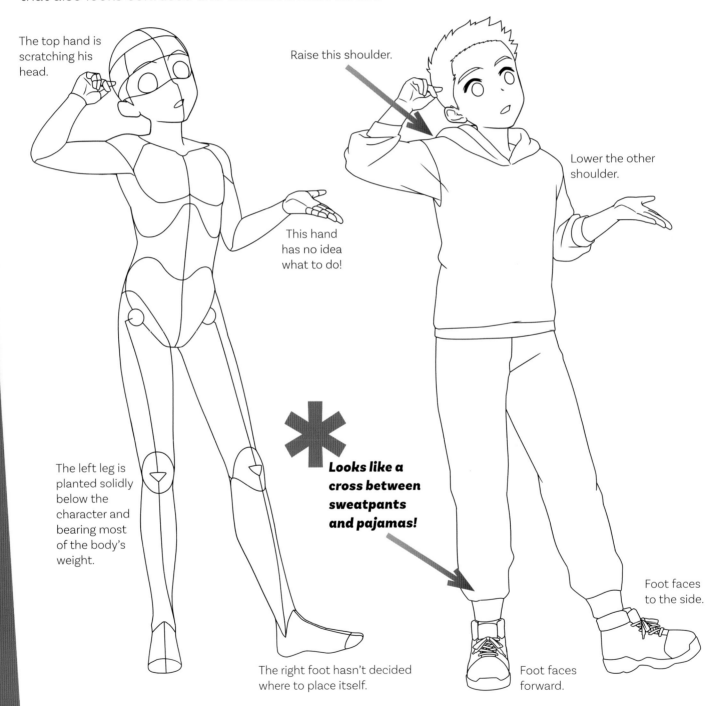

The top hand is scratching his head.

Raise this shoulder.

Lower the other shoulder.

This hand has no idea what to do!

The left leg is planted solidly below the character and bearing most of the body's weight.

Looks like a cross between sweatpants and pajamas!

The right foot hasn't decided where to place itself.

Foot faces to the side.

Foot faces forward.

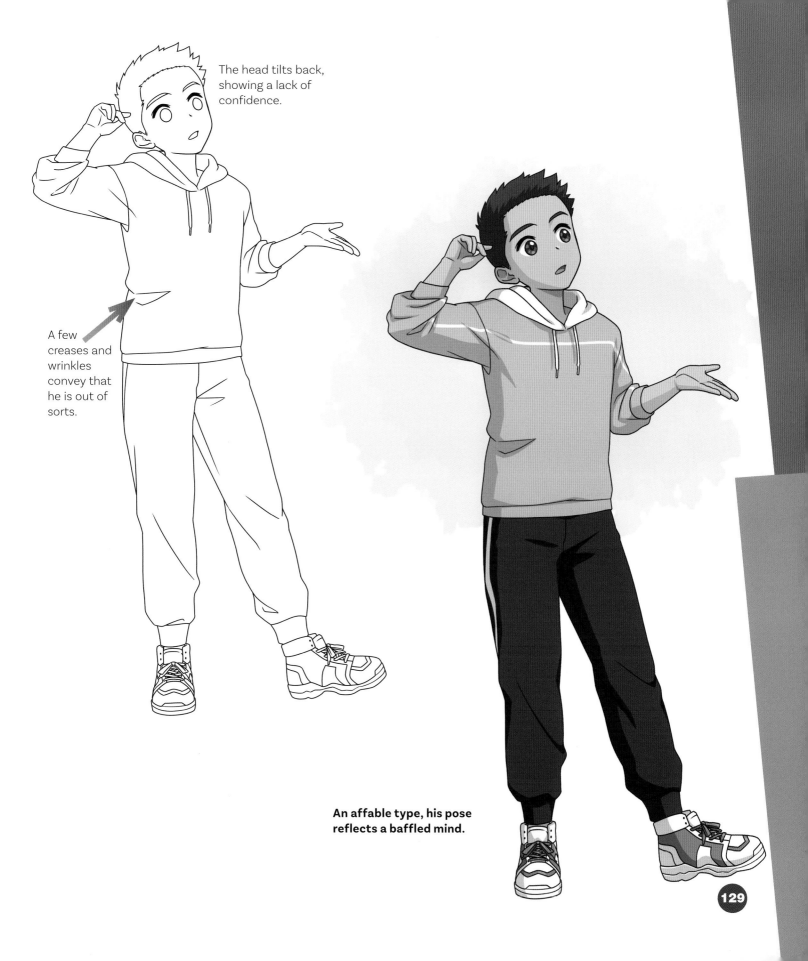

The head tilts back, showing a lack of confidence.

A few creases and wrinkles convey that he is out of sorts.

An affable type, his pose reflects a baffled mind.

WHO IS SHE REALLY? (SECRET IDENTITIES)

Another popular trope is the character with a secret identity. She looks like just another student to her classmates, but she's actually undercover on a secret mission. A character with two identities requires two character designs. Let's draw a schoolgirl who is, in reality, an international spy.

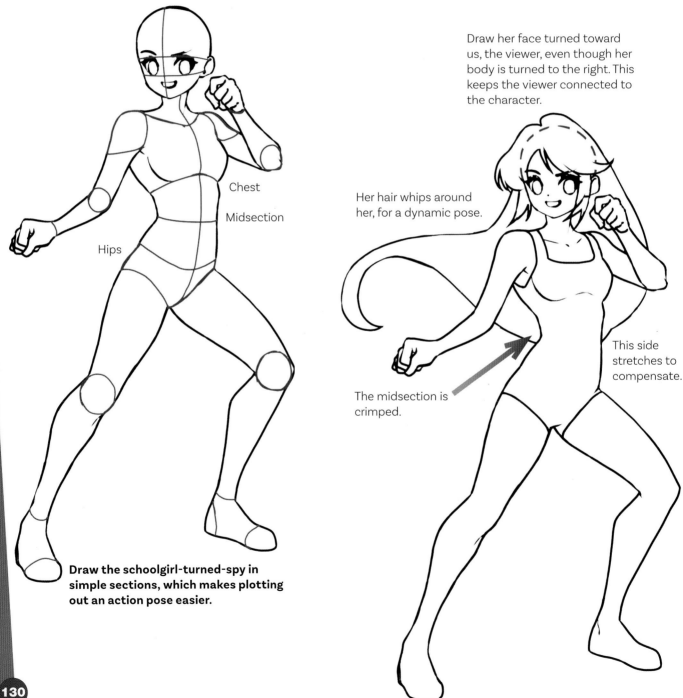

Chest

Midsection

Hips

Draw the schoolgirl-turned-spy in simple sections, which makes plotting out an action pose easier.

Draw her face turned toward us, the viewer, even though her body is turned to the right. This keeps the viewer connected to the character.

Her hair whips around her, for a dynamic pose.

The midsection is crimped.

This side stretches to compensate.

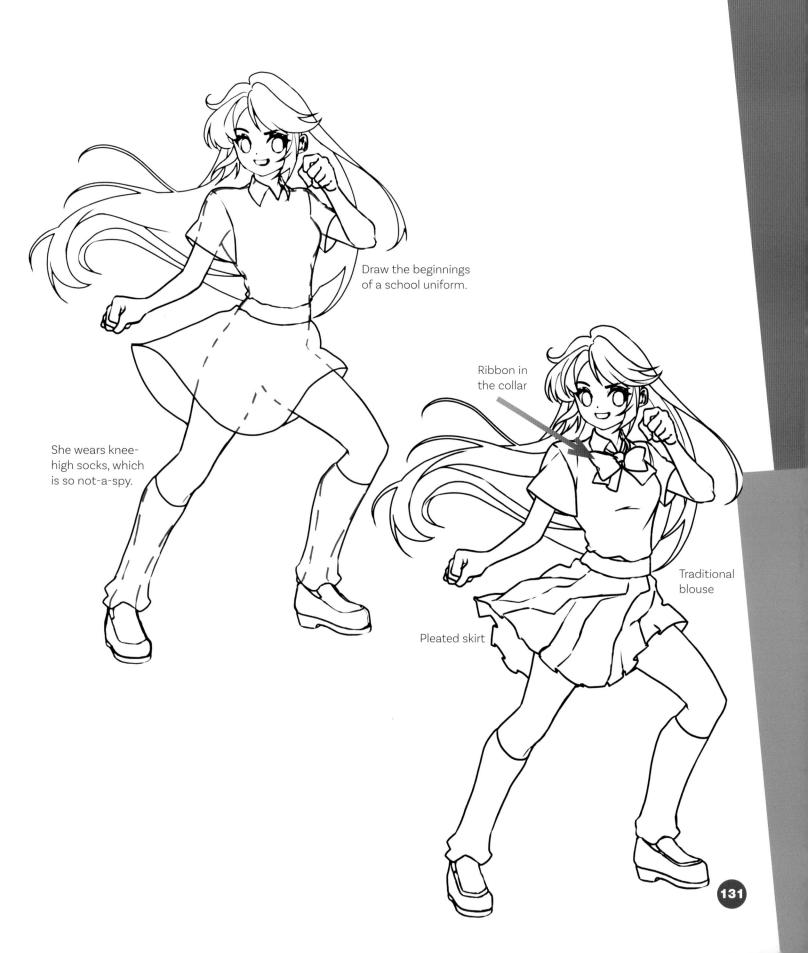

Draw the beginnings of a school uniform.

Ribbon in the collar

She wears knee-high socks, which is so not-a-spy.

Traditional blouse

Pleated skirt

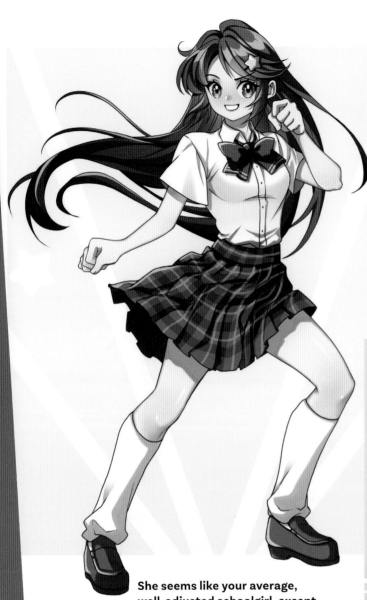

At some point in every double-identity story, someone will accidentally see the character in her true state. It can be funny listening to her try to explain it away: "I found this spy outfit at a consignment shop."

She seems like your average, well-adjusted schoolgirl, except that she's really 23 years old, speaks 40 languages, and knows how to start a car engine with a pair of tweezers.

Spy Accessories

Characters on a secret mission may need tools to help them evade danger. Be inventive in devising gadgets but keep them simple so they don't distract the viewer.

Very handy. It can do high-speed computing and calculate a tip at the same time.

It looks like a compact case, but it's actually a satellite tracking device.

Sunglasses that allow the wearer to view objects 100 miles away

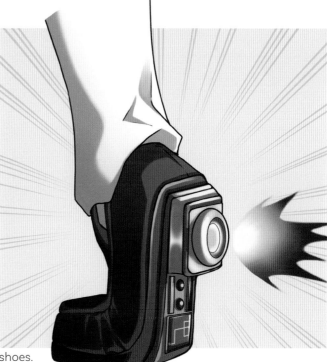

Not ordinary shoes. These can blast our hero over a traffic jam without paying a toll.

From Concept to Drawing

Many artists draw spontaneously, allowing their pencil to take them where it will. But to create a specific character type, start with a general idea about who the character is and what they're about. This is called a concept, and it gives your sketch purpose. It's like driving a car with directions versus without. Let's give it a try.

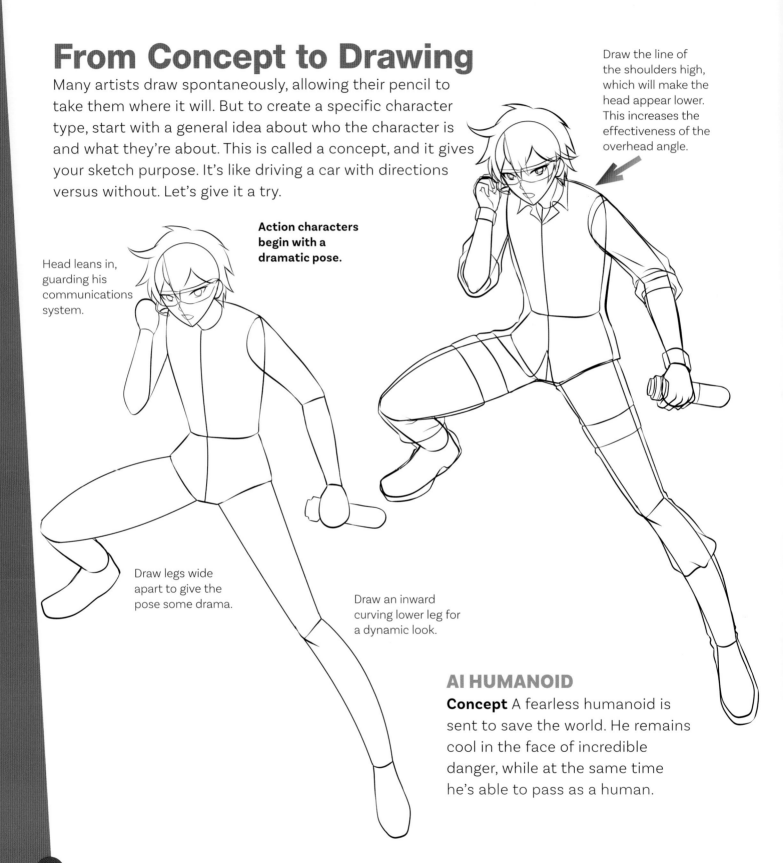

Head leans in, guarding his communications system.

Action characters begin with a dramatic pose.

Draw the line of the shoulders high, which will make the head appear lower. This increases the effectiveness of the overhead angle.

Draw legs wide apart to give the pose some drama.

Draw an inward curving lower leg for a dynamic look.

AI HUMANOID

Concept A fearless humanoid is sent to save the world. He remains cool in the face of incredible danger, while at the same time he's able to pass as a human.

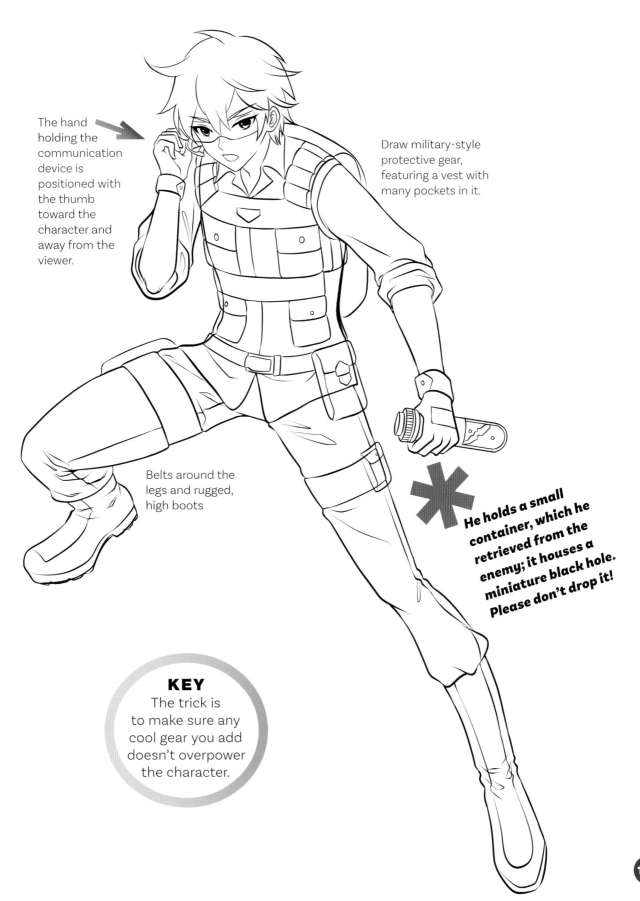

The hand holding the communication device is positioned with the thumb toward the character and away from the viewer.

Draw military-style protective gear, featuring a vest with many pockets in it.

Belts around the legs and rugged, high boots

He holds a small container, which he retrieved from the enemy; it houses a miniature black hole. Please don't drop it!

KEY
The trick is to make sure any cool gear you add doesn't overpower the character.

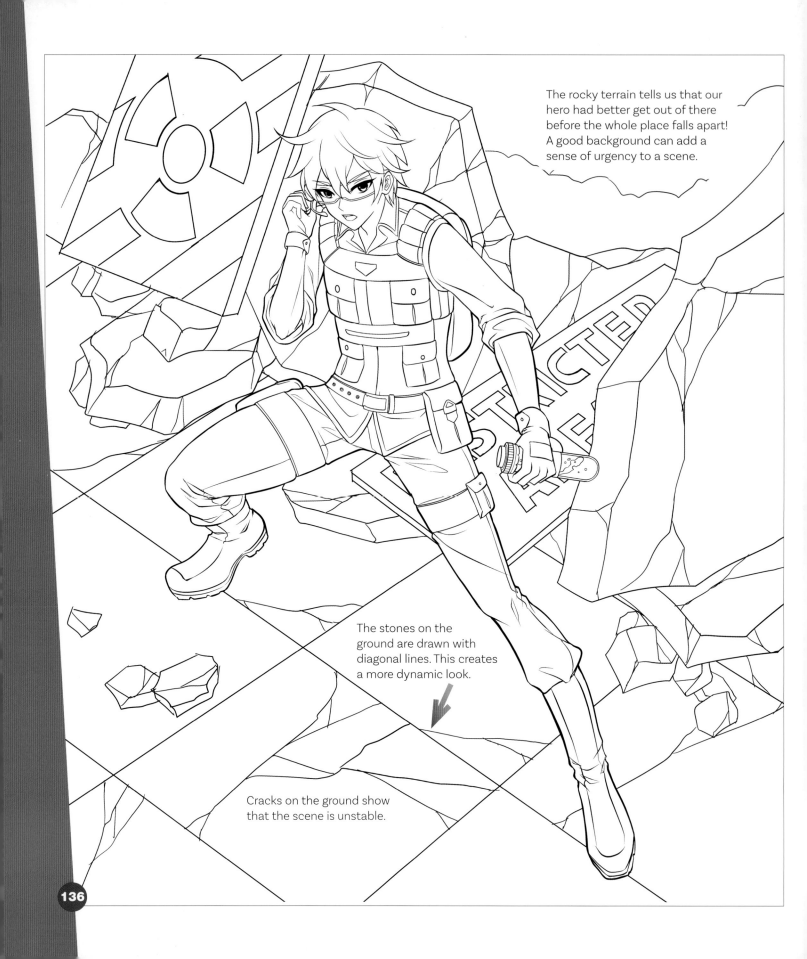

The rocky terrain tells us that our hero had better get out of there before the whole place falls apart! A good background can add a sense of urgency to a scene.

The stones on the ground are drawn with diagonal lines. This creates a more dynamic look.

Cracks on the ground show that the scene is unstable.

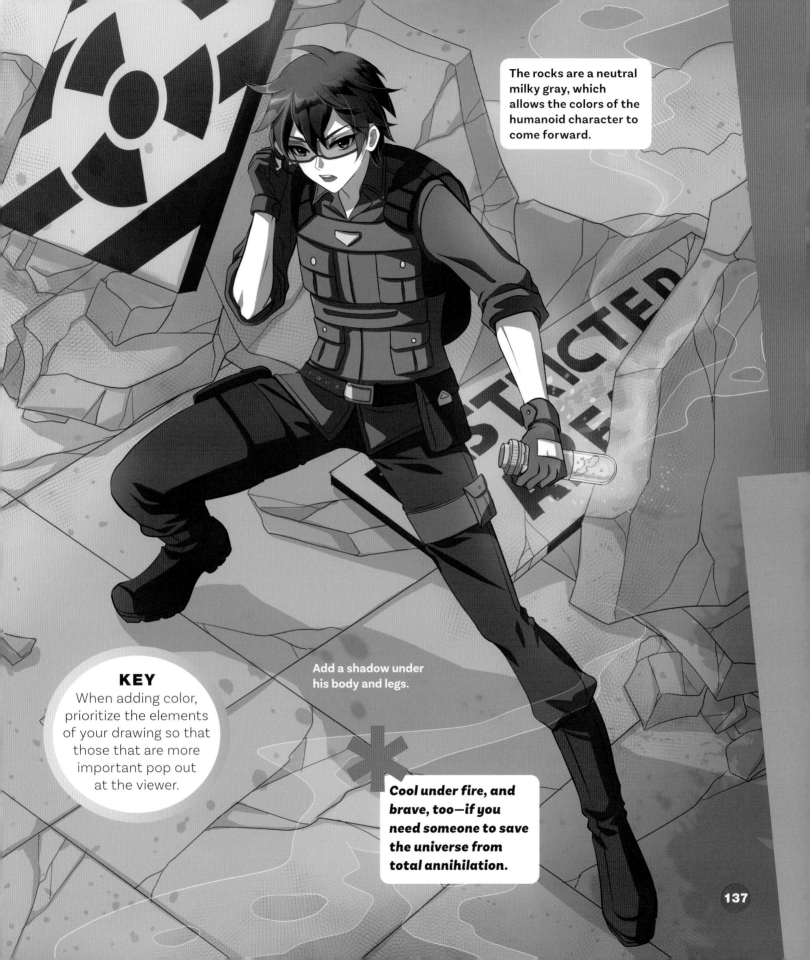

The rocks are a neutral milky gray, which allows the colors of the humanoid character to come forward.

KEY
When adding color, prioritize the elements of your drawing so that those that are more important pop out at the viewer.

Add a shadow under his body and legs.

Cool under fire, and brave, too—if you need someone to save the universe from total annihilation.

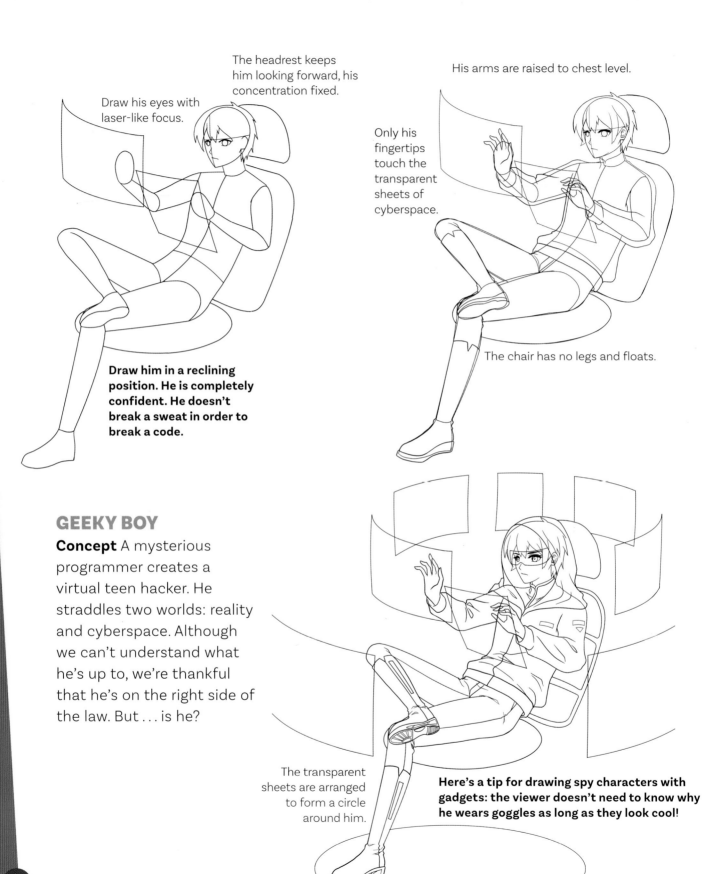

Draw his eyes with laser-like focus.

The headrest keeps him looking forward, his concentration fixed.

His arms are raised to chest level.

Only his fingertips touch the transparent sheets of cyberspace.

Draw him in a reclining position. He is completely confident. He doesn't break a sweat in order to break a code.

The chair has no legs and floats.

GEEKY BOY

Concept A mysterious programmer creates a virtual teen hacker. He straddles two worlds: reality and cyberspace. Although we can't understand what he's up to, we're thankful that he's on the right side of the law. But . . . is he?

The transparent sheets are arranged to form a circle around him.

Here's a tip for drawing spy characters with gadgets: the viewer doesn't need to know why he wears goggles as long as they look cool!

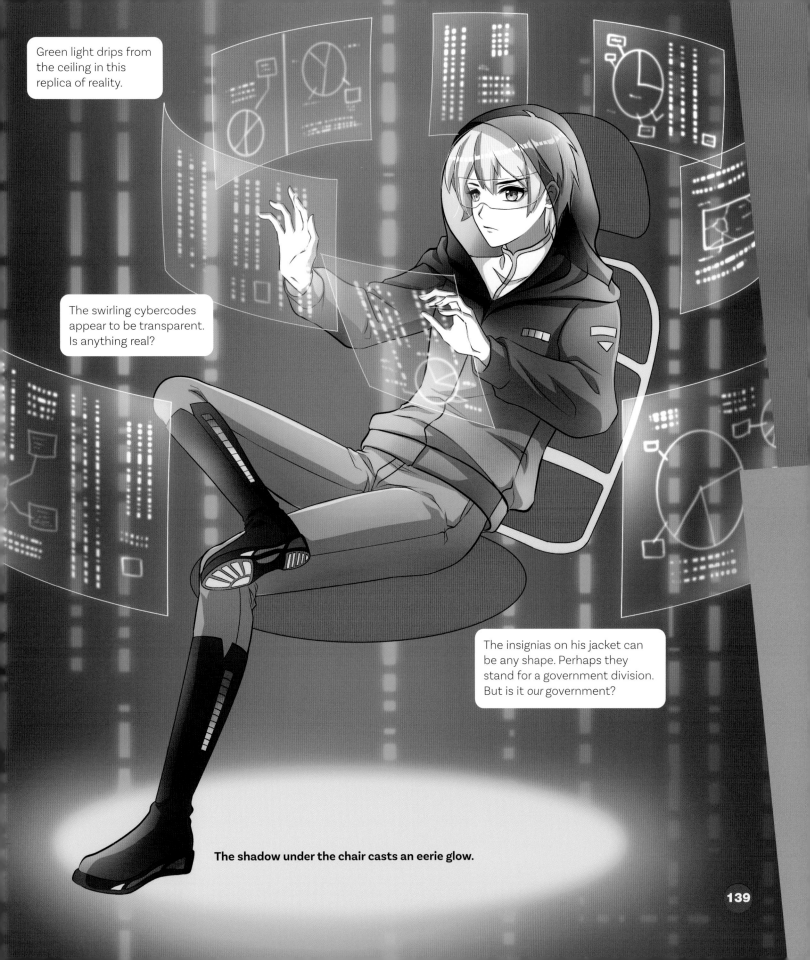

Green light drips from the ceiling in this replica of reality.

The swirling cybercodes appear to be transparent. Is anything real?

The insignias on his jacket can be any shape. Perhaps they stand for a government division. But is it *our* government?

The shadow under the chair casts an eerie glow.

SHE'S A LITTLE DIFFERENT

Concept Her mom's a vampire. Her dad's a zombie. And that cat by her feet? It's her little brother. Spooky comedy genres are fun and feature creative concepts and character designs.

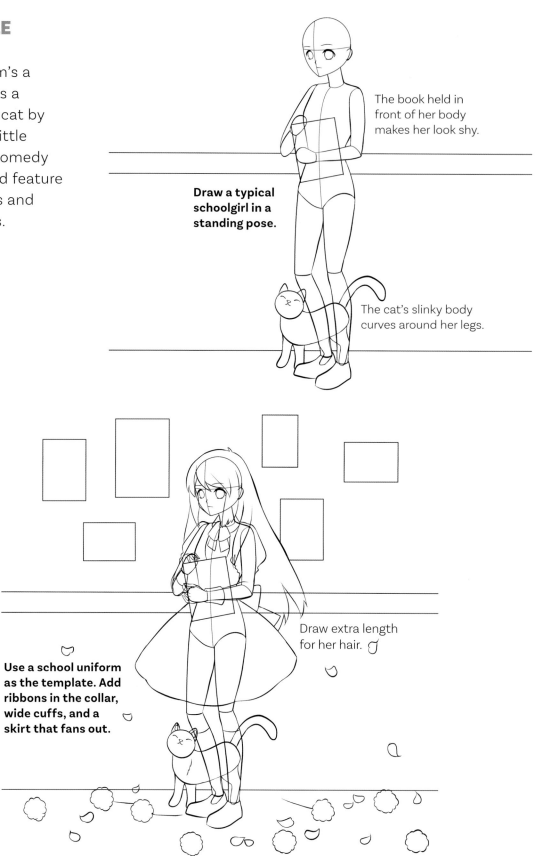

The book held in front of her body makes her look shy.

Draw a typical schoolgirl in a standing pose.

The cat's slinky body curves around her legs.

Use a school uniform as the template. Add ribbons in the collar, wide cuffs, and a skirt that fans out.

Draw extra length for her hair.

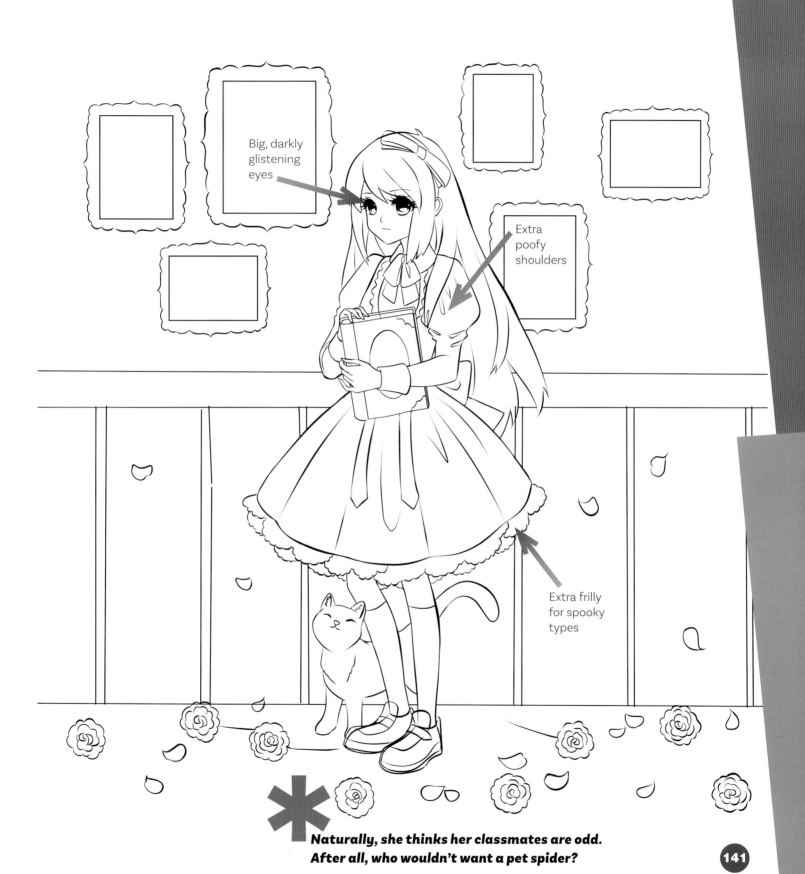

Big, darkly
glistening
eyes

Extra
poofy
shoulders

Extra frilly
for spooky
types

*Naturally, she thinks her classmates are odd.
After all, who wouldn't want a pet spider?*

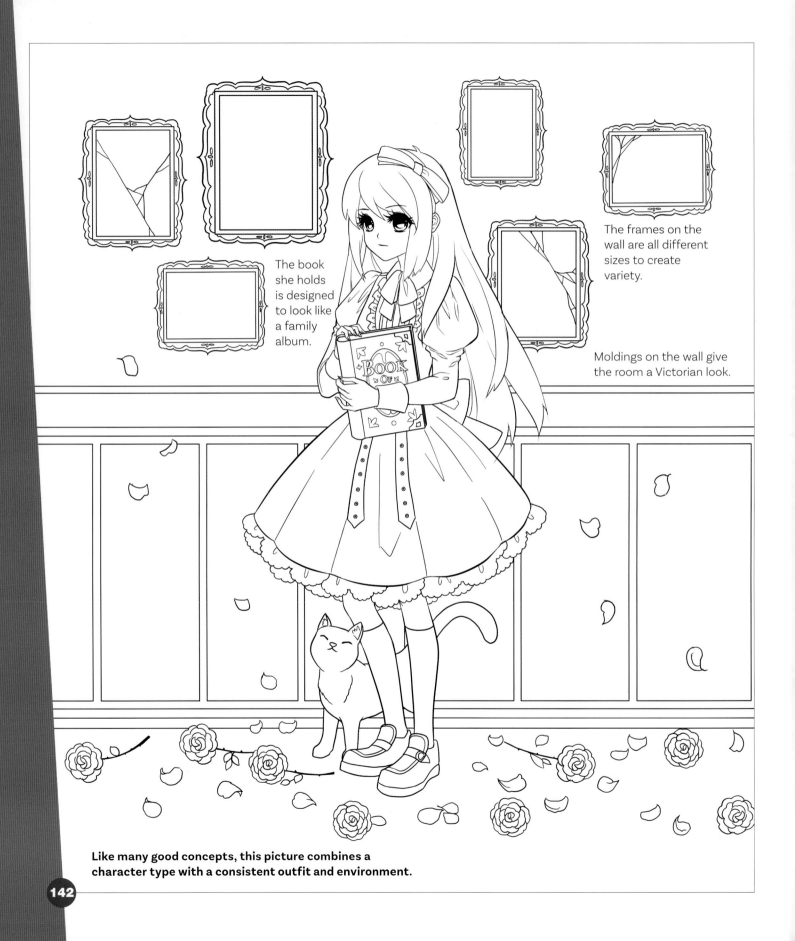

The book she holds is designed to look like a family album.

The frames on the wall are all different sizes to create variety.

Moldings on the wall give the room a Victorian look.

BOOK OF

Like many good concepts, this picture combines a character type with a consistent outfit and environment.

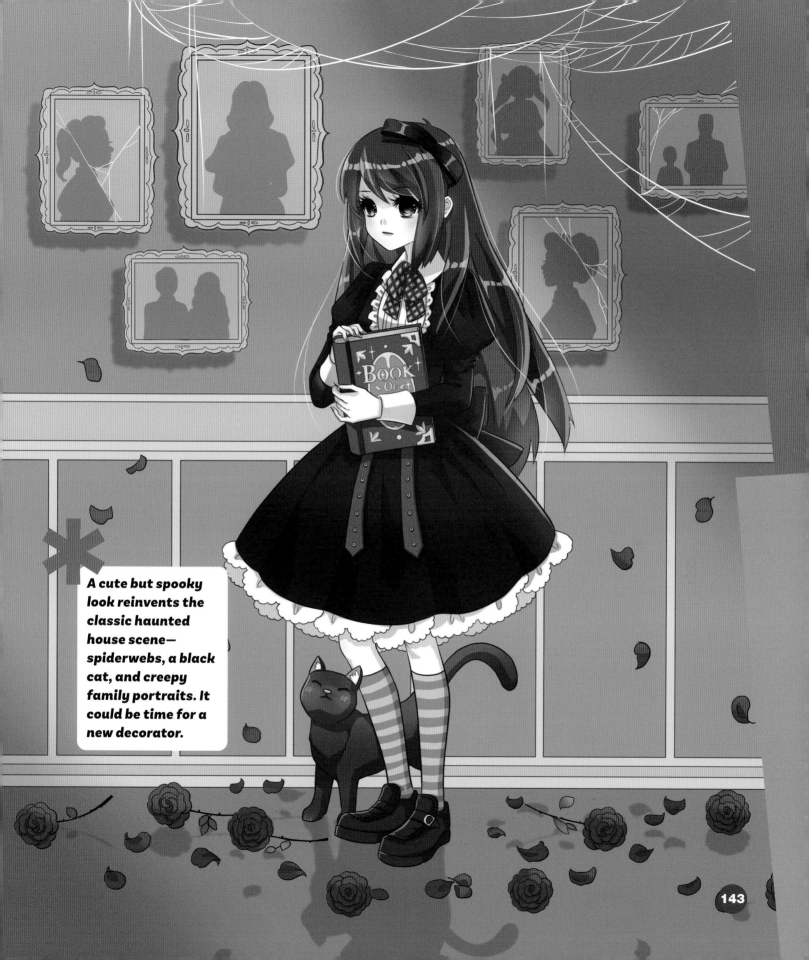

A cute but spooky look reinvents the classic haunted house scene—spiderwebs, a black cat, and creepy family portraits. It could be time for a new decorator.

ENCHANTED BOY

Concept A teenager appears out of nowhere, offering to help. You could use a friend at a time like this. But is he good, mischievous, or bad? Should you trust him? We'll find out!

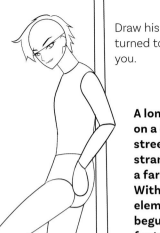

Draw his head turned toward you.

A lonely lamppost on a desolate street and a strange boy from a faraway place. With just three elements, you've begun to create a fantastical scene.

The upper foot is flush against the lamppost.

The lower foot props up the body.

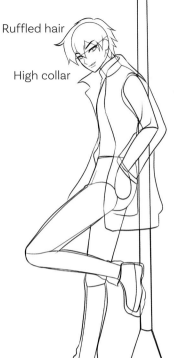

Ruffled hair

High collar

The long jacket conceals some of the figure, adding to the mysterious quality.

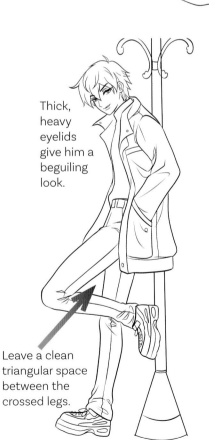

Thick, heavy eyelids give him a beguiling look.

Leave a clean triangular space between the crossed legs.

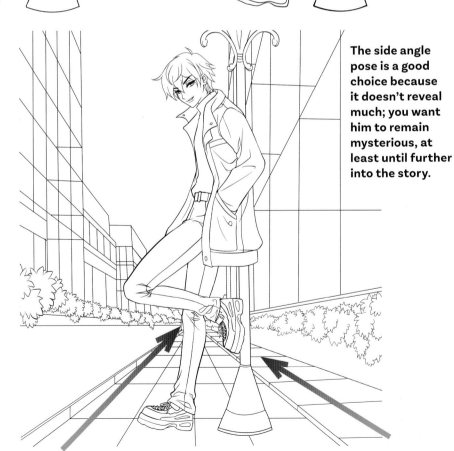

The side angle pose is a good choice because it doesn't reveal much; you want him to remain mysterious, at least until further into the story.

The lines of the sidewalk, as well as the buildings, converge toward the horizon, which creates the look of simple perspective.

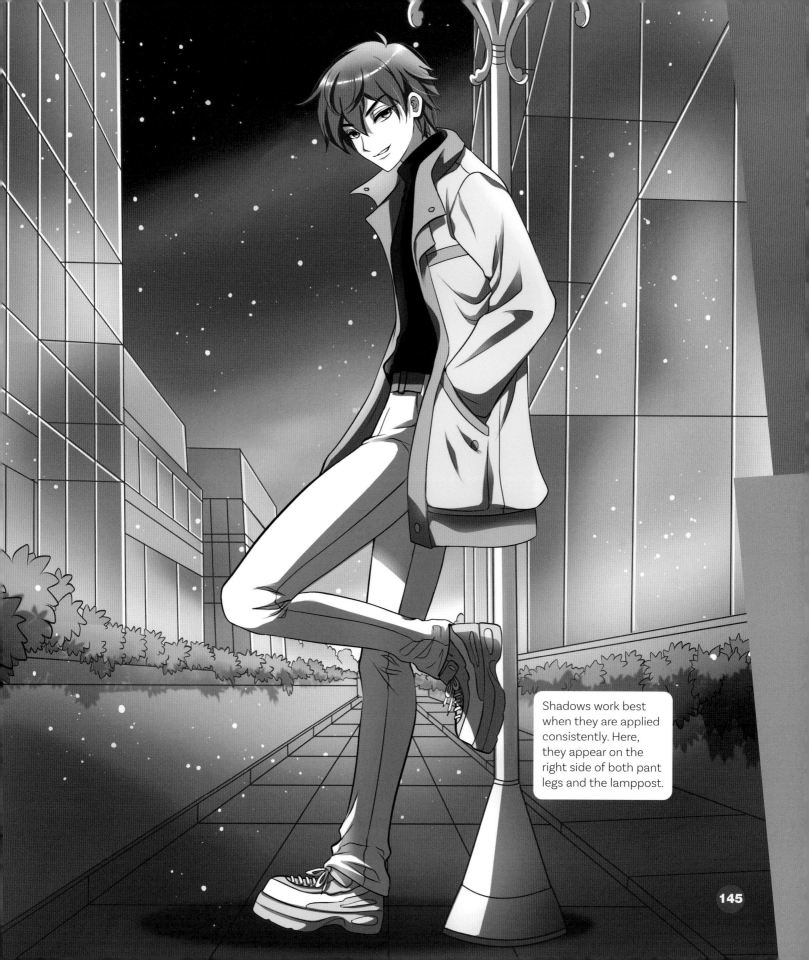

Shadows work best when they are applied consistently. Here, they appear on the right side of both pant legs and the lamppost.

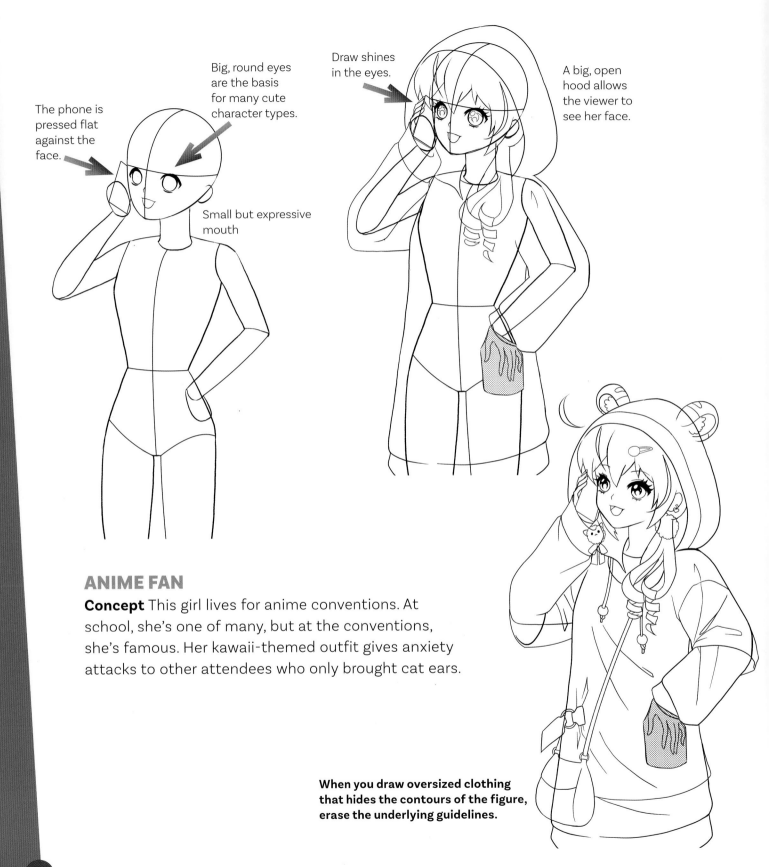

The phone is pressed flat against the face.

Big, round eyes are the basis for many cute character types.

Small but expressive mouth

Draw shines in the eyes.

A big, open hood allows the viewer to see her face.

ANIME FAN

Concept This girl lives for anime conventions. At school, she's one of many, but at the conventions, she's famous. Her kawaii-themed outfit gives anxiety attacks to other attendees who only brought cat ears.

When you draw oversized clothing that hides the contours of the figure, erase the underlying guidelines.

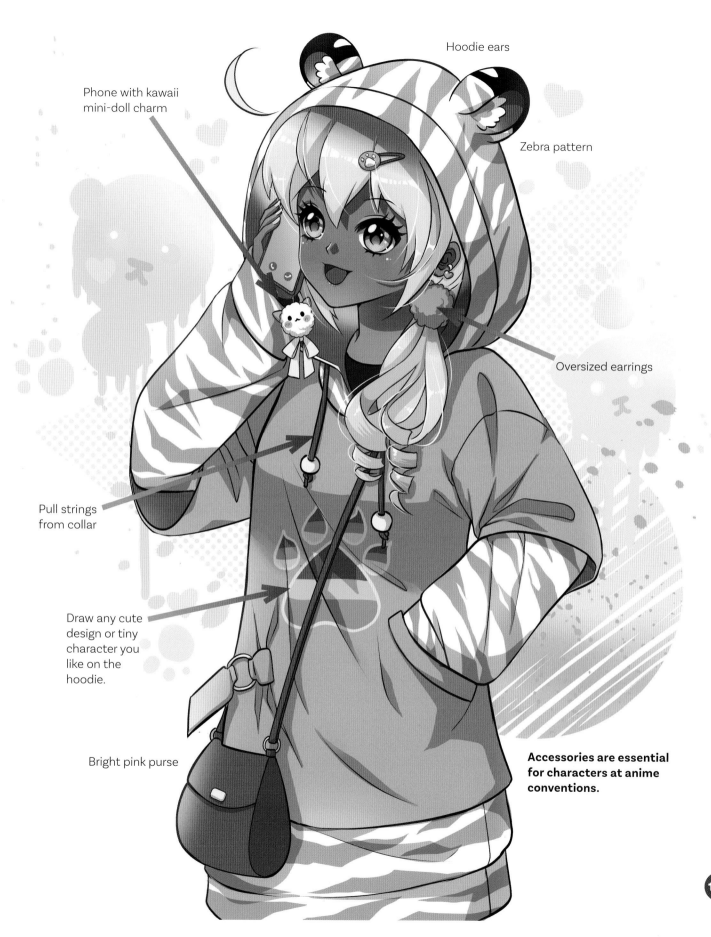

Phone with kawaii mini-doll charm

Hoodie ears

Zebra pattern

Oversized earrings

Pull strings from collar

Draw any cute design or tiny character you like on the hoodie.

Bright pink purse

Accessories are essential for characters at anime conventions.

EMOTIONAL GIRL

Concept We all know this type. She's empathetic and worries about others. But she's also painfully shy. Friends try to coax her out of her shell. Good luck.

She has big, round eyes.

She carries that schoolbook in front of her like a shield.

People stiffen up when they're worried. You can see it in her posture.

Droopy hair indicates an inhibited personality.

Hands pressed together in front read as "shy."

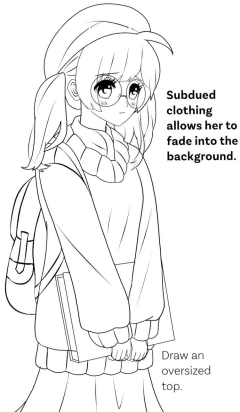

Subdued clothing allows her to fade into the background.

Draw an oversized top.

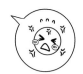

Draw graphic symbols encircling her as a way to show what she is feeling inside.

The shines in her eyes and hair show her inner spark.

This shy character hides under her oversized clothing.

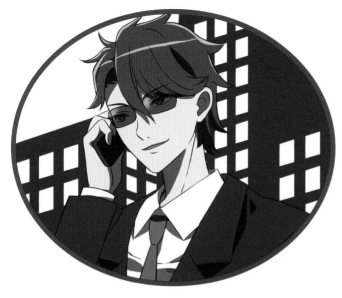

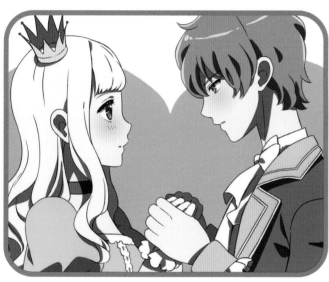

The 9 Must-Know Genres of Anime

Many artists specialize in one or more genres. You may find one in this chapter that inspires you.

Anime fans think in terms of genres. Therefore, by placing your work in the right genre, you can target viewers who may be predisposed to the material you're developing. This chapter is designed to introduce you to a selection of cool character types in today's most popular genres. Think of it as a visual template for creative ideas.

Cute Adventures

This genre features brave young heroes who embark on fantastical quests. Sometimes they bring cute mascots to protect them on their journey. Their stories may be set in a different time and place. They will need determination and a lot of luck to get past the dangers that lie ahead.

Features of this genre can include:

- Childlike characters and animals
- Fighting poses that are more funny than they are threatening
- Cute proportions: big heads with small bodies
- Lots of action
- Fantastical backgrounds

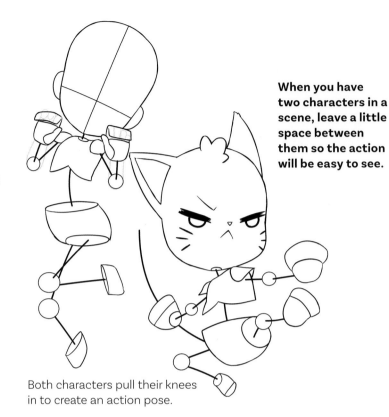

When you have two characters in a scene, leave a little space between them so the action will be easy to see.

Both characters pull their knees in to create an action pose.

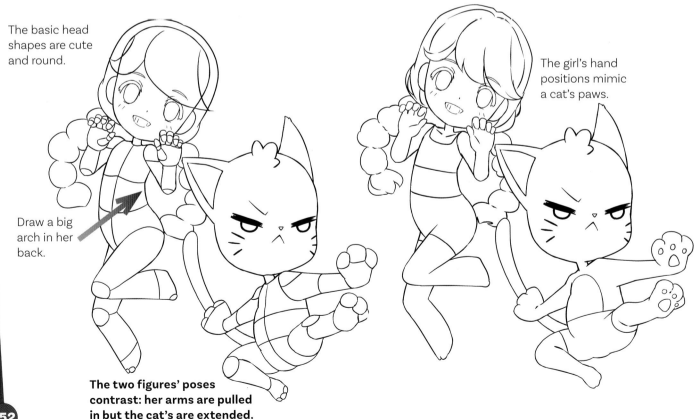

The basic head shapes are cute and round.

Draw a big arch in her back.

The two figures' poses contrast: her arms are pulled in but the cat's are extended.

The girl's hand positions mimic a cat's paws.

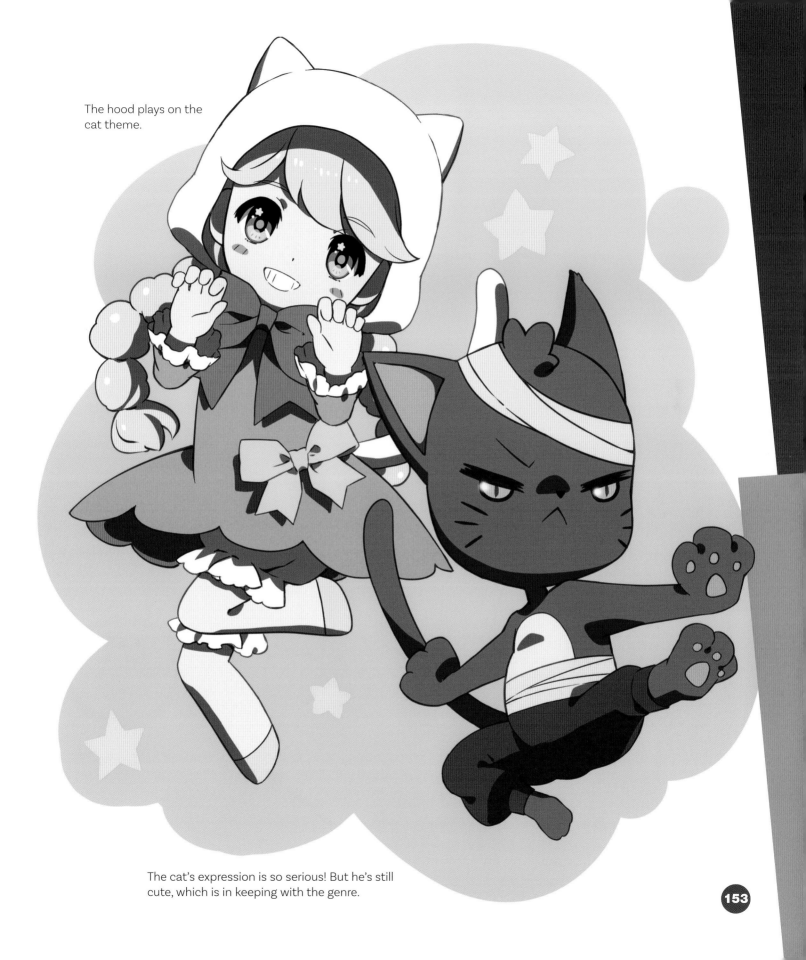

The hood plays on the cat theme.

The cat's expression is so serious! But he's still cute, which is in keeping with the genre.

Isekai

This is a very cool and inventive subgenre of fantasy. In it, characters are swept away to another world, which can be anything you want it to be, from an earth-like planet to a world made of illusions.

The outstretched arm is the most dramatic part of the pose because it's extended at a diagonal.

Notice the plotting of the layout. To keep it from being too busy, the top character strikes the dramatic pose, while the bottom one looks more stable. Drawing is artistic, but it's also strategic!

The male's front shoulder is turned forward, ready for battle.

Don't let her extended arm touch his raised arm. That would result in something called a tangent.

KEY
For more on tangents, see page 181.

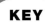

Her body is drawn at a diagonal, toward the left, while his is straight up and down. That contrast creates interest.

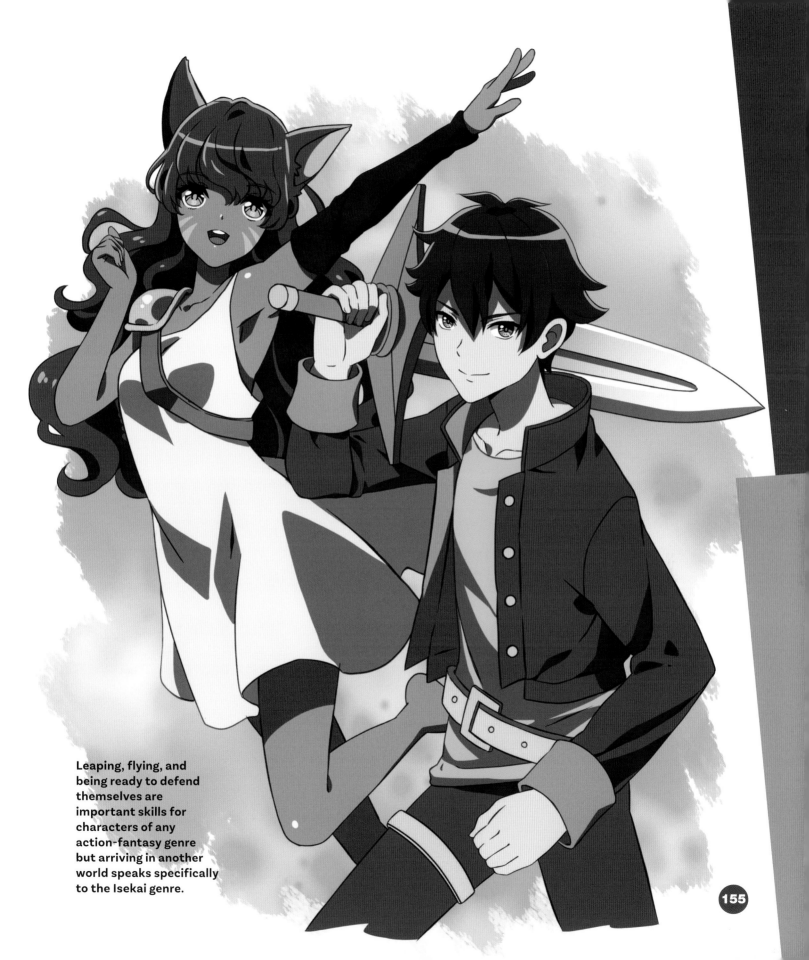

Leaping, flying, and being ready to defend themselves are important skills for characters of any action-fantasy genre but arriving in another world speaks specifically to the Isekai genre.

Slice of Life

This genre reminds us that there's magic in our everyday lives. It provides a fun alternative to other fast-moving genres of anime. Slice of Life explores relationships, with some good-natured humor.

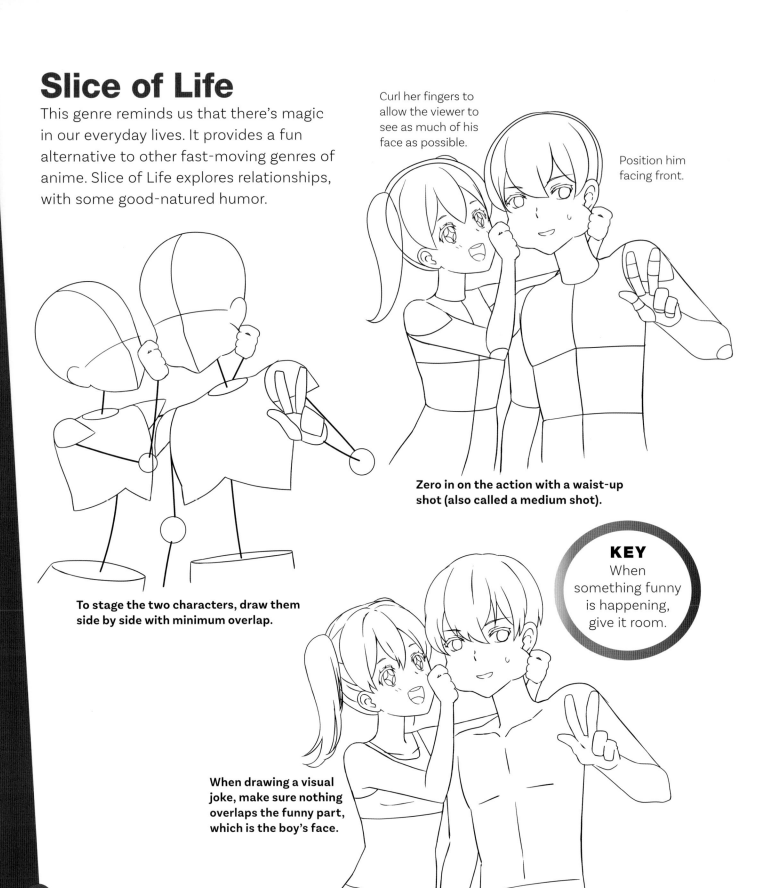

Curl her fingers to allow the viewer to see as much of his face as possible.

Position him facing front.

Zero in on the action with a waist-up shot (also called a medium shot).

To stage the two characters, draw them side by side with minimum overlap.

KEY
When something funny is happening, give it room.

When drawing a visual joke, make sure nothing overlaps the funny part, which is the boy's face.

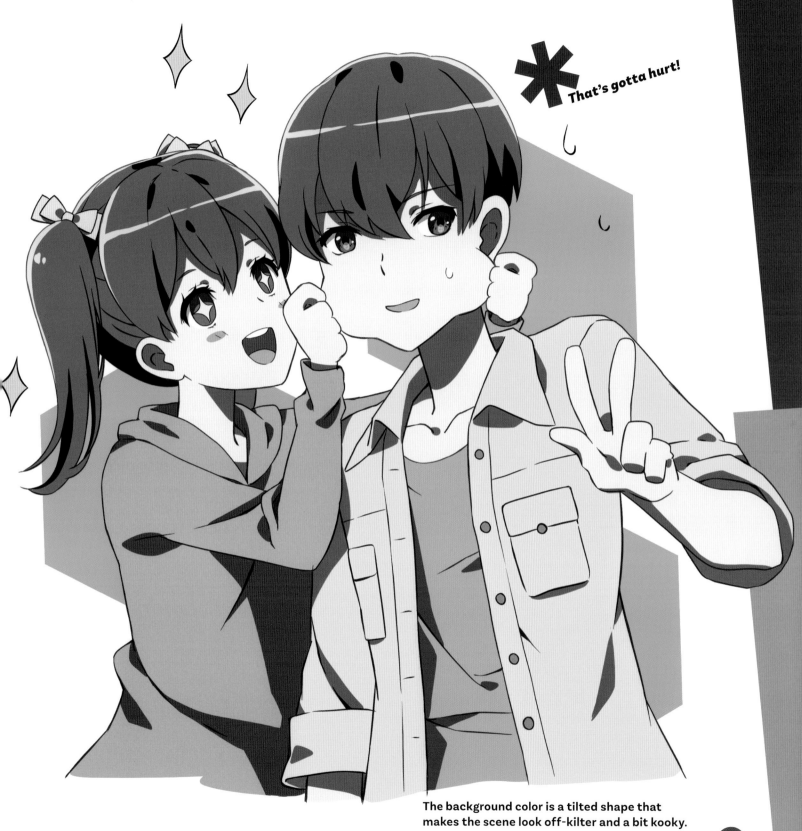

That's gotta hurt!

The background color is a tilted shape that makes the scene look off-kilter and a bit kooky.

Remarkable Journey

Only the most determined characters start out on an impossible quest. The path is filled with obstacles that must be overcome. Along the way, the hero may acquire some odd friends and encounter fierce enemies. Heroes on a quest often travel with companions—human or not.

The creature and teenager face front to give the viewer a clear look at them and establish an emotional connection.

The boy's stick-figure construction shows a lot of motion (the arms and legs coming at us dynamically). The creature does not, in order to avoid what artists refer to as "eye fatigue."

KEY
The creature's wings can't possibly carry his weight. However, it's more important that they match his cute personality.

Because of perspective, the foot and leg coming toward us are drawn to appear slightly larger than the back foot and leg.

Foreshortening is why the fist is enlarged while the arm behind it is compressed.

The teen's figure leans to the left in a long, curved line.

Draw the creature's far limbs, which are overlapped by his body.

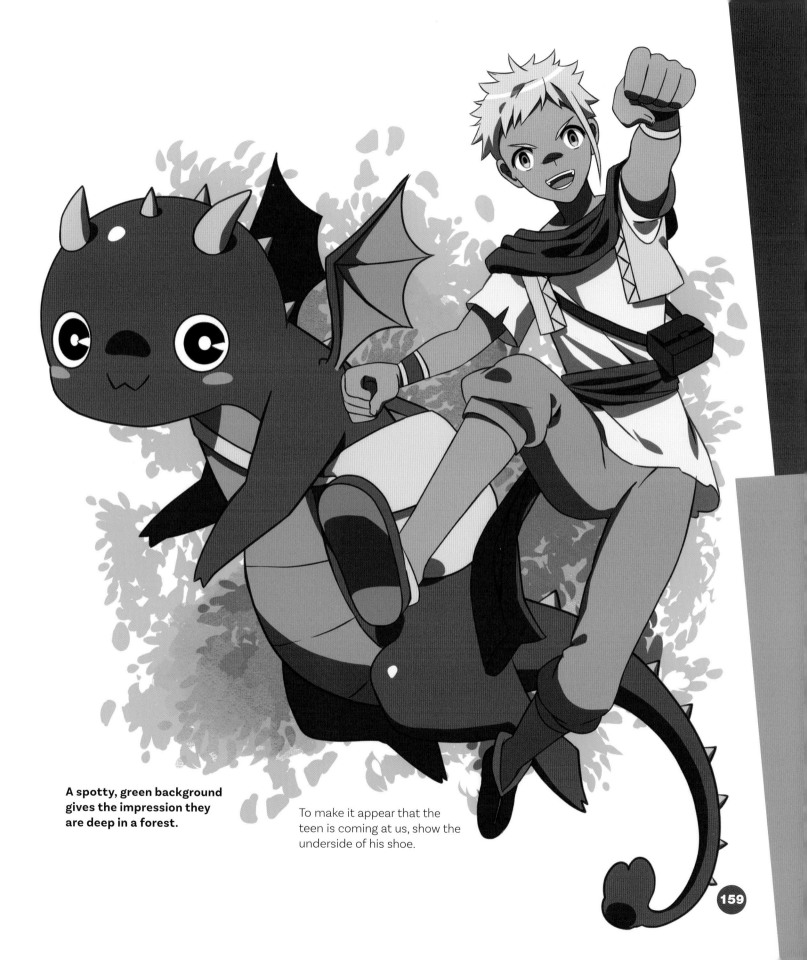

A spotty, green background gives the impression they are deep in a forest.

To make it appear that the teen is coming at us, show the underside of his shoe.

Paranormal

More than just horror, the paranormal genre features intriguing characters that stir the imagination. You'll have to keep your wits about you in this strange world, where nothing is what it seems and things can transform before your very eyes.

This is a symmetrical pose. Symmetrical poses look calm—but in this case, it's the calm before the storm. Draw her head first, then the hands in front of it for the correct placement.

Level the shoulders.

Bring the elbows close to each other and have each come to a point.

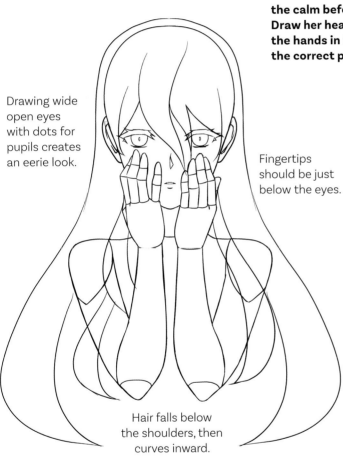

Drawing wide open eyes with dots for pupils creates an eerie look.

Fingertips should be just below the eyes.

Hair falls below the shoulders, then curves inward.

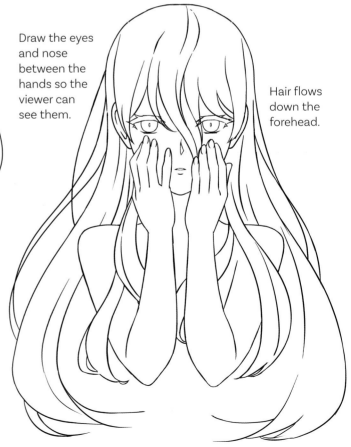

Draw the eyes and nose between the hands so the viewer can see them.

Hair flows down the forehead.

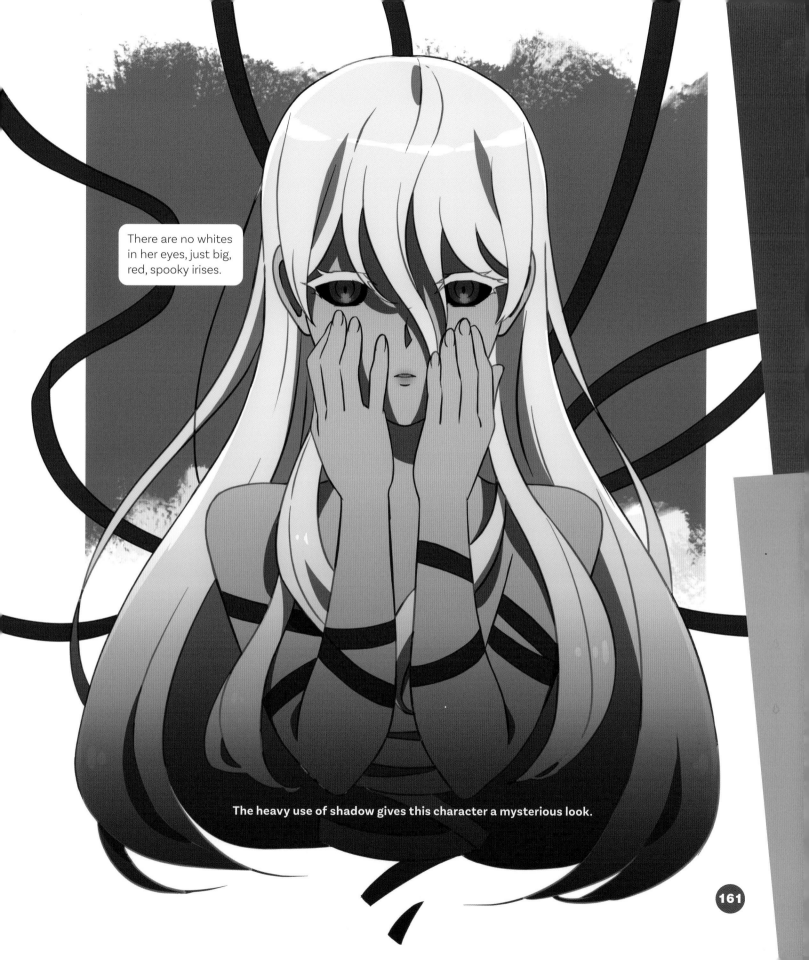

There are no whites in her eyes, just big, red, spooky irises.

The heavy use of shadow gives this character a mysterious look.

Magic & Fantasy

In a magical fantasy world, all things are possible, but only one choice is the correct one. The others lead to danger. That setup provides the suspense that keeps the audience engaged. In anime, magic is as much an attitude as it is a power. It's often possessed by cheerful, adventurous types.

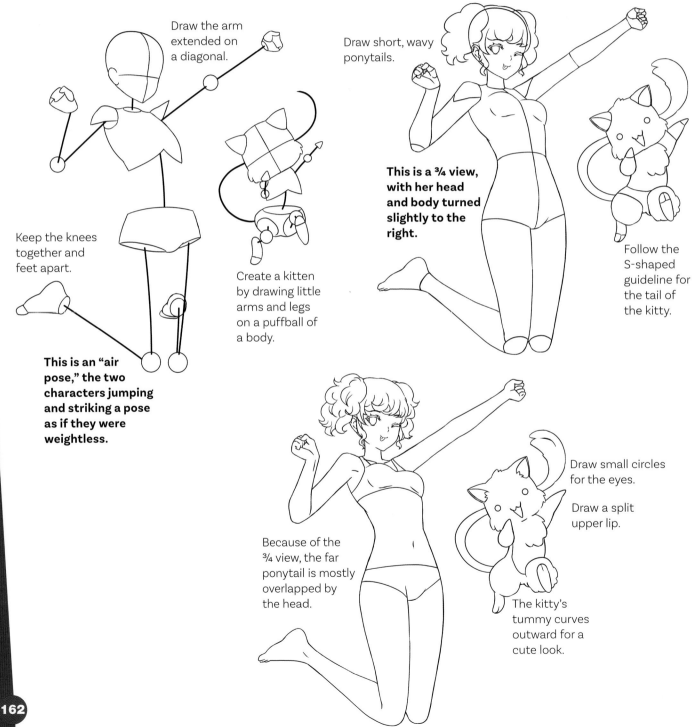

Draw the arm extended on a diagonal.

Draw short, wavy ponytails.

This is a ¾ view, with her head and body turned slightly to the right.

Follow the S-shaped guideline for the tail of the kitty.

Keep the knees together and feet apart.

Create a kitten by drawing little arms and legs on a puffball of a body.

This is an "air pose," the two characters jumping and striking a pose as if they were weightless.

Because of the ¾ view, the far ponytail is mostly overlapped by the head.

Draw small circles for the eyes.

Draw a split upper lip.

The kitty's tummy curves outward for a cute look.

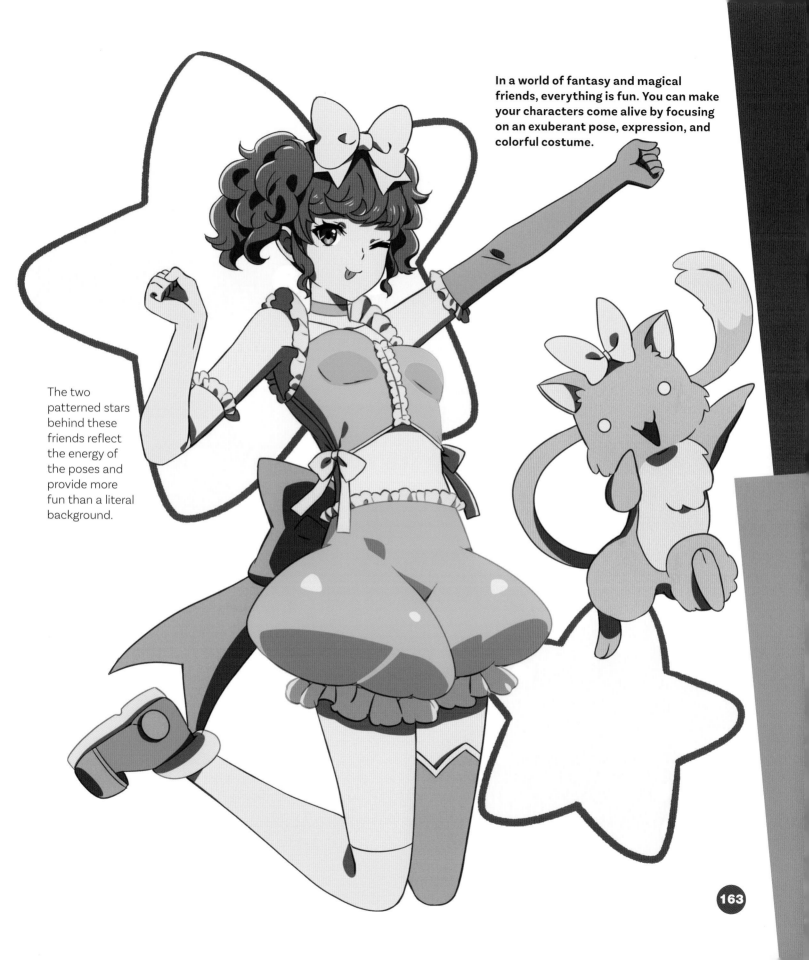

In a world of fantasy and magical friends, everything is fun. You can make your characters come alive by focusing on an exuberant pose, expression, and colorful costume.

The two patterned stars behind these friends reflect the energy of the poses and provide more fun than a literal background.

Thrillers

Thrillers are like a roller coaster, taking the viewer on a wild ride. Just when you think it's going to turn this way, it goes that way. The character who remains unflappable through all of this is usually the hero. Thrillers feature some of the coolest characters for high-octane car chases and fight scenes.

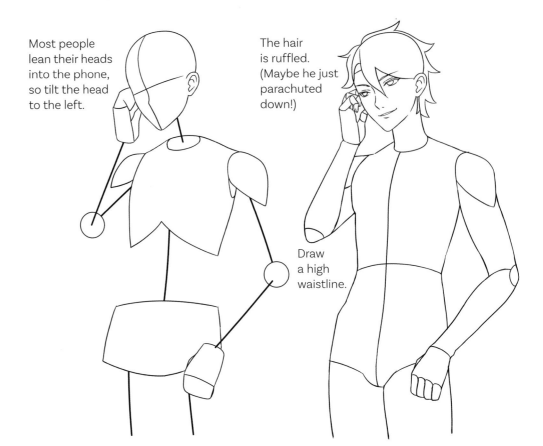

Most people lean their heads into the phone, so tilt the head to the left.

Draw a high waistline.

The hair is ruffled. (Maybe he just parachuted down!)

A relaxed pose shows that he's not worried about handling the bad guys.

Create space between the elbow and torso to open up the pose and help it read clearly.

6 Reasons to Use a Partial Background

1. It doesn't overwhelm the character.

2. It doesn't require a lot of "fill," like sky, clouds, or other buildings.

3. It frames the character and keeps the viewer's attention where you want it.

4. It has a design quality to it.

5. It leaves some of the background to the viewer's imagination.

6. All the detail goes to the important areas; the rest is left off.

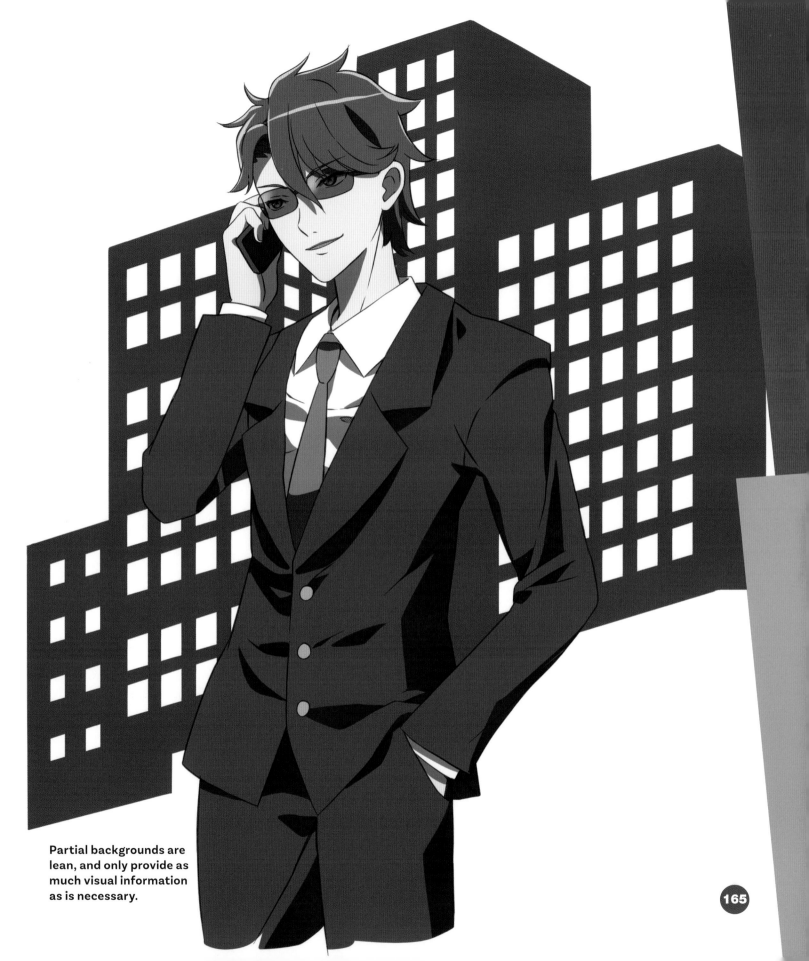

Partial backgrounds are lean, and only provide as much visual information as is necessary.

Romance & Relationships

This popular category is mostly situational, where rivalries stir up combustible emotions. This genre has classic character types, including the hyper-infatuated type, jealous type, cheating type, lonely heart, and true-blue friend. It's roiling drama-comedy, and fans love it.

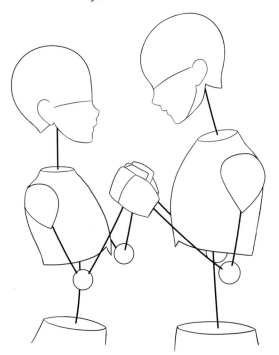

Draw their arms in symmetrical positions to show that they're sharing a singular moment. The elbows are at the midsection, which shows the proper proportions.

KEY
When the details get small, don't try to do too much with them.

Hands can be difficult to draw, especially a hand in a hand. Simplify the pose by drawing the fingers side by side.

Maintain the shared eyeline between the characters.

The lowered shoulders indicate this is a relaxed pose.

Her hair falls in waves to the middle of her back.

Show her far elbow.

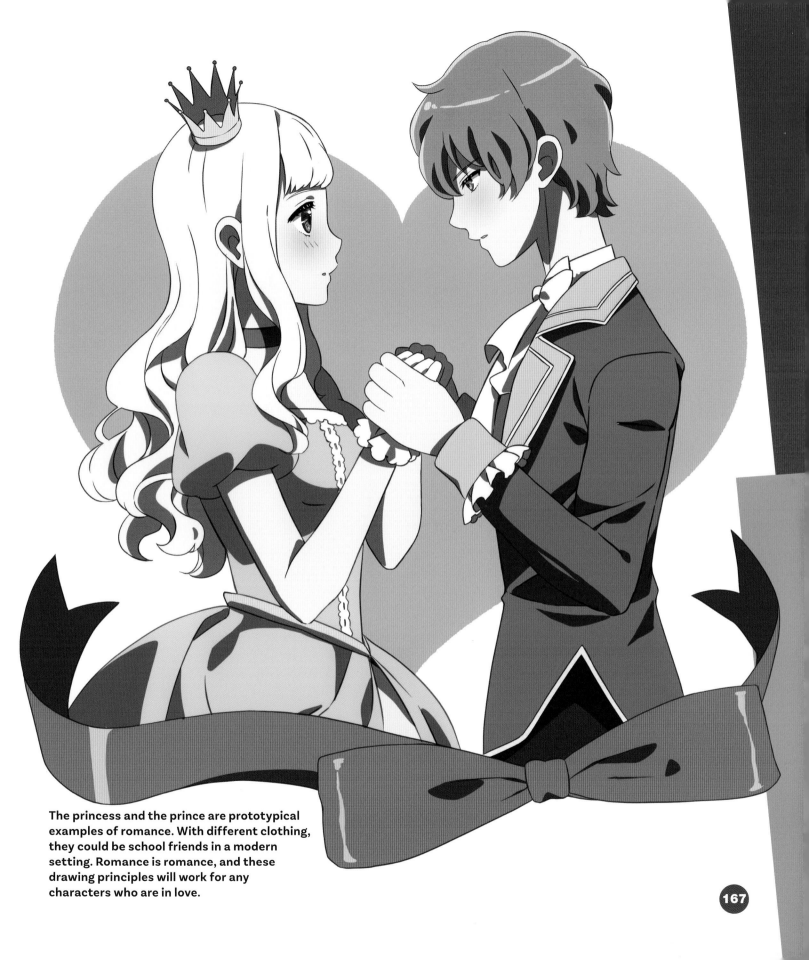

The princess and the prince are prototypical examples of romance. With different clothing, they could be school friends in a modern setting. Romance is romance, and these drawing principles will work for any characters who are in love.

Dystopian

The future is not as we expected it to be, but rather is a world where civilization has broken down. Hackers rule society. Into this maelstrom enters our hero. He's read about how it once was and how it should be again. This is a dynamic genre, with unique characters and a sense of urgency.

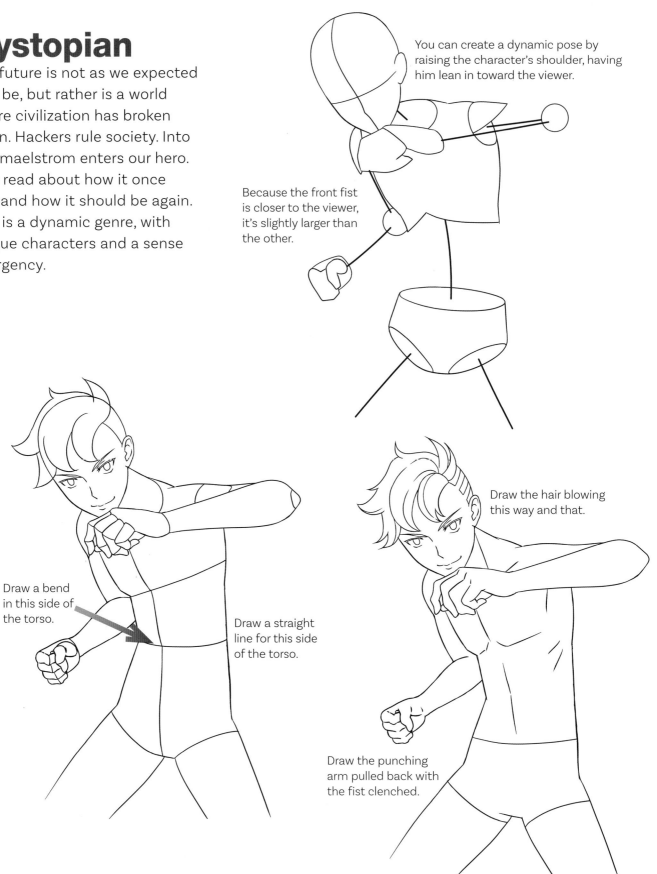

You can create a dynamic pose by raising the character's shoulder, having him lean in toward the viewer.

Because the front fist is closer to the viewer, it's slightly larger than the other.

Draw a bend in this side of the torso.

Draw a straight line for this side of the torso.

Draw the hair blowing this way and that.

Draw the punching arm pulled back with the fist clenched.

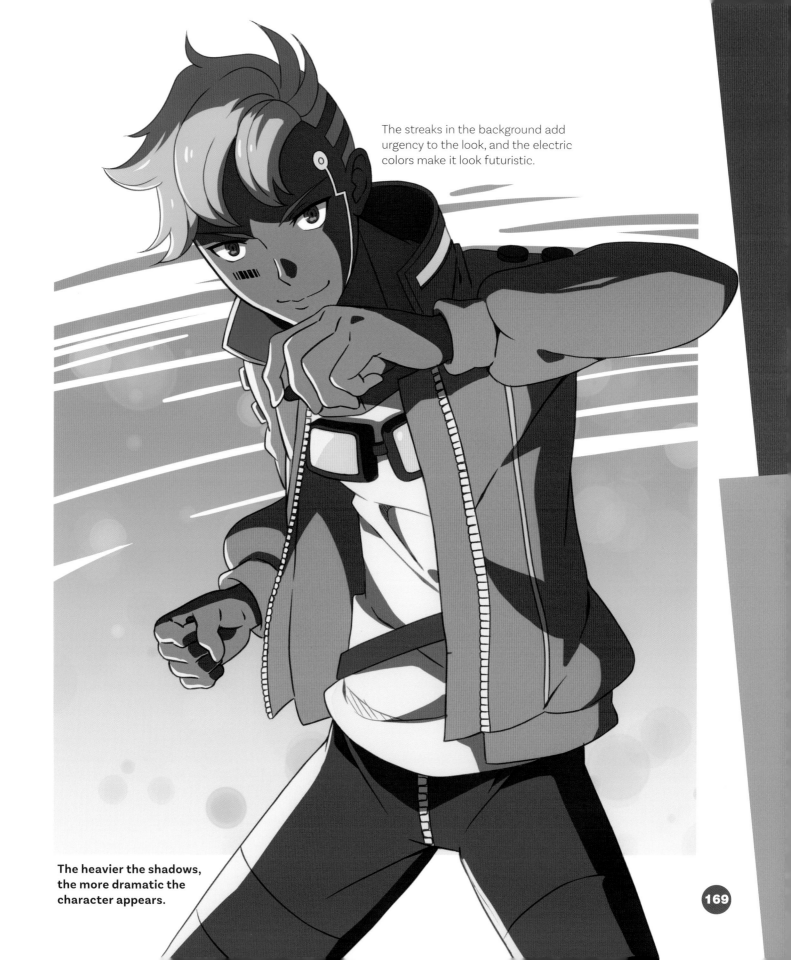

The streaks in the background add urgency to the look, and the electric colors make it look futuristic.

The heavier the shadows, the more dramatic the character appears.

PETS & PEOPLE: Cute Adventure Genre

In anime, animals can be co-stars. You can stress the relationship with the pose. Here, we have a puppy being rescued.

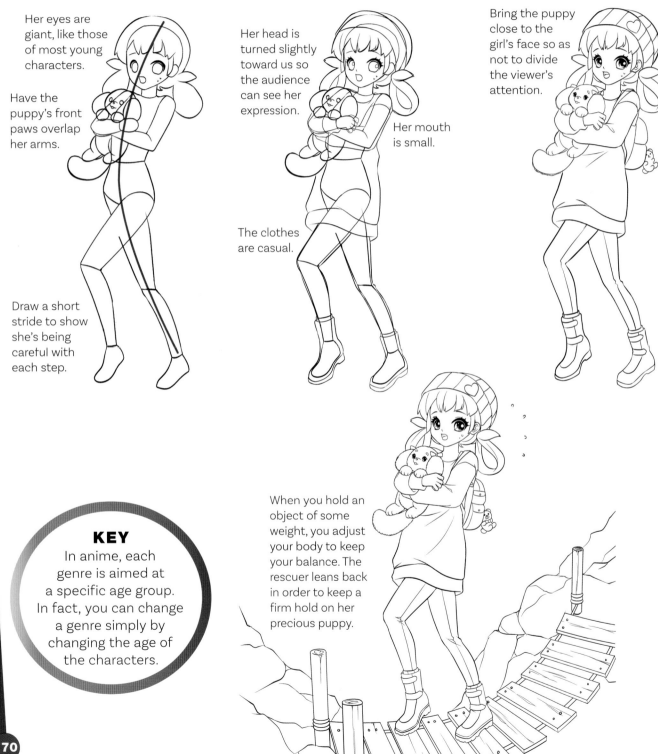

Her eyes are giant, like those of most young characters.

Have the puppy's front paws overlap her arms.

Draw a short stride to show she's being careful with each step.

Her head is turned slightly toward us so the audience can see her expression.

The clothes are casual.

Bring the puppy close to the girl's face so as not to divide the viewer's attention.

Her mouth is small.

When you hold an object of some weight, you adjust your body to keep your balance. The rescuer leans back in order to keep a firm hold on her precious puppy.

KEY
In anime, each genre is aimed at a specific age group. In fact, you can change a genre simply by changing the age of the characters.

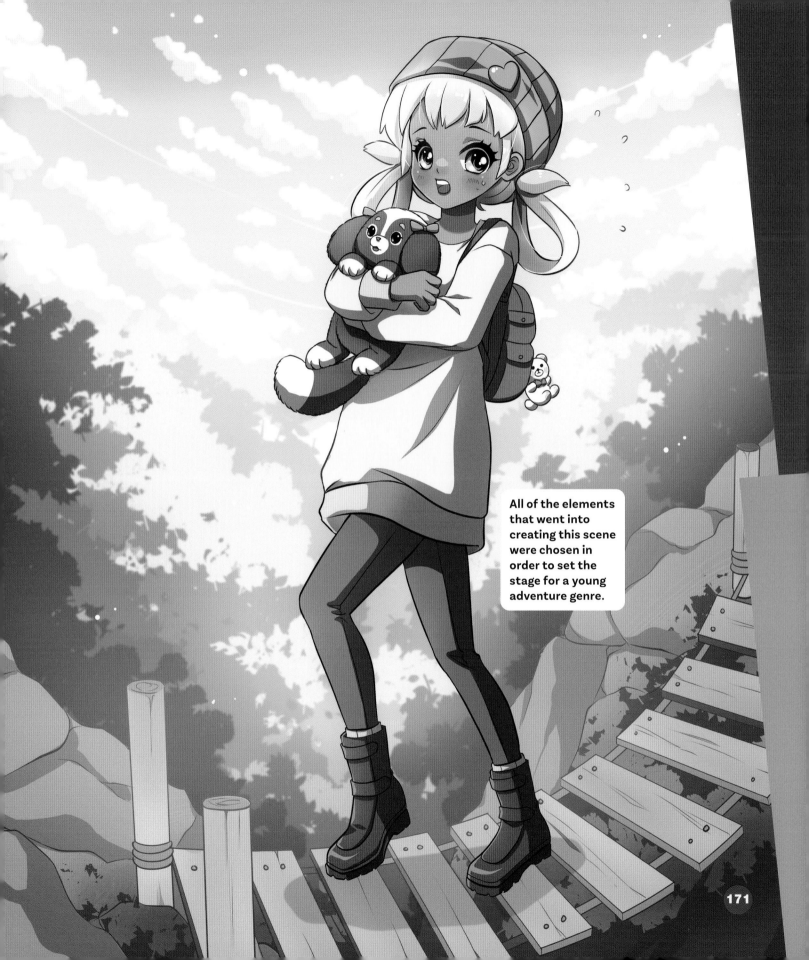

All of the elements that went into creating this scene were chosen in order to set the stage for a young adventure genre.

PETS & PEOPLE: Josei Genre

Here we have the same character type and situation as we did in the previous example, but in the josei style, which is meant for a slightly older audience. It looks quite different even though many of the elements are the same.

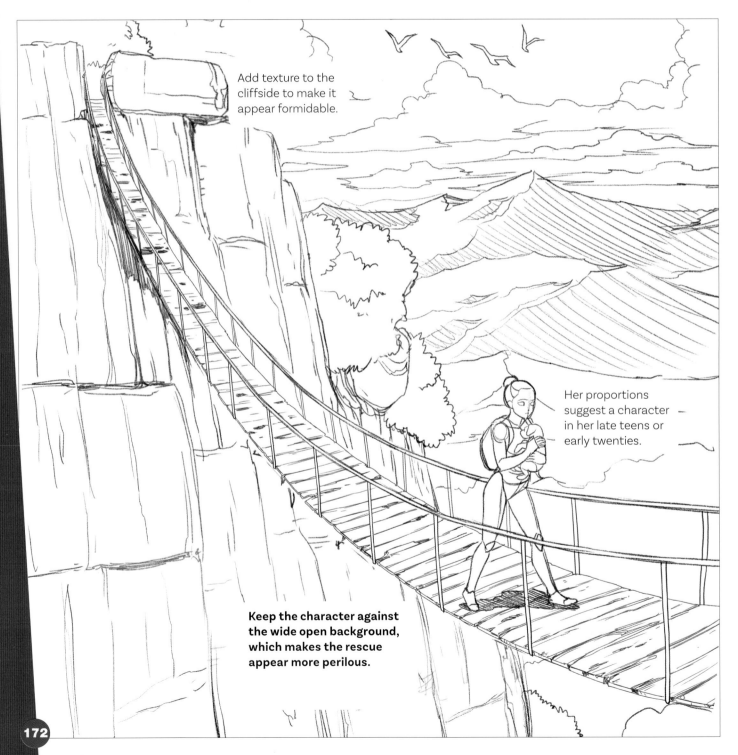

Add texture to the cliffside to make it appear formidable.

Her proportions suggest a character in her late teens or early twenties.

Keep the character against the wide open background, which makes the rescue appear more perilous.

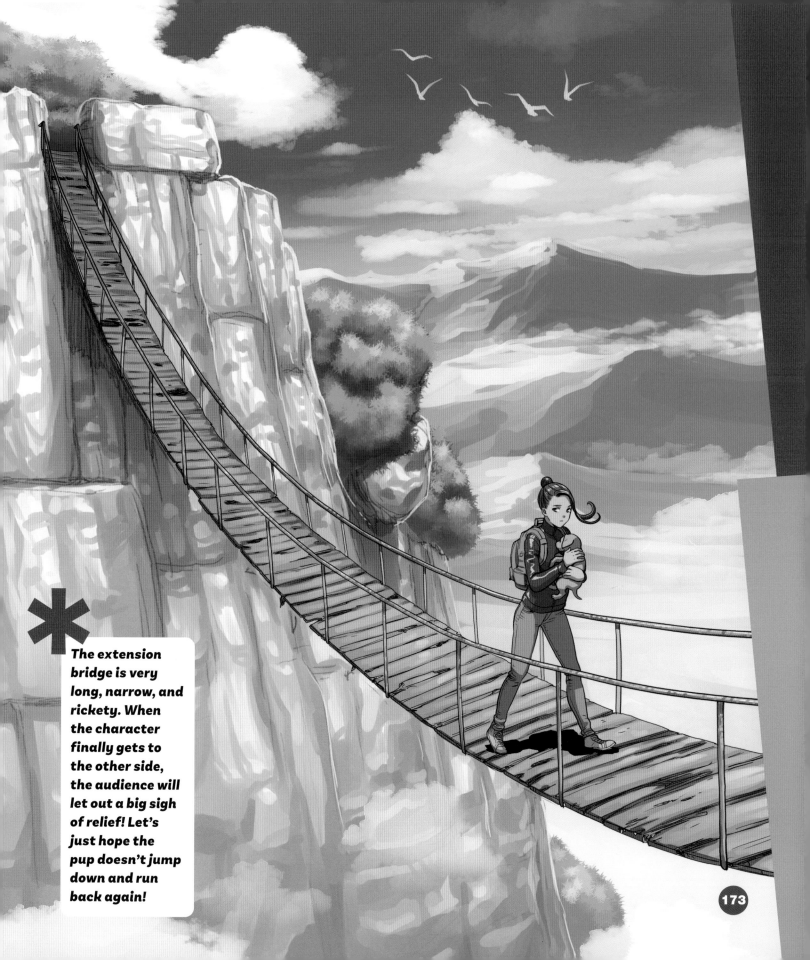

The extension bridge is very long, narrow, and rickety. When the character finally gets to the other side, the audience will let out a big sigh of relief! Let's just hope the pup doesn't jump down and run back again!

Creating Scenes & Stories

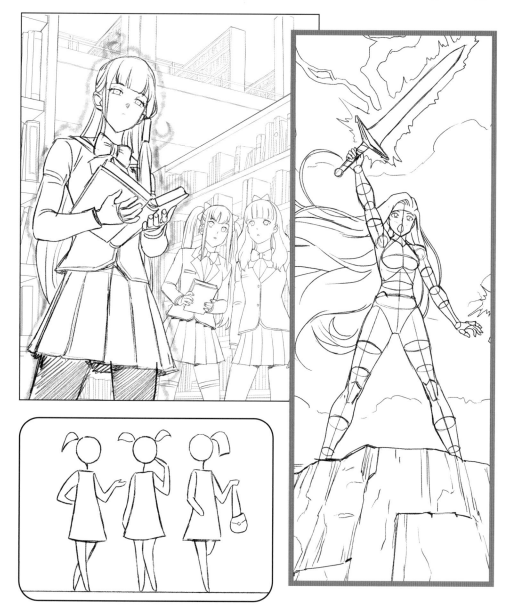

As you progress, you'll probably want to try drawing a setting for your characters. This is where the principles of composition and layout come in. The techniques in this chapter will give you a head start for handling multiple elements effectively. Everything in a scene is designed to focus the viewer's eye in service of the story being told.

Useful Concepts

Suppose you've drawn some friends in a scene, but no matter what expressions you give them, they don't present a friendly impression. Perhaps the problem isn't their expressions, but the way they've been positioned in the illustration.

DISTANCE = ESTRANGEMENT

It doesn't matter how happy the characters are, placing people at a distance from one another lessens the connection between them.

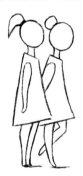

NEARNESS = FRIENDSHIP

There's a noticeable ease when friends are staged closer together.

HEIGHT

Positioning two characters at different heights creates a compelling visual dynamic. Also, the closer two characters are, the bigger the impact a height difference can have.

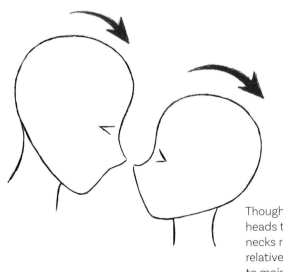

Though the heads tilt, the necks remain relatively vertical, to maintain balance.

Tilt the taller character's head forward and the shorter character's head back, looking up. Draw the tip of the nose slightly higher on the taller one to keep their relative heights consistent.

CREATING THE APPEARANCE OF DEPTH

To create a sense of depth in a scene or background, something has to hold the elements together—that's the horizon line's job.

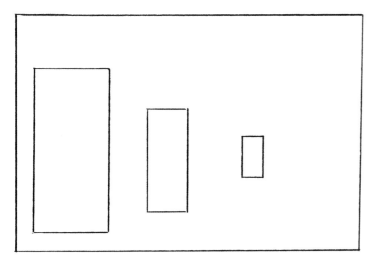

These rectangular forms appear to recede into the distance. But how can we be certain they're receding and not just different sizes?

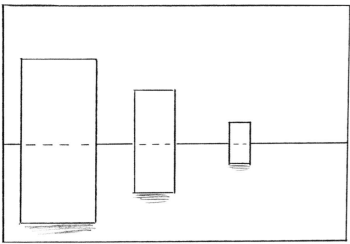

The three rectangles (they could be buildings) are bisected through the middle by the horizon line. This tells the viewer they are at different distances from us.

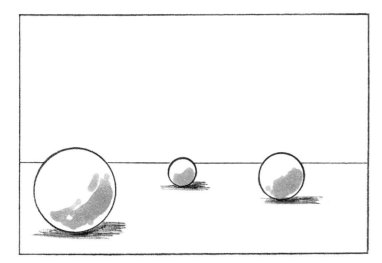

The horizon line intersects each of these spheres at the top, which communicates their distance from the viewer.

FOREGROUNDS

You may have been drawing just backgrounds up until now, but I want you to add foregrounds to your repertoire. They are very effective at setting up a scene and can direct the viewer's eye from the outset.

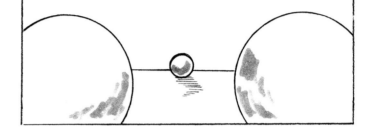

Though the spheres on the right and left foreground are much larger, it's the small sphere in the distance that is the focal point, as the others create a frame that funnels the viewer's attention.

FRAMING THE CHARACTER

Framing means focusing the viewer's attention. It gives you control of the scene. A frame can be a window, a doorway, a scene between two trees, a panel in a graphic novel, or the dimensions of a page.

Drawing without a Frame

Without a frame, the picture looks open and unfocused.

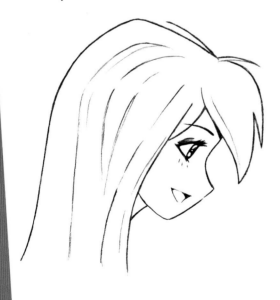

Drawing with a Frame

By framing the character, you focus the viewer's attention.

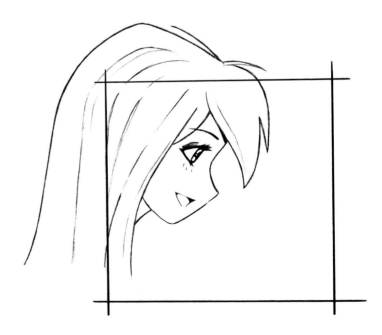

LEADING THE VIEWER'S EYE

Composition does more than help you compose a pretty picture. It also gives you practical tools to create a mood or convey a feeling. In this instance, right, the penguins are arranged to create a sense of distance along a curved horizon line. But only one of them is positioned to be the focus of the scene. Which do you think it is?

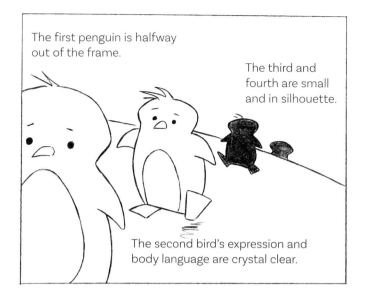

The first penguin is halfway out of the frame.

The third and fourth are small and in silhouette.

The second bird's expression and body language are crystal clear.

CLOSE-UP & DETAIL SHOTS

Many artists utilize only two sizes within a frame: a full shot (from head to toe) and a close-up of the face. But there are additional shots you can use to add variety and interest to your work. Here are a few.

Close-up

Most people think of a close-up in terms of a front view, but you can also draw a close-up in a side view, which is very effective.

Detail Shot

You can go in even closer, which is called a detail shot.

A detail shot can focus on anything, including the hand, as shown here.

179

DOORWAY AS FRAME

Metaphors are big in anime. Doorways can represent magical portals to another place and are an excellent design choice for framing a scene and leading the viewer's imagination.

The doorway frames the character, who stands at the start of a pathway that winds into the distance.

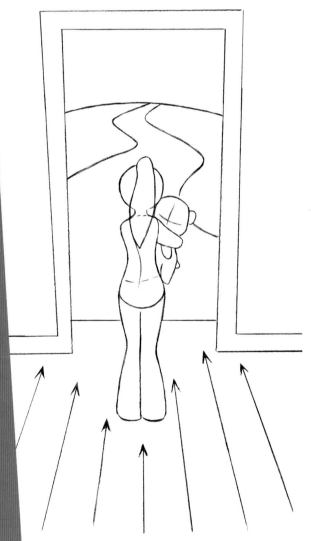

Draw floor slats so they point toward to the horizon, further directing the viewer.

Add mountains and a rainbow that converge in the distance, drawing the eye forward to what lies ahead.

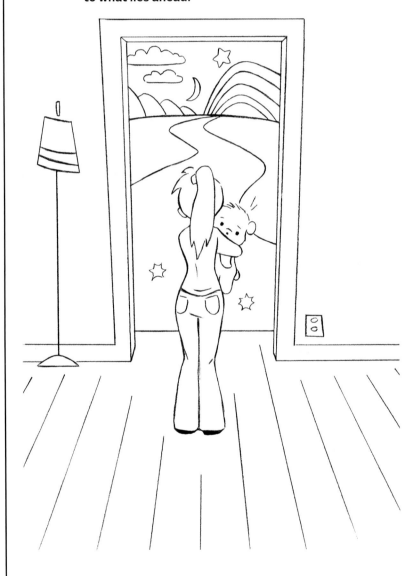

GROUNDING

Grounding is a technique that makes your character appear firmly placed in a scene or environment.

This little monster looks like he's floating in the middle of the page, even though he's standing. How can we tweak it without adding a lot of background detail?

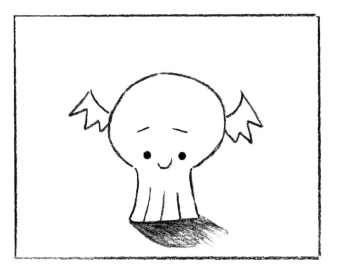

By adding a shadow, we suggest the ground beneath him; now his appearance looks solid.

TANGENTS

A tangent is when two things touch in a drawing in a way that doesn't seem natural. This draws the viewer's eye to a nonessential point in the composition, distracting from the rest of the illustration.

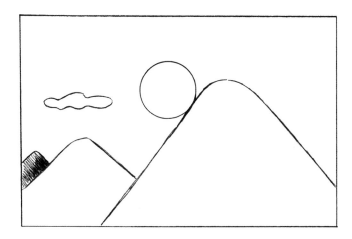

The sun touches the mountain, causing the viewer to focus on it and its somewhat odd placement.

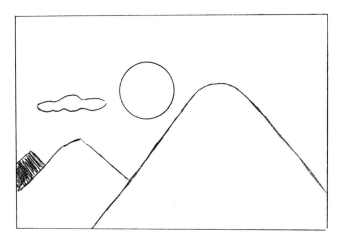

Maintain ample space between the sun and the mountain and the scene looks pleasing.

OVERLAPPING

Sometimes it is important to unify the elements of a scene so they work together. Keeping the window and the character separate is an unfocused look.

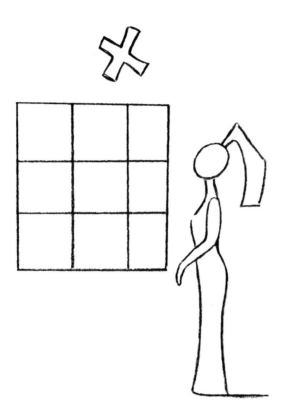

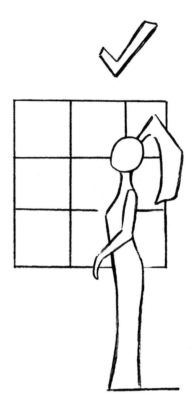

By creating a space between the window and the figure, you end up with two unrelated images.

Overlapping the figure with the window creates a single image, with the viewer's attention no longer divided.

LAYERING

Layering is an effective way to make something look awesome. The key is that the character itself becomes one of the layers. By showing the character between layers, the viewer can get a sense of its size.

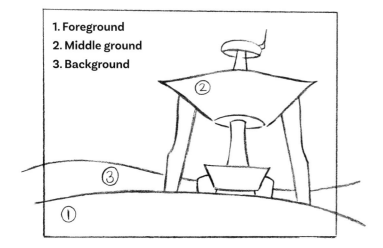

1. Foreground
2. Middle ground
3. Background

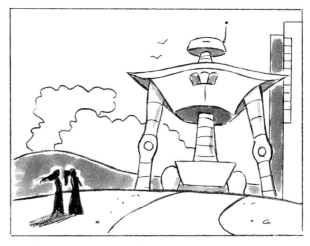

By drawing some people in the foreground the viewer can compare and get an idea of how big the robot is.

SILHOUETTING

When you draw something big, you're often forced to accompany it by something small to dramatize the size difference. The problem is that it's tough to show detail in the smaller object. What should you do? Silhouette!

By drawing both characters in silhouette, you solve the problem. Silhouettes require no detail, and they lead the viewer to focus only on the size difference.

Drawing Couples: A New Approach

When you draw a couple, you have three elements: the first figure, the second figure, and the visual dynamics between them. By using a few simple design techniques, you can make your drawings more effective and engaging.

Here is how most beginners draw a couple:

1. Draw a little of the person on the left.

2. Switch and draw a little of the person on the right.

3. Then the left.

4. Then the right.

5. You suddenly realize it's not coming together. What went wrong?

Switching back and forth creates two variables—both keep changing. If instead you were to complete the basic construction of the first character, you could turn your attention to the second character. And the first character would become the anchor for the drawing.

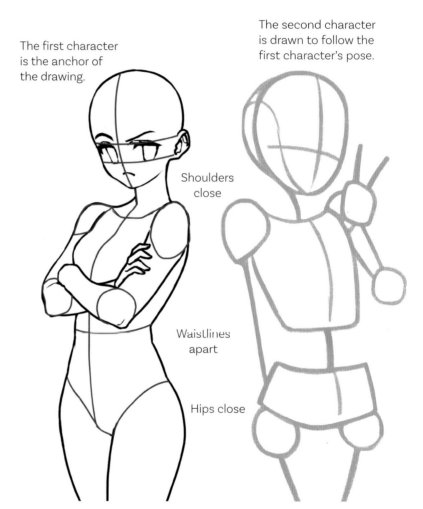

The first character is the anchor of the drawing.

The second character is drawn to follow the first character's pose.

Shoulders close

Waistlines apart

Hips close

Draw the basic pose of the figure on the left, then replicate it in the figure on the right, facing in the opposite direction.

MIRROR POSE

A mirror pose is when two characters stand with the same pose but face in opposite directions. It's eye-catching and well suited for drawing the characters one at a time. The finished drawing of the first character becomes the reference point for re-creating the pose with the second figure.

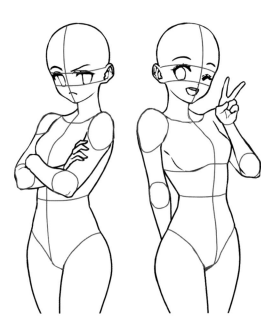

Although there are some minor differences in the arm poses, the angles of the head and the curving line of both backs are identical.

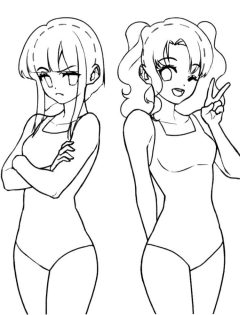

The characters need a few differences so they aren't entirely repetitive of each other. Different hairstyles and expressions will help tell your story.

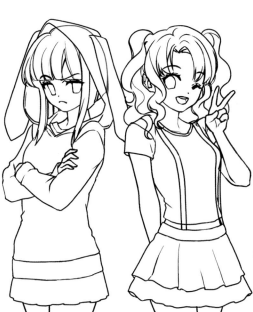

Even though they're wearing different outfits, the mirrored pose remains effective.

The mirrored pose communicates friction between these two friends.

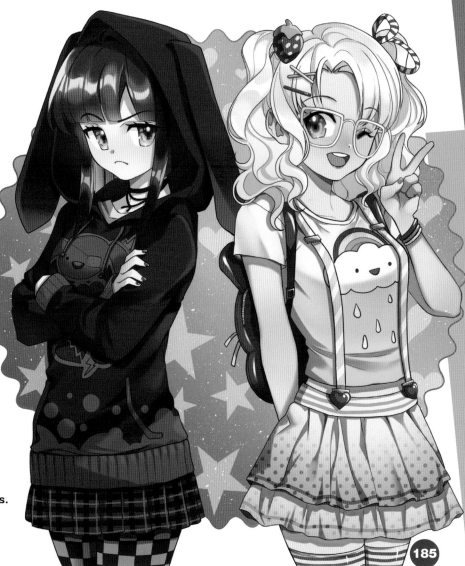

SHOULD SHE TRUST HIM?

The boy, caught with way too many numbers on his phone, is in profile. The girl faces him in a ¾ view. These angles don't meld—and that's the point. This scene is not going to be about joy and harmony.

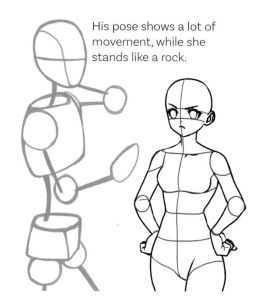

His pose shows a lot of movement, while she stands like a rock.

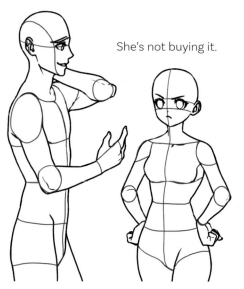

She's not buying it.

His hand gestures indicate stupid excuses.

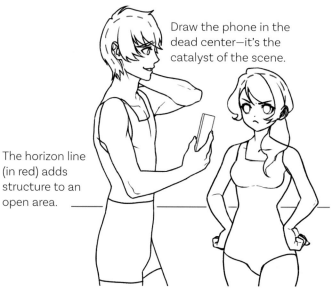

Draw the phone in the dead center—it's the catalyst of the scene.

The horizon line (in red) adds structure to an open area.

Rubbing your neck is a classic anime gesture for nervousness.

KEY
Turn the phone so the viewer can see more than just a side sliver of it. If something is important, let your audience get a good look at it.

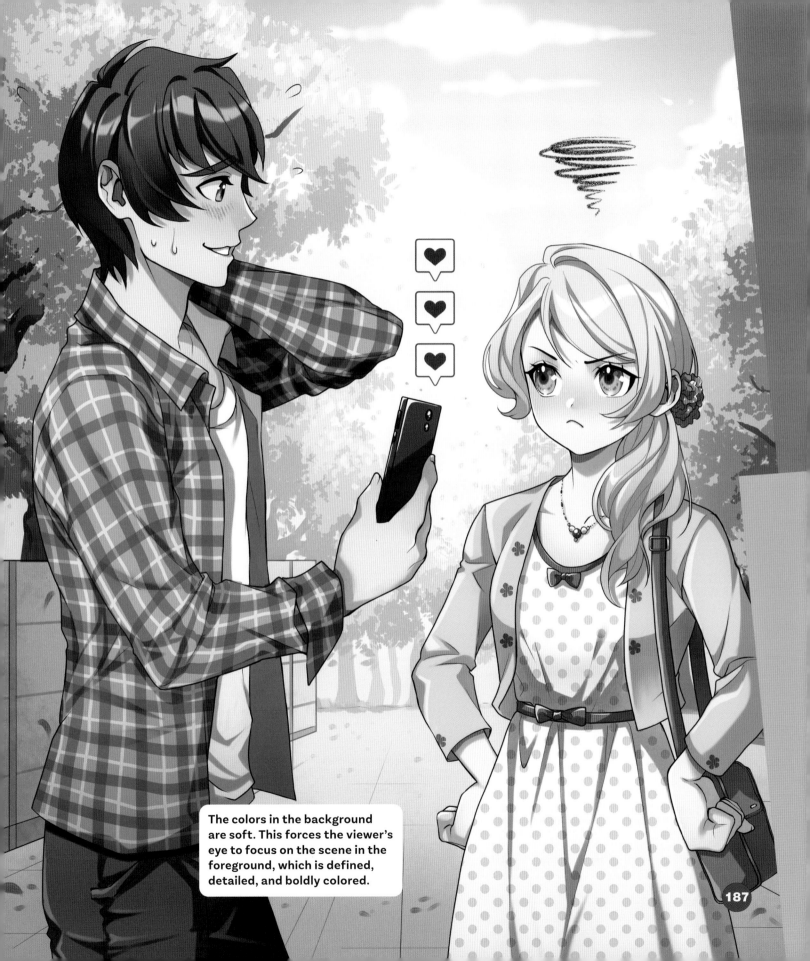

The colors in the background are soft. This forces the viewer's eye to focus on the scene in the foreground, which is defined, detailed, and boldly colored.

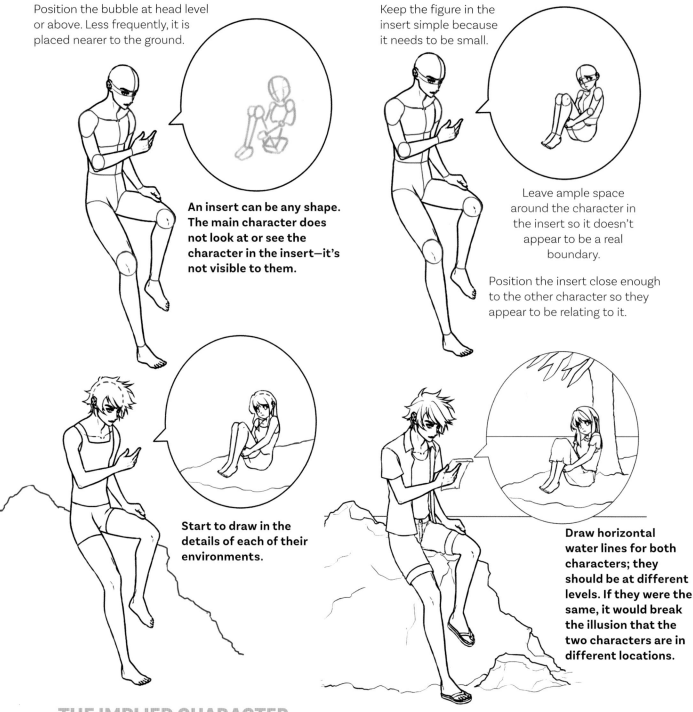

Position the bubble at head level or above. Less frequently, it is placed nearer to the ground.

An insert can be any shape. The main character does not look at or see the character in the insert—it's not visible to them.

Keep the figure in the insert simple because it needs to be small.

Leave ample space around the character in the insert so it doesn't appear to be a real boundary.

Position the insert close enough to the other character so they appear to be relating to it.

Start to draw in the details of each of their environments.

Draw horizontal water lines for both characters; they should be at different levels. If they were the same, it would break the illusion that the two characters are in different locations.

THE IMPLIED CHARACTER

This is an inventive, entertaining way to include a second character in a scene. Let's suppose this character is far away but you'd still like to include them. All you need is to create what is called an insert, which is basically a bubble within the scene. Draw your character in the insert, bringing them into the scene even though they are not physically there.

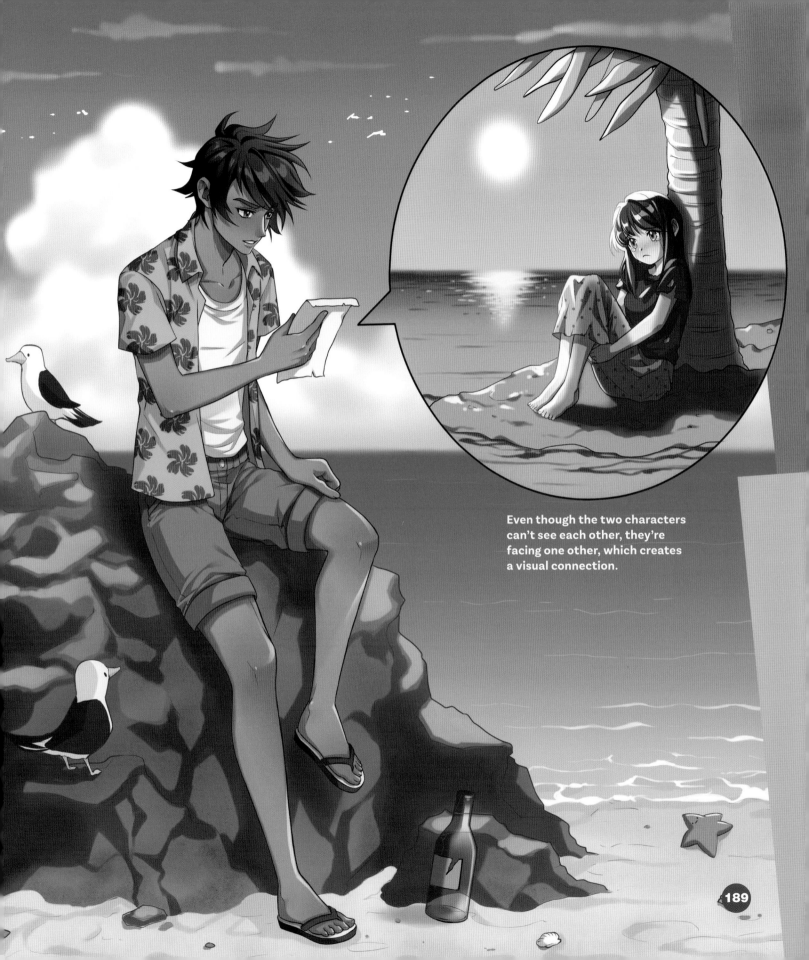

Even though the two characters can't see each other, they're facing one other, which creates a visual connection.

UNLIKELY FRIENDS

Some characters make unlikely couples. This leaves the viewer with a sense of optimism and hopefulness: if they can get along, then everybody can get along, and my dog would stop stealing my socks. Maybe that's a reach. Anyway, such is the case with the little kitten and her big protector.

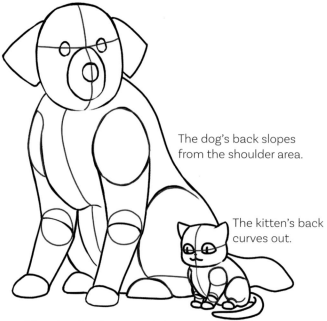

The dog's back slopes from the shoulder area.

The kitten's back curves out.

With animals, the overall shape is more important than the details; a chubby and compact body gives the kitten a dear quality.

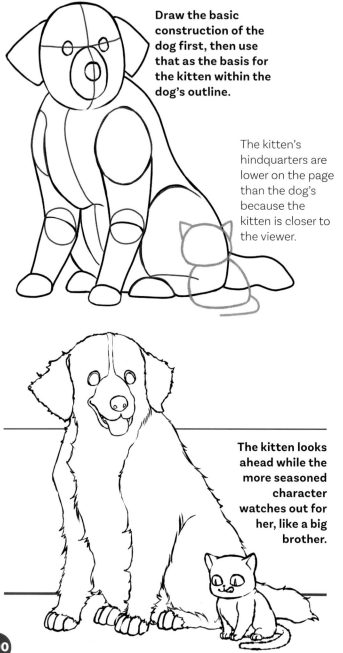

Draw the basic construction of the dog first, then use that as the basis for the kitten within the dog's outline.

The kitten's hindquarters are lower on the page than the dog's because the kitten is closer to the viewer.

The kitten looks ahead while the more seasoned character watches out for her, like a big brother.

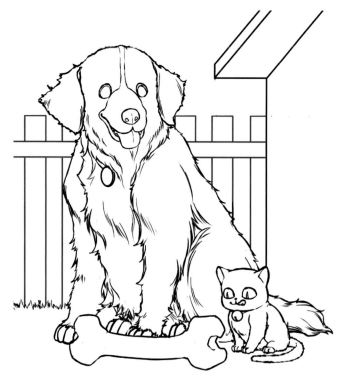

The fence, with its strong vertical lines, gives the scene a sense of stability.

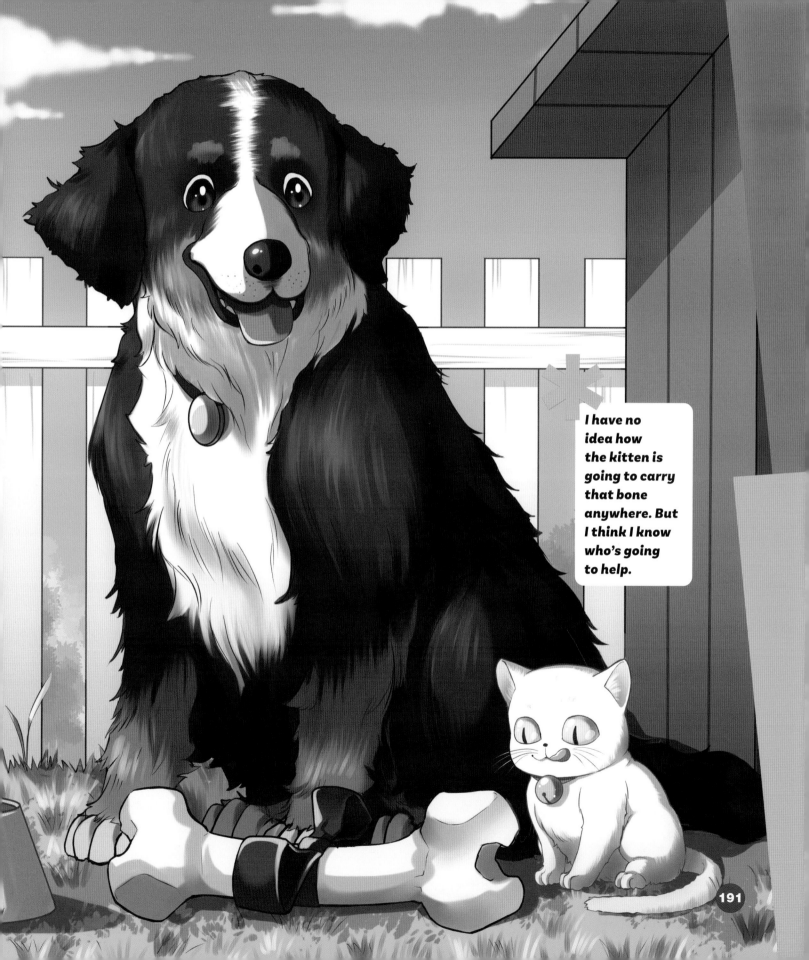

Exaggeration

Exaggeration is key to action scenes and big moments. It isn't the sole province of characters; it's also part of creating special effects and backgrounds.

LOOKING DOWN AT THE CHARACTER (PERSPECTIVE SHOT)

When we're looking down on a character from a height, the head will seem big for the body, while the lower legs will look shortened and the feet reduced in size.

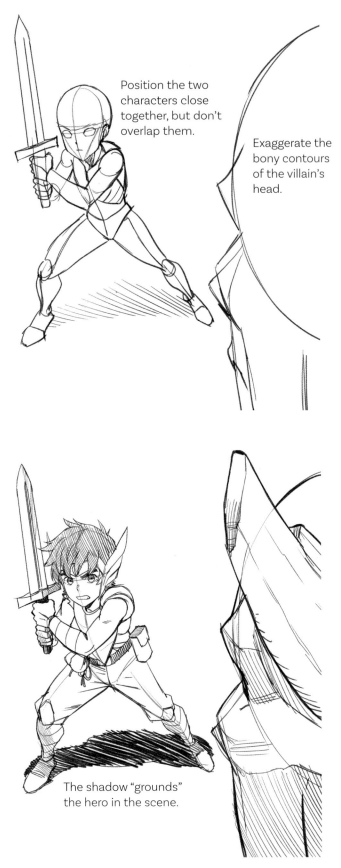

Position the two characters close together, but don't overlap them.

Exaggerate the bony contours of the villain's head.

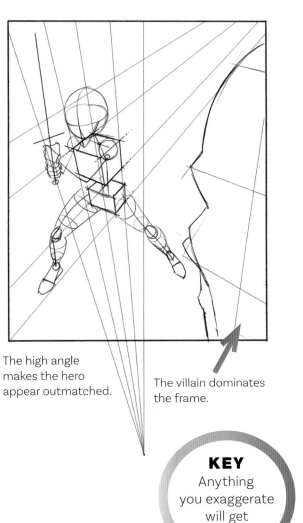

The high angle makes the hero appear outmatched.

The villain dominates the frame.

The shadow "grounds" the hero in the scene.

KEY
Anything you exaggerate will get noticed.

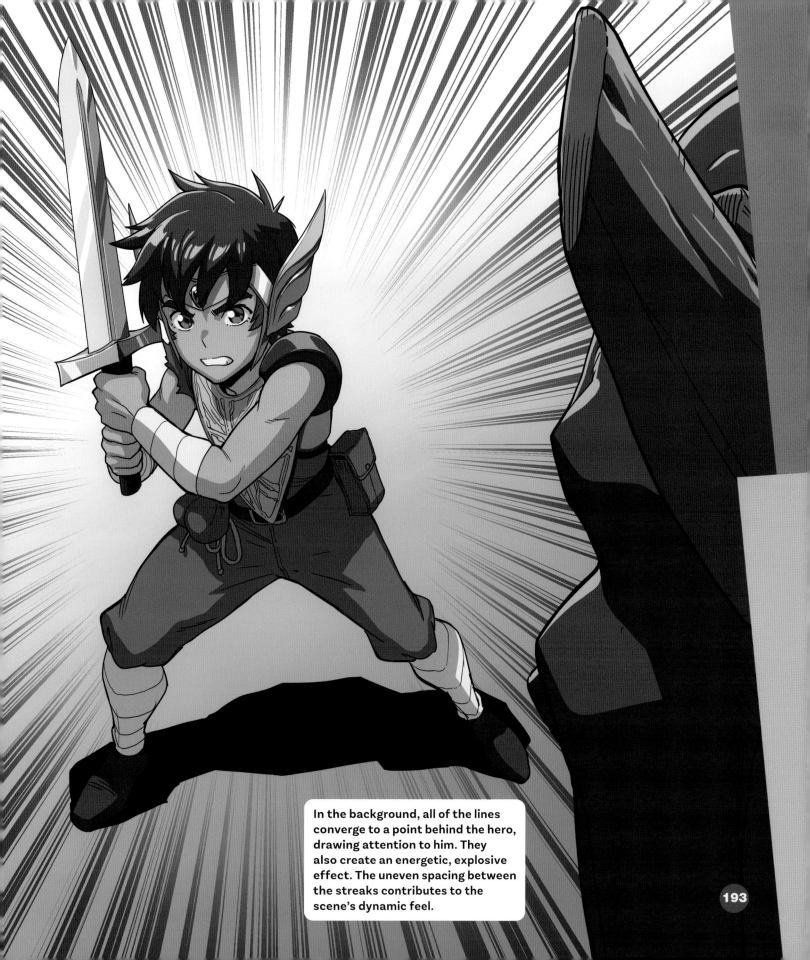

In the background, all of the lines converge to a point behind the hero, drawing attention to him. They also create an energetic, explosive effect. The uneven spacing between the streaks contributes to the scene's dynamic feel.

Advanced Layout Tips

These concepts can be easily understood. What makes them advanced is that many beginners overlook them, but not everyone—you will have them as part of your skill set.

LOOKING UP AT A CHARACTER (REVERSING PERSPECTIVE)

You can use vanishing guidelines to exaggerate the size of a figure and make it look powerful.

The horizontal guidelines are widest at the bottom of the figure and converge at the head.

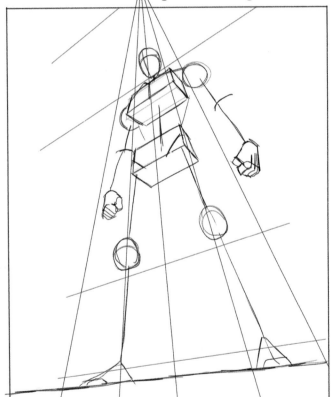

Perspective = power. Evil types are usually drawn as impressive figures in order to give the story urgency.

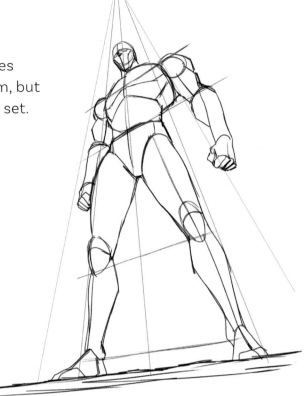

As you block out the head and body, continue to taper the figure along the ascending vanishing lines.

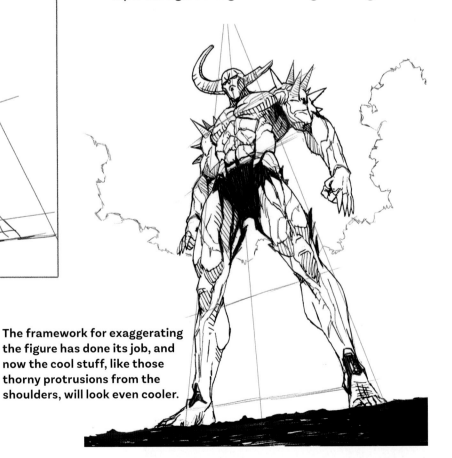

The framework for exaggerating the figure has done its job, and now the cool stuff, like those thorny protrusions from the shoulders, will look even cooler.

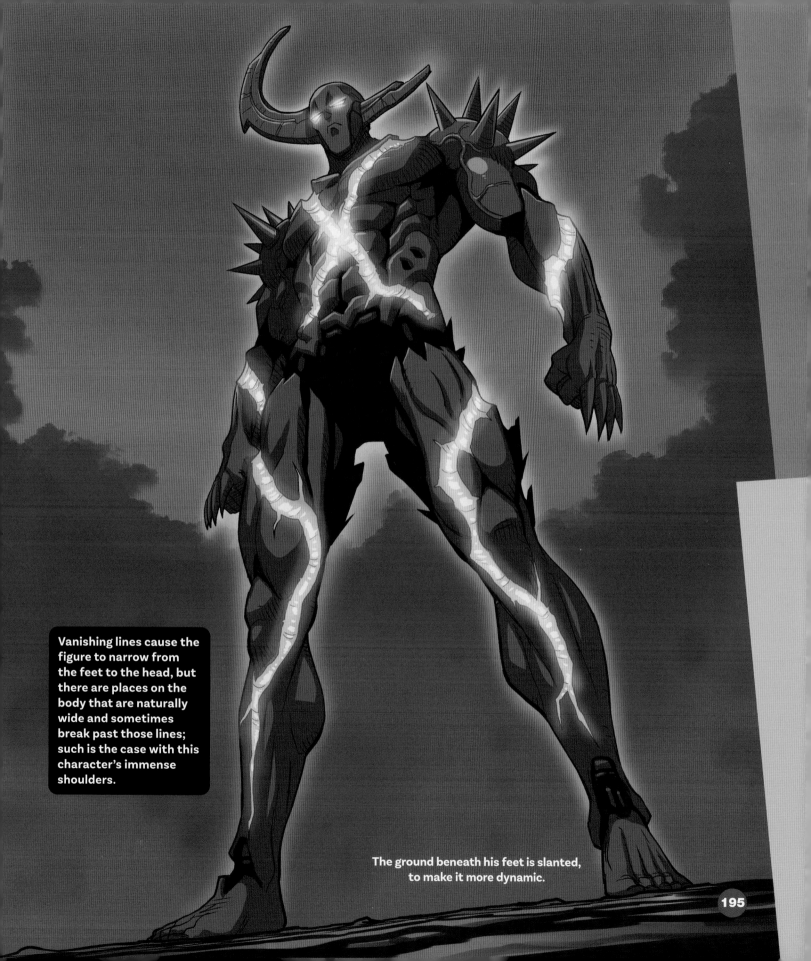

Vanishing lines cause the figure to narrow from the feet to the head, but there are places on the body that are naturally wide and sometimes break past those lines; such is the case with this character's immense shoulders.

The ground beneath his feet is slanted, to make it more dynamic.

BUMPING UP THE INTENSITY

This widely used technique could make the intensity of your scenes soar. Interestingly, it doesn't focus on the character but rather it charges up the background. To demonstrate how effective it is, compare two different scenes using the same exact character.

VERSION A

This scene is built on a horizontal line that represents the ground. It's straight, low, and stable.

One arm is raised overhead, in a heroic sword pose.

A victor's stance is drawn with the legs apart, which shows strength.

The hair is drawn like a cape, flapping in a storm. This adds to the illusion of motion when there actually isn't any!

The pose is strong but almost completely symmetrical, with the legs placed an equal distance apart. To introduce more energy, we'll have to rely on the background.

The clouds are roiling (energetic) rather than horizontal (calming).

KEY
Dynamic hair reflects a charged atmosphere—a visual metaphor for bad things yet to come.

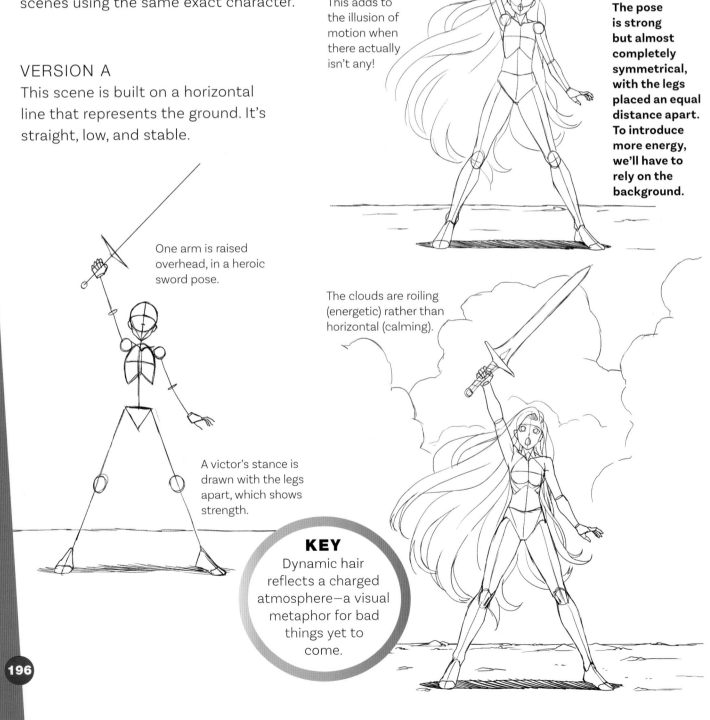

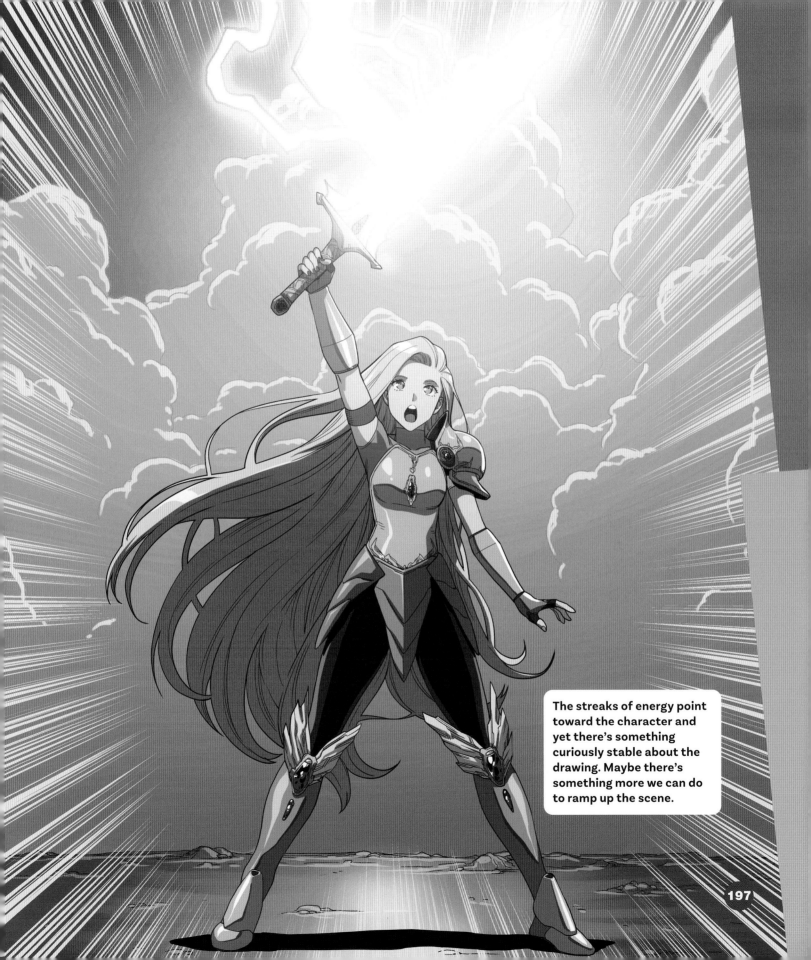

The streaks of energy point toward the character and yet there's something curiously stable about the drawing. Maybe there's something more we can do to ramp up the scene.

197

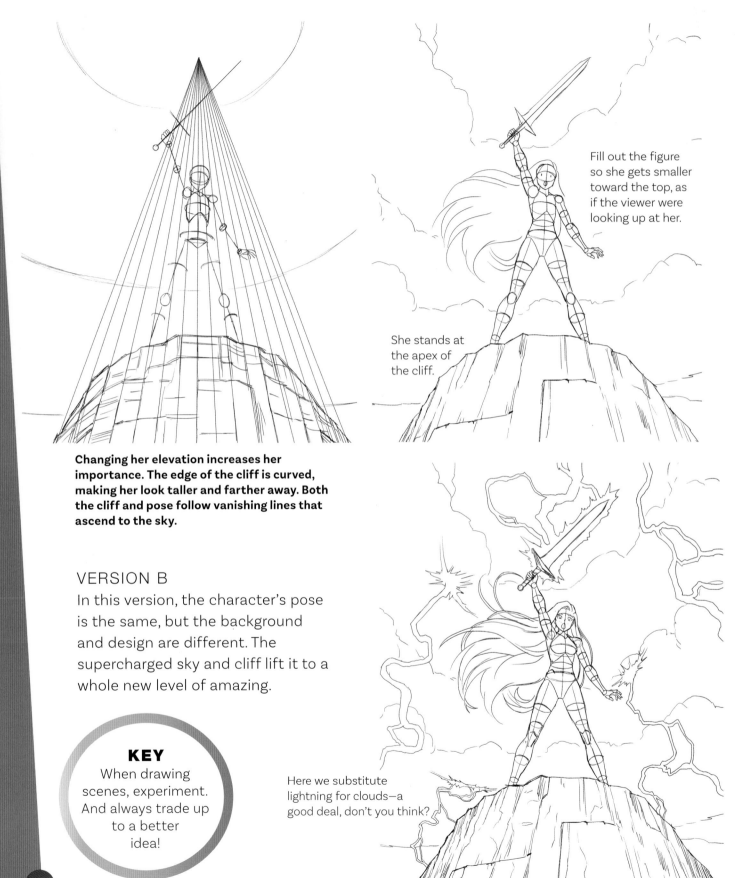

Changing her elevation increases her importance. The edge of the cliff is curved, making her look taller and farther away. Both the cliff and pose follow vanishing lines that ascend to the sky.

VERSION B

In this version, the character's pose is the same, but the background and design are different. The supercharged sky and cliff lift it to a whole new level of amazing.

KEY
When drawing scenes, experiment. And always trade up to a better idea!

Fill out the figure so she gets smaller toward the top, as if the viewer were looking up at her.

She stands at the apex of the cliff.

Here we substitute lightning for clouds—a good deal, don't you think?

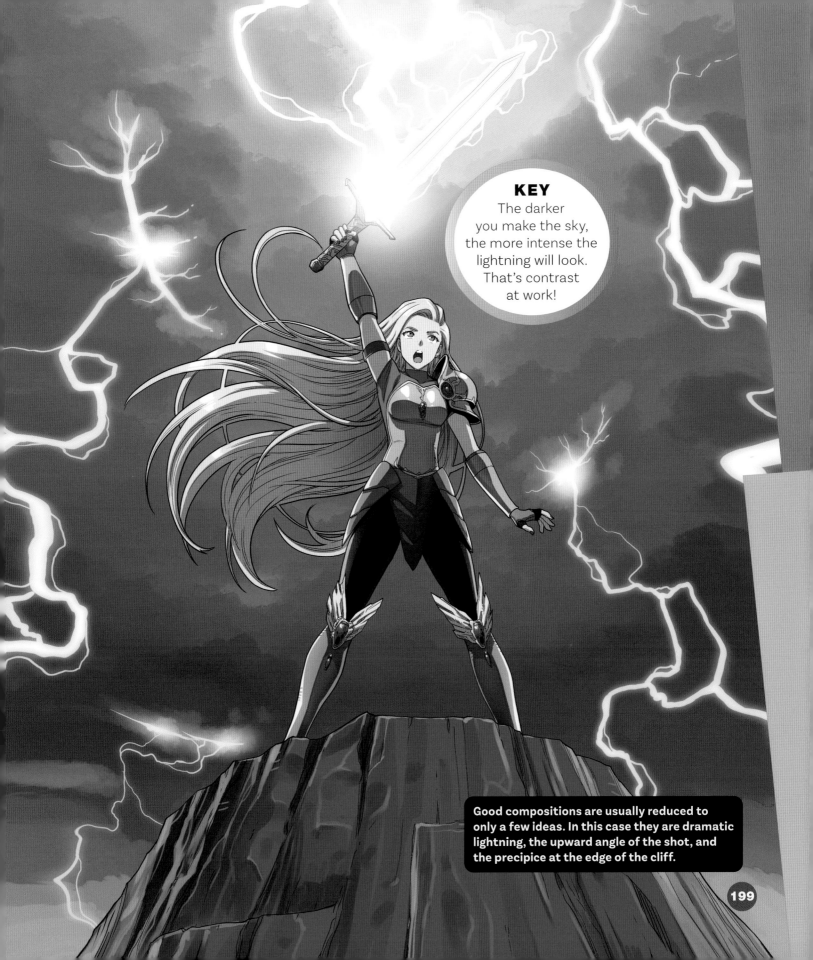

Creating Scenes

What is a scene? Put simply, it's a setting that features characters. Period. Some artists draw their characters first. Once they're done, they draw the background. The problem with this approach is that no one wants to erase their finished characters, even if a background design sparks a better idea about how to stage them. A better approach is to include a rough background as you begin your scene. Don't wait until the end to make the characters and the background work together.

PUBLIC TRANSIT IN JAPAN

Public transit is a way of life in Japan, the home of anime. It's a good place to set up a scene. A train station is instantly recognizable—subterranean, long, and narrow.

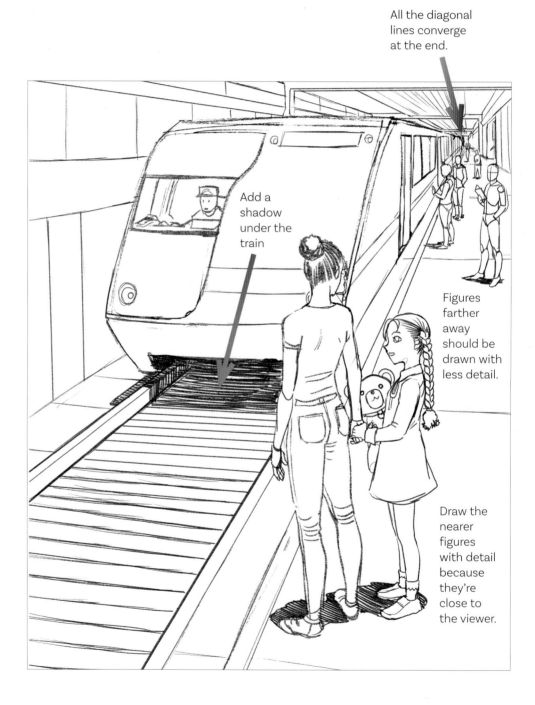

All the diagonal lines converge at the end.

Add a shadow under the train

Figures farther away should be drawn with less detail.

Draw the nearer figures with detail because they're close to the viewer.

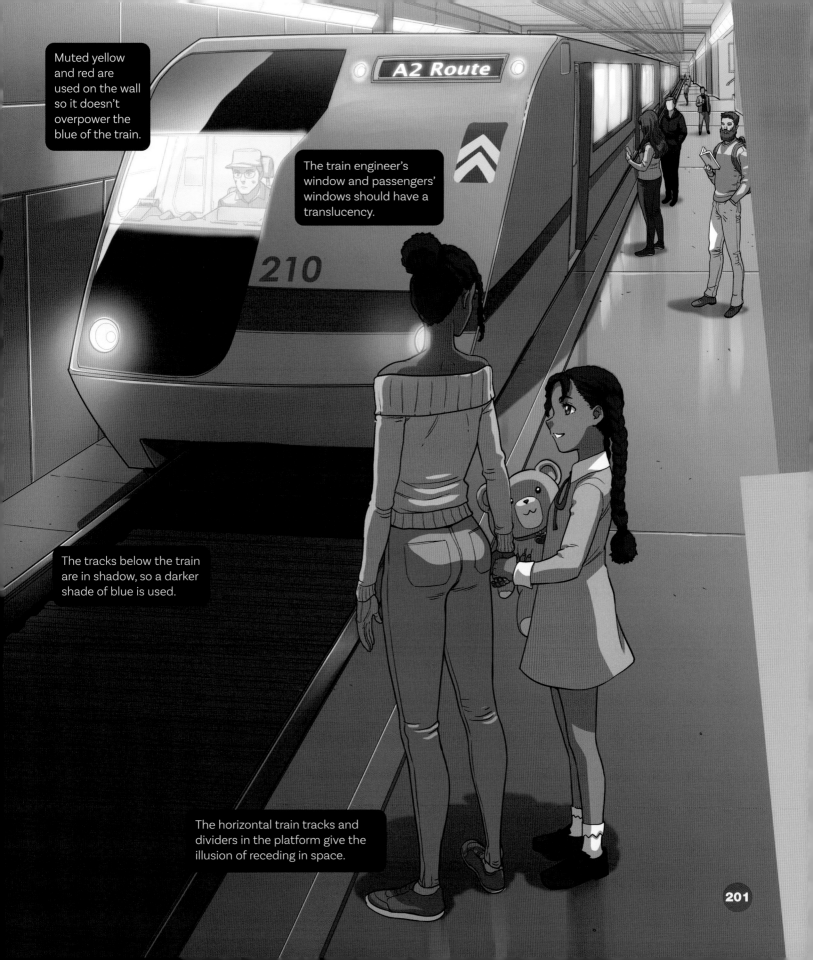

201

SCHOOL SETTING

This setting is ultra-traditional, and contrasts with that strange visitor from who-knows-where. She's read every book in the school library—in six languages! Okay, that's the setup. The question is, how do you show, visually, her mysterious qualities *before* adding special effects? The answer is in staging the other two girls.

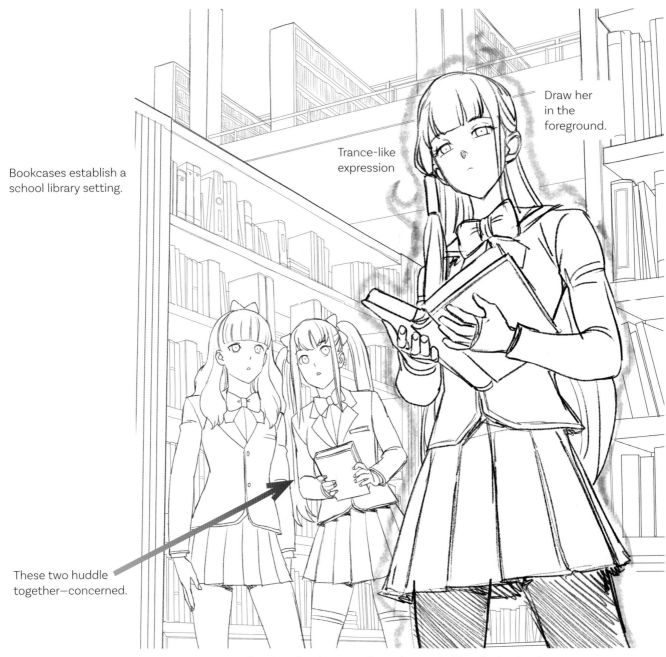

Draw her in the foreground.

Trance-like expression

Bookcases establish a school library setting.

These two huddle together—concerned.

By drawing the three students in nearly identical school uniforms, any differences between them will stand out, such as their expressions and the glow around the strange girl.

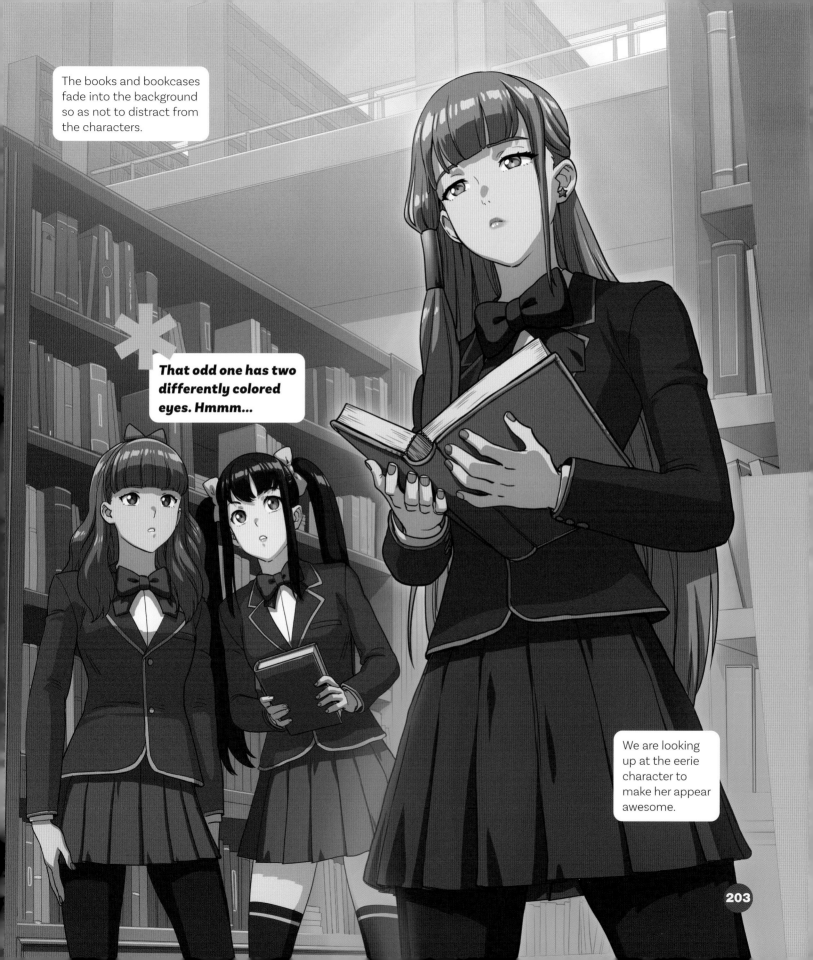

FUTURISTIC LANDSCAPE

It's the year 2059. Dogs are still man's best friend. However, both have changed. Compressors, titanium valves, and ion pods have replaced almost every organ in their bodies. Playing fetch will be the last connection to what makes us human. Let's see how we can make this scene convincing.

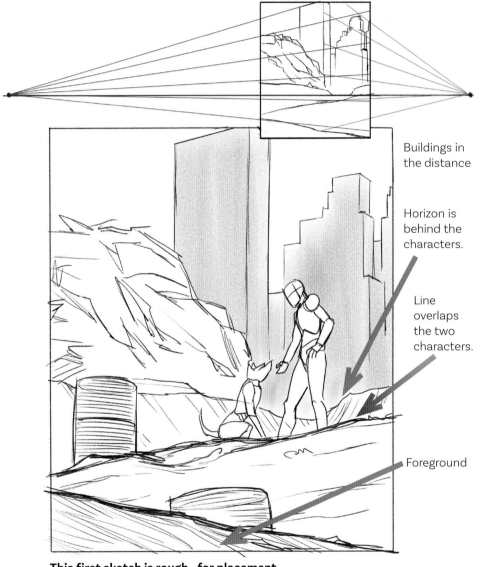

Horizon line (in red)

Buildings in the distance

Horizon is behind the characters.

Line overlaps the two characters.

Foreground

This first sketch is rough—for placement only. The characters are small against a vast background, creating a look of desolation.

Using Perspective

Artists generally use guidelines to draw buildings in perspective. It doesn't have to be precise but it's helpful. The horizon line (in red on the top drawing) represents ground level. The blue vanishing lines converge to the left. These lines relate to the tops of the buildings. The angle of the tops of the buildings should match the angle of the vanishing lines. By following the vanishing lines, you'll maintain correct perspective.

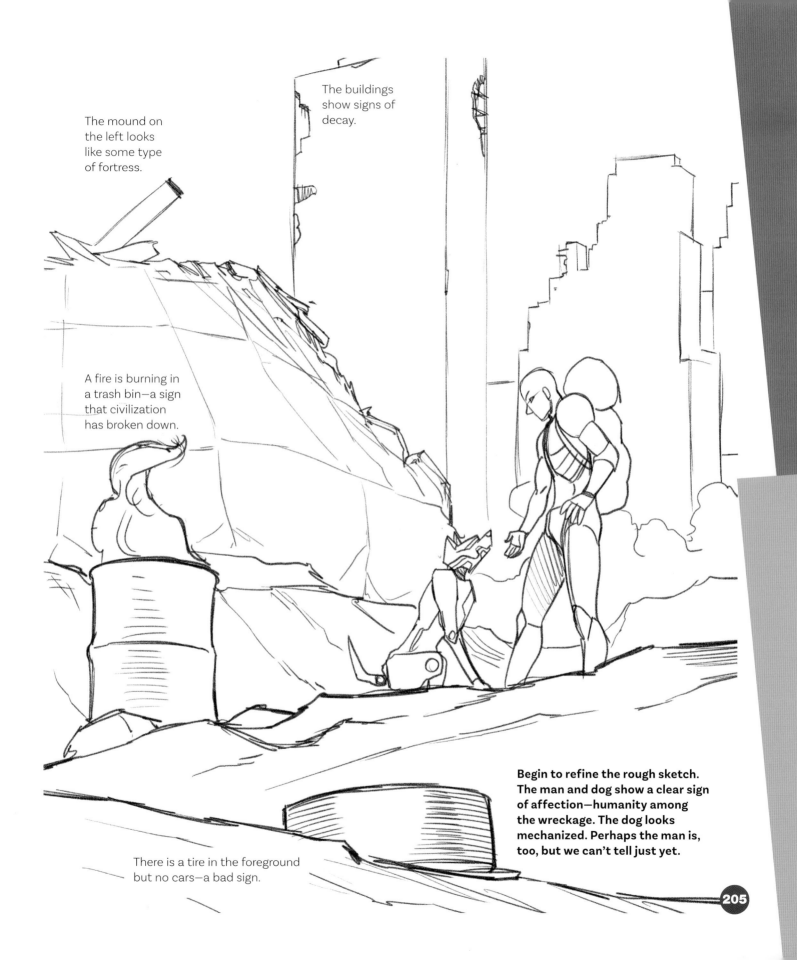

The mound on the left looks like some type of fortress.

The buildings show signs of decay.

A fire is burning in a trash bin—a sign that civilization has broken down.

Begin to refine the rough sketch. The man and dog show a clear sign of affection—humanity among the wreckage. The dog looks mechanized. Perhaps the man is, too, but we can't tell just yet.

There is a tire in the foreground but no cars—a bad sign.

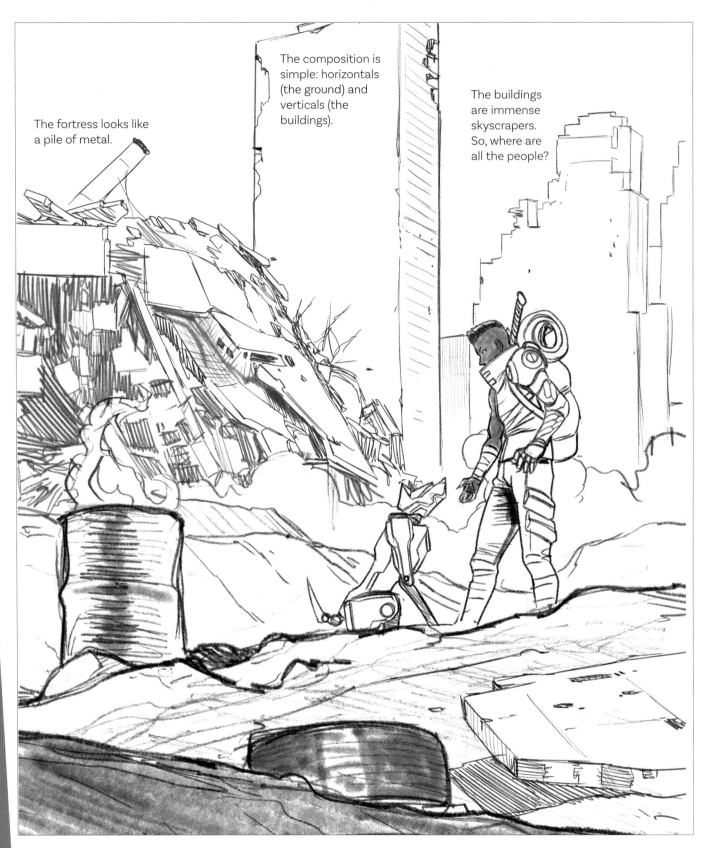

The fortress looks like a pile of metal.

The composition is simple: horizontals (the ground) and verticals (the buildings).

The buildings are immense skyscrapers. So, where are all the people?

Add shading and shadow to give the picture more weight and definition. The areas with no shading or tone contrast against the heavily shaded areas. That's good for pacing. You don't want everything to look the same.

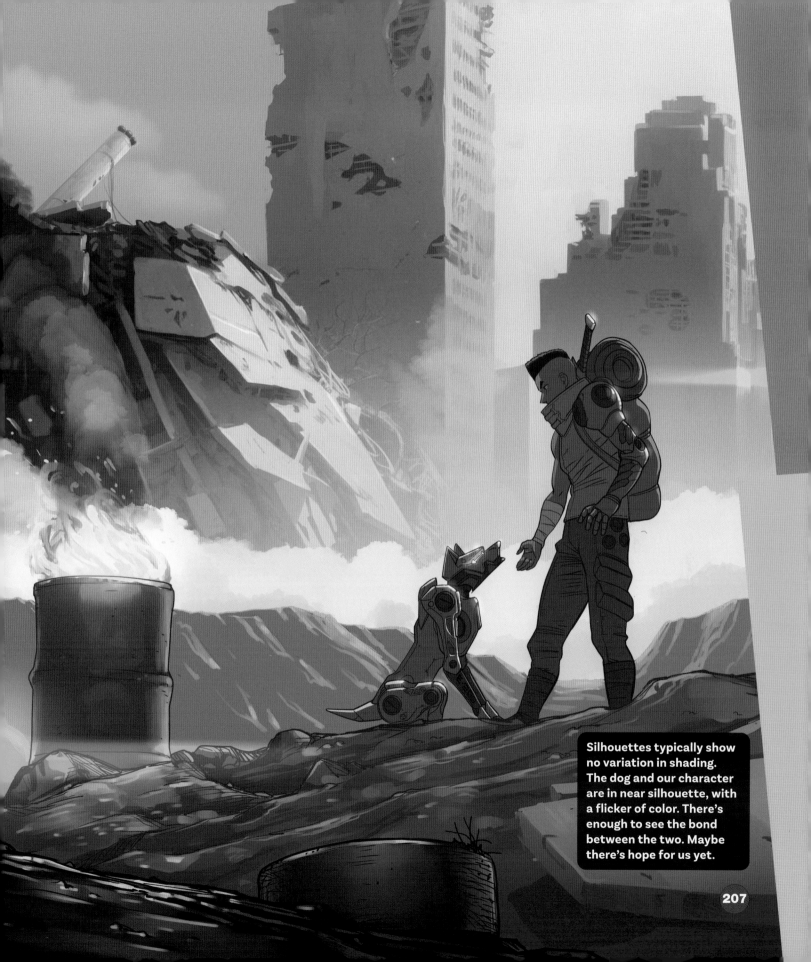

Silhouettes typically show no variation in shading. The dog and our character are in near silhouette, with a flicker of color. There's enough to see the bond between the two. Maybe there's hope for us yet.

207

Visual Storytelling

Everyone knows how to tell a story with words. But what about telling a story with pictures?

In a visual medium, the audience gleans information about what's going on from what they observe in the picture. For example, if two characters are arguing, and the artist has drawn a door, the viewer will wonder if one of them is going to storm out. That's visual storytelling.

When moments are strung together—in an anime episode, or graphic novel, or sketches based on a premise—the artist visualizes the story in terms of what happens next. This creates flow. A variety of shots are used to keep it interesting.

Alternating between points of view is also important. For example, in a real-life chase scene, you would see one car following another. In visual storytelling, however, you would continually change the point of view, shifting from the fleeing driver to the pursuing driver and back again.

Let's take an example of an original scene created for this book and see how the choices of panels and shots can heighten the drama.

A script written for an artist to draw from is typically lean—it doesn't describe too much, leaving the visual look to the artist's imagination.

The main thing to notice is the pacing of the action; switching from shot to shot (or panel to panel) drives the excitement as much as what is taking place inside of the panels.

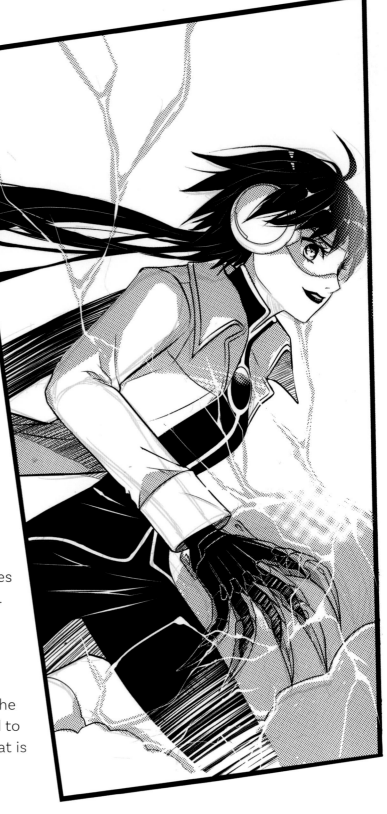

CHASE SCENE

PAGE 1

1. Establishing shot. We see the scene from a distance. Two small figures are scaling the top of a building in a city.
2. Cut in closer to the top of the roof, where a teen girl is running from a female assassin. The girl looks outmatched.
3. Cut in closer to the girl, running and very much afraid.

PAGE 2

1. Cut to the assassin, as her hands turn into claw-like weapons.
2. Pull back to see the teenager stop. She's at the edge of a tall building, with nowhere to go.
3. Reaction shot: The assassin stops and smiles. She comments into her earpiece, "Got her!"

PAGE 3

1. The teenager closes her eyes and allows herself to fall backward—from a 30-story building! It's like, *what the heck?!*

PAGE 4

1. The assassin peers over the edge of the building and is stunned to see the teenager rising up, as a huge pair of magical wings emerges from her back.
2. The teen flies off into the distance.
3. The assassin grumbles, "I hate when they know how to fly!"

END OF SCENE

CONSIDERING THE CHOICES

Let's explore some of the thinking that typically goes into the development of a dramatic scene like this one. An artist working on a script must keep the audience's experience foremost in their mind. They have to change the script in order to turn it from a reading experience into a visual one. Many ideas in the script will remain as written, but others will be combined, adjusted, or even eliminated. This is part of the creative process, and necessary. You can compare the illustrated version, here, to the script on the page 209.

These sequential drawings are very similar to a storyboard, which plots the action for animation. Artists in both related fields, anime and manga, try to plot an interesting course of shots to get the most out of the action. Ask yourself what other ways you might have designed this sequence.

When you create your own original story, ask yourself these four basic questions:

- How can I make it more interesting?
- What can I do to vary the pacing?
- What should I do to propel the story forward?
- What can I include to hold the viewer's attention?

The wide shot establishes the scene at the beginning of a desperate chase. This allows the viewer to see everything and to understand what the situation is and the stakes at play.

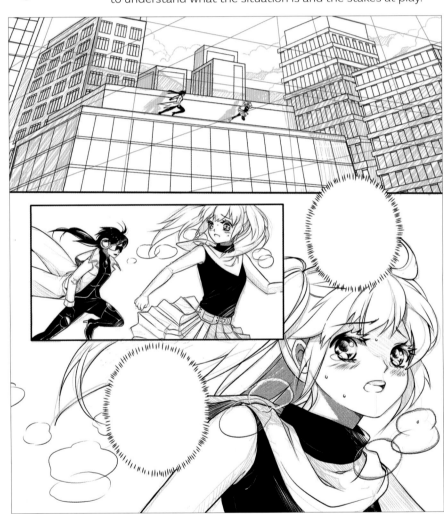

The boxed insert serves as a bridge to the close-up of the girl. Without it, the cut would be too abrupt.

The close-up tells the audience that she's in grave danger.

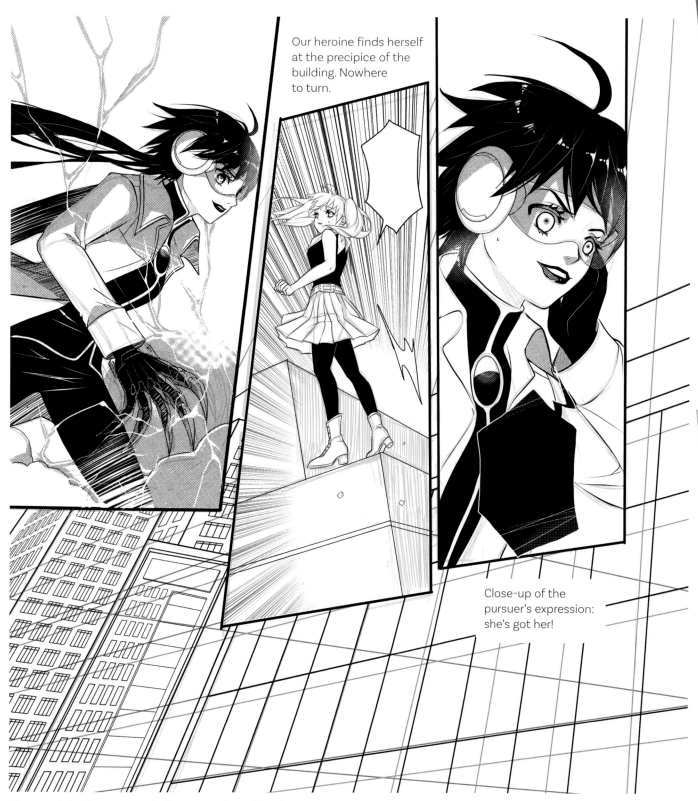

Our heroine finds herself at the precipice of the building. Nowhere to turn.

Close-up of the pursuer's expression: she's got her!

Three quick, choppy panels in succession raise the urgency.

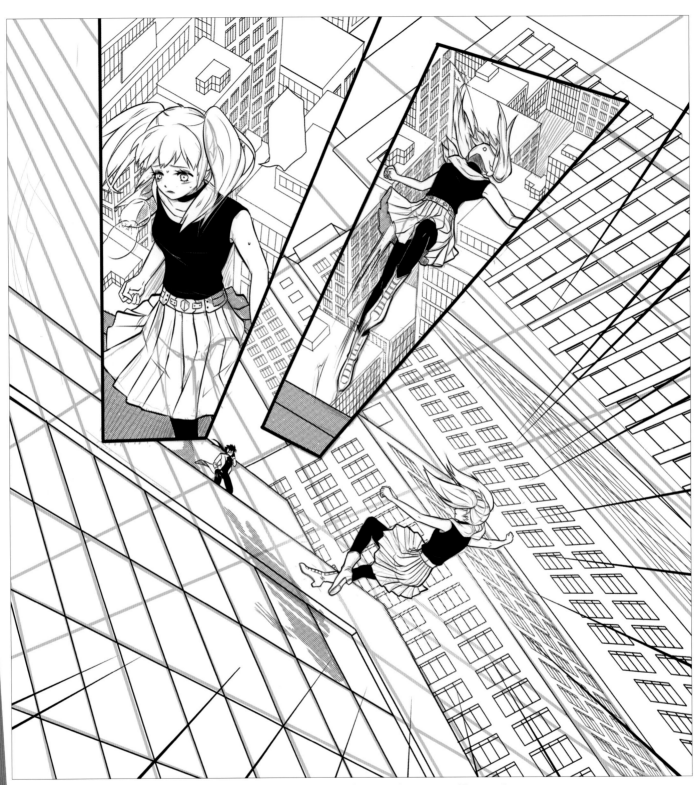

She stands on the precipice. She lifts her foot and then . . . she steps off. Done in
a series of small panels, it slows down the action, so we can watch in disbelief.

This is the classic "reveal," a device used to show a surprise twist. The heroine sprouts wings, safe and out of reach.

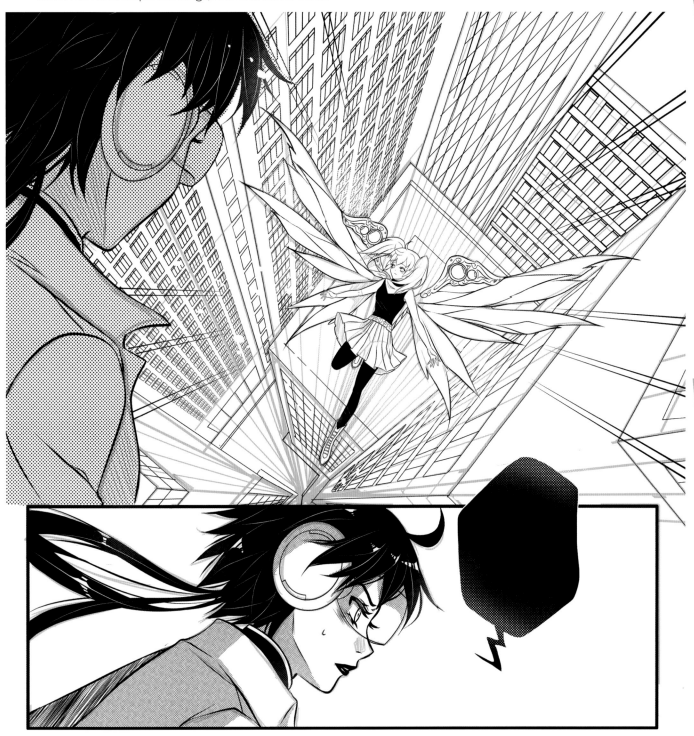

End on a reaction. All the frustrated enemy can do is watch.

So, You Want to Be an Anime Artist

All artists, from beginners to more advanced, can benefit from understanding what it's like to work as a professional artist. We've got three experts who will speak to different aspects of working as an anime artist: working as an animator in Japan, illustrating graphic novels, and representing the legal rights of creative artists. I think you'll find it interesting and helpful.

Cindy Yamauchi
Japan-Based Animator

As an animator in Japan, Cindy Yamauchi has a wealth of experience. Many anime fans wonder what it would be like to work as an artist in Japan's anime industry. Cindy gives you an insider's view, which could help you grow as an artist and help you set your goals, here or abroad.

Tell me a little about your background.

YAMAUCHI: While attending school, I took on a part-time job as an inbetweener [an animator who draws the connective poses of a character between the key poses] for an animation studio in Tokyo. After graduating, I became a freelance animator, working on various anime projects. I left the industry in my late twenties to live in the U.S. for awhile but returned to Tokyo to work on Madhouse's *Gungrave*. I've been living here ever since. I am a character designer, chief animation director, episode animation director, and illustrator for TV and theatrical anime projects.

Which projects that you worked on are you proudest of, and why?

YAMAUCHI: I work hard on every project and always hope to do better the next time. That naturally makes me proud of every work I do, but I try to leave them all behind so I can make a fresh start.

What anime shows, or films, do you think every aspiring anime artist should see, and why?

YAMAUCHI: This is always a difficult question for me to answer. I'd say *Akira* and *The Super Dimension Fortress Macross: Do You Remember Love?* I recommend these two for the same reasons—both were animated by young animators (many of them in their twenties) and share a strong, energetic feeling that could only be felt through a production prior to the digital age. They both were animated in the traditional style but the direction they were taking is very different, and I remember learning a lot just by comparing the two films.

What should someone include in their portfolio?

YAMAUCHI: I'm not in the hiring position, so I could only guess what the current trend is. I'd say a set of figure drawings, a variety of character/background illustrations, and a demo reel should be good enough. Quality means more than quantity.

What character types are the most important to master in anime?

YAMAUCHI: Good artists can draw a variety of characters in different styles, and that's exactly the kind of skills that are required in anime.

How important is social media for artists?

YAMAUCHI: I think social media is becoming an indispensable tool as more and more artists are learning how to draw in digital format right from the beginning. It allows for easy uploading of the artwork to social media platforms such as Twitter [now X], Instagram, etc., to gain greater exposure and even find work by networking with others. Though some criticisms are expected as your audience grows, it's very gratifying to know that there's somebody out there in this world that loves your artwork!

What types of specialties or jobs are there in anime?

YAMAUCHI: I'm listing the most common jobs in the anime industry.

1. Producer/Assistant Producer
2. Production Assistant/Coordinator
3. Director/Assistant Director
4. Writer
5. Music Director/Composer
6. Character Designer/Prop Designer/Mechanical Designer/Creature Designer
7. Art Director/Background Designer
8. Color Designer
9. Episode Director
10. Chief Animation Director/Animation Director/Special Effects Animation Director/Action Animation Director/Mechanical Animation Director/Assistant Animation Director
11. Layout Artist/Key Animator/Inbetweener
12. Background Artist
13. Color Supervisor/Special Effects Artist/Digital Painter
14. Composite Director/Compositor
15. Casting Director/Voice Actor
16. Sound Director/Sound Designer/Sound Engineer
17. Video Editor

If someone's dream is to work in anime or in manga in Japan, what advice would you give them?

YAMAUCHI: The most important thing is to learn the Japanese language—reading, writing, and speaking. Unfortunately, there is no easy way around this.

How does working in Japan differ from working in the U.S.?

YAMAUCHI: My work experience in the U.S. animation industry is somewhat limited, so I'll describe [what] the Japanese anime industry lifestyle is like and readers can make their own comparisons.

The employment structure is very different. Most animators in Japan are freelancers who work on a project-by-project basis. Though full-time employment has increased in recent years, the animator is still far from being considered a "real job" that includes benefits such as overtime pay, paid vacation, and health insurance. On the other hand, the positions in background, color, composites, and sound are often employed full-time, along with the producer/coordinator jobs.

Working long hours to meet the deadline is the norm, more so if you're a freelancer. This may sound grim, but the good news is you can set your own working hours and take time off whenever you want as long as you deliver your work on time.

You may have heard about how low the wages are in the Japanese anime industry. This always turns into a political topic, so I'm keeping it short. It's always difficult both financially and emotionally when you're just starting out as a young artist. An automatic raise can't be expected like regular employment, but in many cases, the studios are generous to those who are talented.

Where do you see anime headed in the future?

YAMAUCHI: Anime has survived many natural and man-made disasters over the years. The recent surge of AI-generated art and animation can be described as the next threat, but I'm very confident that the industry will learn to control and make good use of this new technology, just like they did in the past. Overall, I think the anime industry is resilient and has a bright future ahead, and will continue to be loved by fans all over the world. ■

Anzu
Graphic Novel Artist

Anzu is based in Southeast Asia. Like many of you, she's not only an artist, she's also a fan of anime and manga. She has worked on graphic novels, webtoons, comics, and more. In this interview, she describes some of the creative thinking that goes into her artwork.

Please tell us how you came to be an artist of graphic novels and webtoons.

ANZU: I had a strong desire to become a comic artist, so I often put samples of my work online. I was contacted by a professional writer through social media, and after that, I began working with them.

You have an interesting combination of perspectives: You have drawn manga for an Asian audience and comics for American audiences. How do the experiences differ?

ANZU: I think the biggest difference is the culture. Some humor and habits are not applicable in both. For example, I used to draw certain plants as manga backgrounds (I love plants, and mostly drew my favorite ones), but they are not applicable in American comics set in America because those plants only grow in Asia.

When you draw a graphic novel or a webtoon, do you subconsciously develop favorite characters?

ANZU: Of course! When I draw a character a lot and then read about their feelings and actions, I feel like I'm forming a connection to them. I feel sad when a comic ends because it means I have to say goodbye to the characters!

Which genres do you like to draw the most, and what do you like about them?

ANZU: I like drawing girls' comics, shoujo romance, and mystery. A combination of both is even better! I like drawing pretty things, and girls' comics involve a lot of emotions. I also like feeling curious!

Do you find that most artists write their own stories, or do they work as a team with a writer?

ANZU: I think it's both. Half of them write their own stories.

How long does it take you to complete a graphic novel?

ANZU: I usually begin by drawing the "hard to do" panels first and leave the

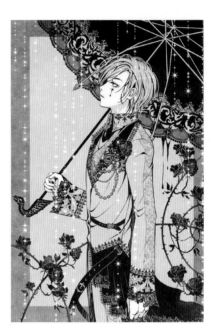

simplest panels for later because when we start, we have a lot of energy, and finishing the difficult tasks first is easier. With time passing, our energy drains, and finishing simple panels becomes harder. That's when the comic is finished.

How do you feel when you meet a longtime fan of your work in person, for example, at a convention?

ANZU: I get so excited and maybe a little shy. I'm a stay-at-home person, so it might

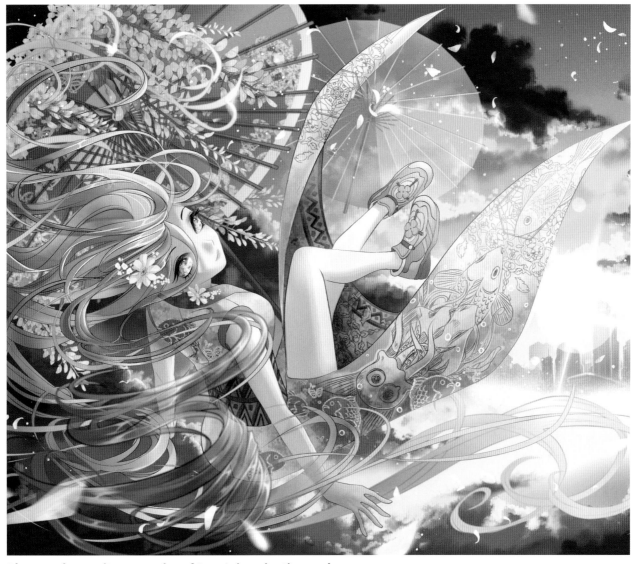

Above and opposite, examples of Anzu's imaginative work

be awkward. But I will be so happy.

How do you deal with deadlines?
ANZU: I'm the type who suddenly has a lot of energy when the deadline is near!

When you have several different ideas, how do you decide which to do next?
ANZU: I try them one by one, starting with what I find the most interesting. If it fails, I move on to the others until I find something that I can really finish!

Do you have any tips or words of encouragement for the readers of this book?

ANZU: If you want to be a comic artist, it takes a lot of determination. Your result will be different if you draw a hundred pieces a week compared to a few pieces a week. Just keep drawing, keep practicing, keep loving what you do. Sometimes you will get to the place you've always dreamed of. ■

Wallace E. J. Collins III, Esq.
Intellectual Property Attorney

Wallace Collins is an attorney who works with intellectual property to protect the rights of artists in many creative fields. If you're interested in developing your own original work, this interview could hold some valuable information for you.

Can you share with the readers some of your background as an intellectual property attorney, and what that means?
COLLINS: The term "intellectual property" quite literally means creations of the mind, property created by a client's mental efforts and intellectual labor, which is entitled to protection under copyright or trademark laws. As an intellectual property attorney with thirty-plus years of experience, I handle matters related to this property by advising clients on how to protect their rights, how to contract for the use of their rights (and I negotiate those contracts), and also discuss how to defend those rights as necessary.

You mentioned this in a prior interview, but it's so important, so let me ask again: What do you mean when you say an idea can't be copyrighted?
COLLINS: Under United States copyright law, only the expression of an idea is protected (i.e., how an artist draws the artwork or writes the words or records the music), not the idea itself. The ideas are free to inspire each author or creator to express it in his or her own way.

Some beginning artists put a little copyright © and a warning next to their work. Is that enough to protect it?
COLLINS: Under current U.S. copyright law, a work is protected from the moment it is "fixed in a tangible medium" (i.e., written down or recorded in some format). Although it is advisable to add the © or a warning, it does not grant any more protection than the law already provides but functions more as a source indicator for knowing who is the copyright claimant.

What is a typical mistake aspiring artists make when it comes to protecting their work or signing contracts?
COLLINS: My advice is never to sign anything—other than an autograph—unless you have your lawyer review it first. Under copyright law, an author or creator owns the rights to the work created unless it is transferred in a "signed writing" (so it is best to be careful before signing any contract). Under U.S. copyright law, there is also a registration process, which provides advantages and additional protections for a creator, and I usually suggest it is a good idea to register a copyright before circulating the work to the public.

What can someone do if they find that their art or characters are being ripped off and reposted on social media?

COLLINS: Copyright or trademark infringement is the unauthorized use of a copyright or trademark by another. The Internet and social media have opened up a vast new frontier and made enforcement and protection more difficult than ever, but the usual first step is to contact the alleged infringer and demand that the use cease and the infringement stop. In most cases, we contact the person posting it and we also do a "takedown notice" to the Internet service provider.

© © © ? TM

What is the difference between a trademark and a copyright? Many artists are unclear on the concept.

COLLINS: Copyright law protects the expression of an idea when the author or creator fixes it in a tangible medium. However, words, titles, phrases, and slogans are not protected by copyright law. Trademark law governs the use of a word, phrase, symbol, or logo by a person or entity to identify its goods and to distinguish those goods from those made or sold by another. Trademark rights are based on first "use" and are usually valued as a source or quality indicator in the marketplace.

If you do commissions (charge a fee to draw an original character for fans), should you have something in writing?

COLLINS: In order to avoid confusion, and faulty memories about what was agreed to, it is usually best to get something in writing to confirm the arrangement. However, remember, under copyright law, in the absence of a signed writing, the author of the work retains all rights in the work.

Can an artist use an established character to create and sell "fan art"?

COLLINS: In most cases, with the exception of what might be deemed a "fair use" exception to copyright protection (e.g., comment, critique, educational, parody, etc.), an artist must get permission or a license from the author or the owner of the established character before using it on any items.

Index

About the Author

CHRISTOPHER HART is the world's leading author of art instruction books, with over 8 million copies sold and titles translated into over 20 languages. He is the author of the *The Master Guide to Drawing Anime* series, which has sold over 800,000 copies. His books offer artists accessible and clearly written step-by-step instruction on a wide variety of learn-how-to-draw subjects.

Discover Christopher Hart's Other Anime and Manga Titles

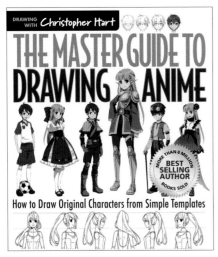

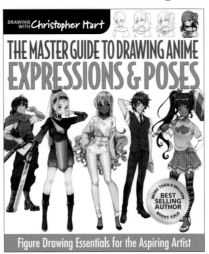

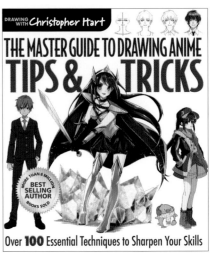

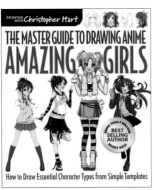